Painting Landscapes in Oils

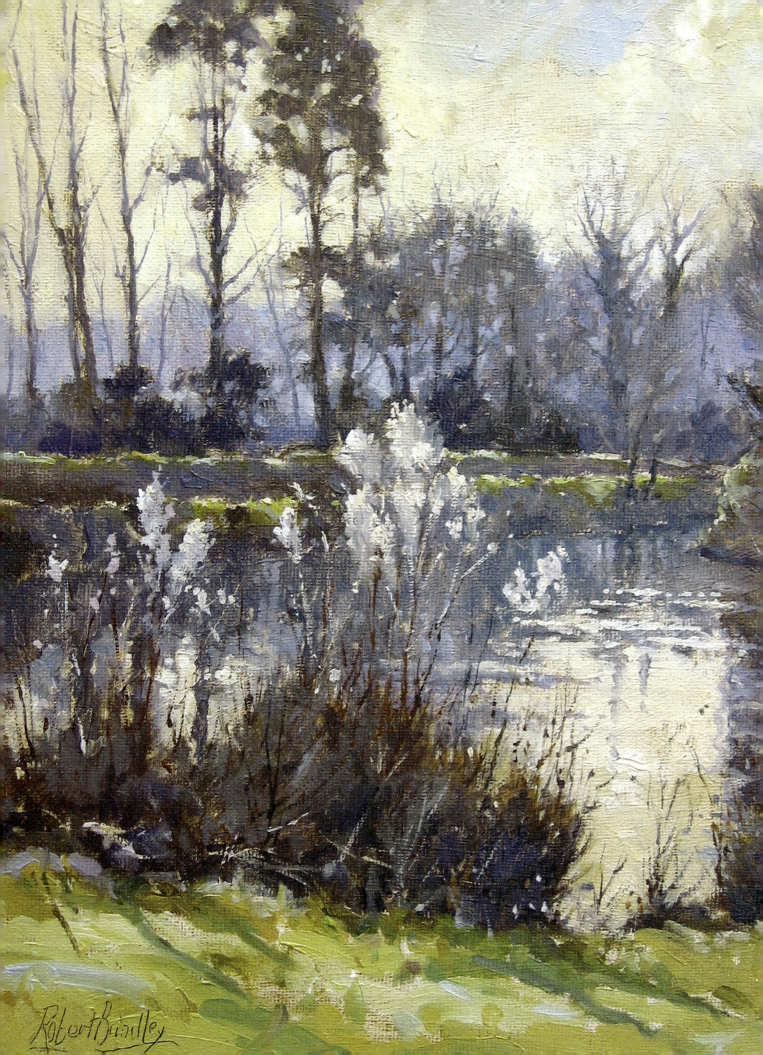

Robert Brindley

Painting Landscapes in Oils

ROBERT BRINDLEY RSMA

THE CROWOOD PRESS

First published in 2012 by
The Crowood Press Ltd
Ramsbury, Marlborough
Wiltshire SN8 2HR

www.crowood.com

British Library Cataloguing-in-Publication Data
A catalogue record for this book is available from the British Library.

ISBN 978 1 84797 314 6

Frontispiece: *Afternoon Light/Grinkle Park*, 25 × 30cm (10 × 12in).

Acknowledgements
I wish to express my warm thanks to Peter Hicks, a friend and much-admired colleague, for
writing the Foreword to this book. Last but not least, thanks to all my family, especially my wife
Liz, for her invaluable assistance in the writing of this book.

Typeset by Kelly-Anne Levey
Printed and bound in Singapore by Craft Print International Ltd

CONTENTS

Foreword by Peter M. Hicks 6

Introduction 7

1	Materials, Equipment and Techniques	11
2	Inspiration, Motivation and Design	21
3	Subject Selection	51
4	Skies	71
5	Painting Coastal Scenery	87
6	Rural Landscapes	107
7	Villages and Rural Buildings	133
8	Urban Landscapes and Travel	143
9	Observations and Conclusion	153

Further Information 158

Index 159

FOREWORD

In the east coastal region around Whitby we have seen in the last twenty years or so an increasing development of interest amongst professional artists in painting the environment again. Curiously, not since the Staithes Group, working around the time of the nineteenth to twentieth century, do we see such variety and quality in *plein air* painting.

Robert Brindley stands out amongst this group as an inspirational painter and teacher. His special concern for qualities of light and atmosphere, evidenced in his use of each of his chosen media, continues the traditions of those artists working along the coast over a century ago. In his pursuit of the changing nuances of light and atmosphere, Robert works in various parts of Britain and Europe. His paintings of Cornwall and parts of the Mediterranean coast sparkle with light and some remain as unforgettable images.

Although Robert's travels enable him to confront colour relationships that challenge his skills, vital to his practice as artist and teacher, he never neglects his own chosen area, where in various seasons and times of day some of his most intense work can be found.

Despite Robert's considerable natural talent he believes much is achievable with practice and perception, hence this highly informative book, which will go a long way toward enriching the lives of many painters in oils looking to meet the challenge of painting from their experience of the visual world.

Peter M. Hicks

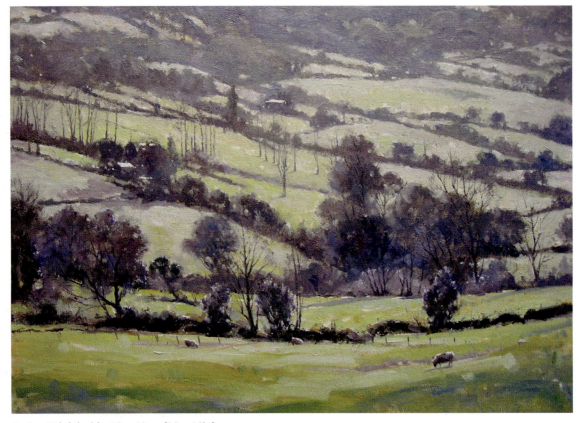

Spring/Eskdaleside, 50 × 40cm (20 × 16in).

INTRODUCTION

The White Sail/Norfolk Broads was undertaken to demonstrate the technique of painting reflections.

This book is a personal observation of painting landscapes in oil from the initial inspiration to the finished piece of work. Any decisions made with regard to subject selection, colour palette and the techniques employed will depend on how you decide these factors can assist you in your interpretation of the subject.

Wonderful things can happen if you put your brush down and let your painting be your teacher.

Charles Reid

Oil paints are an extremely versatile and flexible medium, ideally suited for landscape painting either *plein air* or studio-based. The characteristics of oil paint allow the painter an unparalleled freedom of expression as they can be applied to various surfaces and grounds, using strident or subtle combinations of colour, tone and texture, in conjunction with a wide range of techniques.

This book will discuss many aspects of painting with oils, such as:

- Taking an in-depth look at the materials available and the selection of a working palette of balanced colours, including the benefits of working with a limited palette of three primary colours and white.
- Painting *plein air* and in the studio.
- The construction of a painting with regard to subject selection, composition, the use of colour and the importance of tone, masses and edges.
- How to evaluate and assess your work by identifying and resolving problems.
- Tackling different elements of the landscape such as skies, trees, water, buildings, and so on.

Throughout the book step-by-step demonstrations will be used to aid understanding and to reinforce the topics covered in each chapter.

COLOUR MIXING IN THIS BOOK

The precision and subtlety of mixing specific colour is always difficult to teach as it is impossible to give the exact proportions of one colour to another in any mix. Generally speaking, throughout this book, a hierarchy has been adopted where the predominant colour is named first and the colour used least is mentioned last. To assist further, the following words have been used to help gauge the proportions in the mix more accurately: predominantly, equal quantity, slightly less, a small amount, a touch, and so on.

What is Oil Paint?

Oil paints are pigments that are bound with a medium of drying oil; linseed oil was used almost exclusively in Europe early in their development. The oil was boiled with a resin such as pine, or even frankincense; these were called varnishes and were prized for their body and gloss. Other oils used occasionally include poppy seed oil, walnut oil and sunflower oil. Particular oils give the oil paint various properties, such as less yellowing or different drying times. Certain differences are also visible in the sheen of the paints, depending on the oil. Painters often used different oils in the same painting depending on the specific pigments selected and effects desired. The paints themselves also develop a particular consistency depending on the medium.

At this point I would like to offer a few words of advice and encouragement that may help to vanquish the periods of doubt and uncertainty faced by artists all too frequently.

- Paint from the heart, and only what inspires or excites you.
- Be prepared for disappointment by responding in a positive manner at all times, even when confronted with failure. Remember, you only learn from practice and by making mistakes.
- It is essential to work through the bad times. If this seems difficult, try varying your subject matter, use colour in a different way, experiment with techniques, draw more

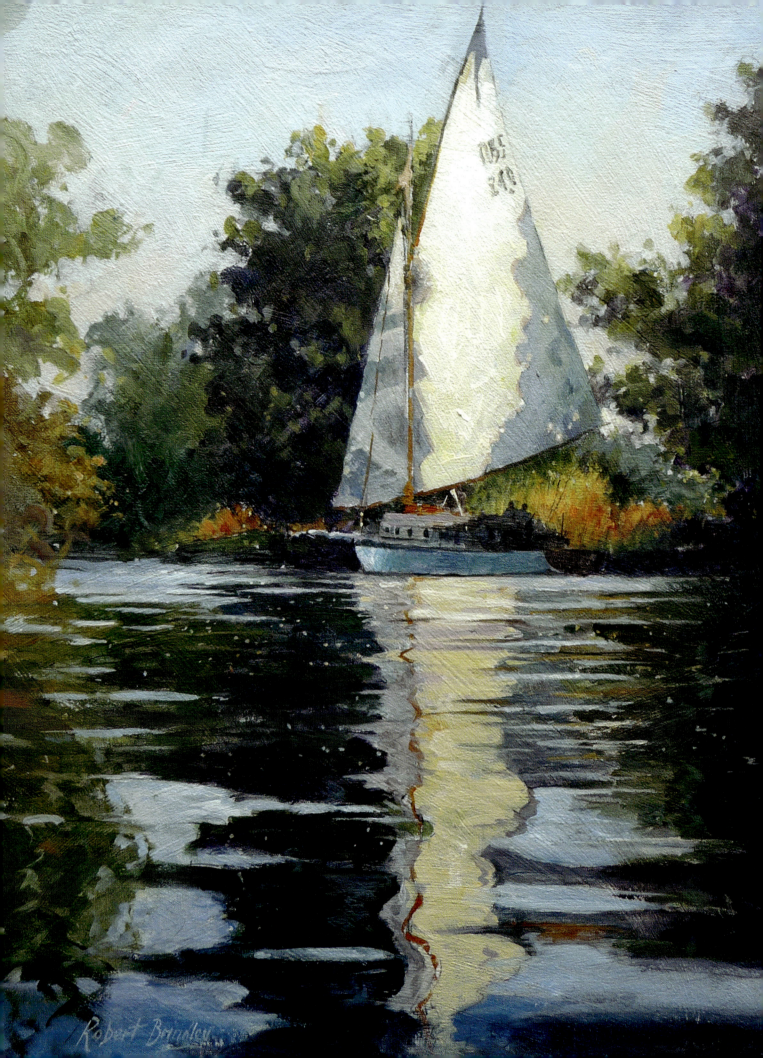

Robert Bradley

frequently or return to basics. By ringing the changes and introducing variety to your paintings you may be able to regain lost enthusiasm or confidence.

- Train yourself to be receptive to everything that surrounds you. Look, listen and learn from all sources; never have a closed mind.
- To stimulate your senses visit exhibitions, read books or view a DVD of one of your favourite artists. When doing this, be analytical: never look at the paintings without asking yourself how they were painted and what makes them appealing to you. Try to put into practice what you have learnt.
- This book concerns painting with oils, however I consider it of enormous value to paint in several mediums. The discipline of painting and expressing yourself in several mediums offers you the options for variety and a change of approach, which can provide a much needed stimulus should you be going through a time of disappointing results.

Probably the most important advice to impart is to work hard. Unless you are fortunate enough to have an exceptional, natural ability, it is only the amount of time spent painting that will ensure improvement. Painting is all too often assumed to be a pastime that can be learnt easily. In reality, it is no different to any other art form or discipline. For instance, no one would expect to be able to play a musical instrument without many hours of hard work, and learning to paint is no different, so be prepared to take pleasure from many small improvements along the way.

When painting in any medium my primary objective has been to capture the light, mood and atmosphere present in the subject matter. The vast majority of my oil paintings are inspired by a 'light effect', which is more often than not present in the simplest of subjects.

Painting *alla prima* (direct painting carried out in one sitting)

A sincere artist is not one who makes a faithful attempt to put on to canvas what is in front of him, but one who tries to create something which is, in itself, a living thing.

Giorgio Morandi

OPPOSITE PAGE:
The White Sail/Norfolk Broads, 30 × 40cm (12 × 16in).

is my preferred method of working; however, more considered works are undertaken in the studio, often based on small *plein air* studies or sketches.

Over time it has become clear to me that subject selection, motivation and interpretation are key factors in the successful rendering of any painting. The subject must be viable on many levels, some of which include composition and viewpoint, colour and tone. However, in addition to these factors there should be an excitement and an irresistible desire to paint the chosen subject. This excitement leads to motivation, without which lacklustre, uninspired paintings with no 'heart and soul' will almost certainly be the result. Interpretation is also vital to the success of any piece of work. The ability to visualize, capture and transmit the essence of the subject to the viewer is essential.

A BRIEF HISTORY OF OIL PAINTING

Although oil paint was first used in western Afghanistan at some time between the fifth and ninth centuries, it did not gain popularity until the fifteenth century, with its use migrating westward during the Middle Ages.

As its advantages became widely known, oil paint eventually became the principal medium used for creating artworks. The transition began in Northern Europe, in the Netherlands, and by the height of the Renaissance in the fifteenth century oil painting techniques using layers and glazes had almost completely replaced tempera paints throughout the majority of Europe.

Most Renaissance sources, in particular Vasari, credited Northern European painters of the fifteenth century with the 'invention' of painting with oils on wooden panels, although documentary evidence dating as far back as 1125 was found to refer to this method of painting. Early works were still painted on wood panels but around the end of the fifteenth century canvas became more popular, as it was cheaper, easier to transport and allowed for larger works. Venice, where sail canvas was readily available, led the move. The popularity of oil painting on canvas spread through Italy from the north and by 1540 the earlier method of painting on wood panels using tempera had become all but extinct.

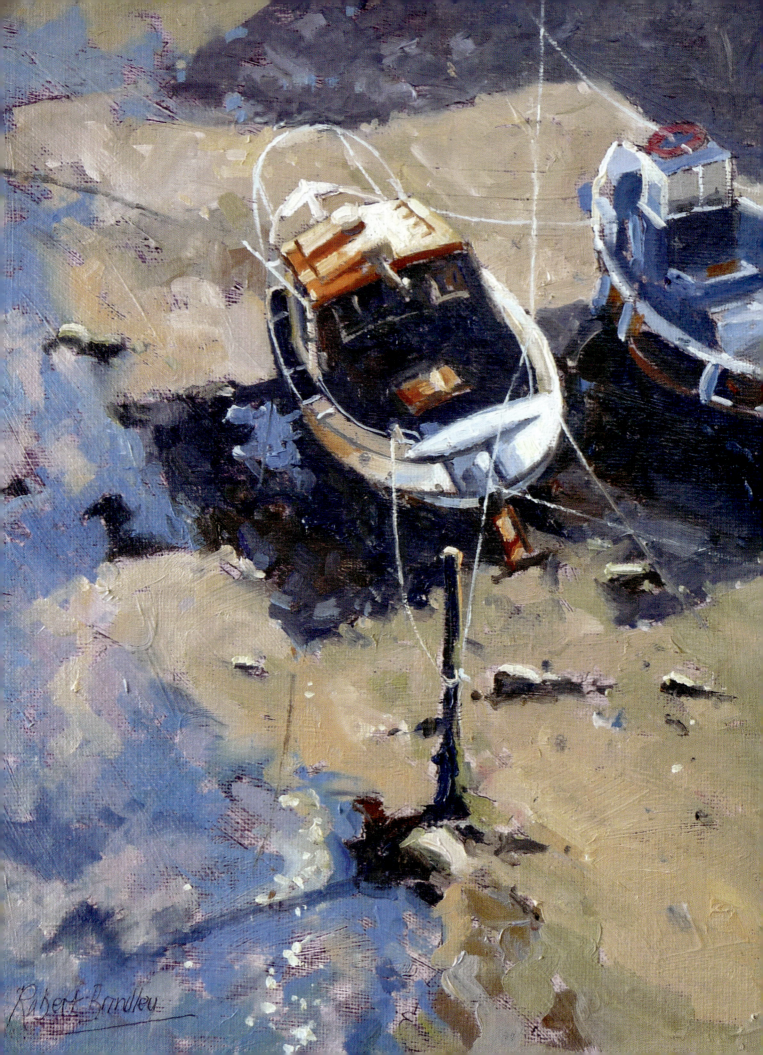

Robert Bradley

MATERIALS, EQUIPMENT AND TECHNIQUES

Boats/Staithes Beck was painted on a blue/grey toned board using Ultramarine Blue with a touch of Permanent Red Light. This 'cool' ground suited the subject matter perfectly, emphasizing the warmth of the sand and unifying the whole painting.

The Characteristics of Oil Paints

Oils are an extremely versatile and expressive medium, with the potential to carry far more impact and drama than many of the other media. Depending upon their application they can be used to create either vibrant, dense colour and texture, or atmospheric, subtle renderings of colour and texture. By 'glazing' over previously dry colour, transparent effects can be achieved to create mood and atmosphere. This method relies on patience and some knowledge of the interaction of colour, but it will enable you to capture some of the more transient and gentle lighting conditions.

Oil paint is a perfect medium for *plein air* painting as work can usually be continued in all but extreme weather conditions, in situations when painting in other media would be unsuitable. *Cottage/Esk Hall/Sleights*, was painted *plein air*, over a two-hour period of windy conditions, changing light and intermittent showers, where it would have been almost impossible to continue working in any other medium.

What Do I Need to Get Started?

The choice of materials and equipment can be overwhelming, especially for the beginner. With a little knowledge, the cost of a selection of suitable materials can be reduced drastically. If chosen wisely, the basic requirements for anyone new to painting in oils need not extend further than:

- six or eight tubes of paint;
- three or four brushes;
- a cheap bottle of turpentine substitute;
- a simple wooden palette; and
- a surface on which to paint.

It is important, however, that you always buy the best quality that you can afford.

OPPOSITE PAGE:
Boats/Staithes Becks, 25 × 30cm (10 × 12in).

Cottage/Esk Hall/Sleights, 30 × 25cm (12 × 10in).

Oil Paints

Modern oil paints are produced in many forms and by an ever-increasing number of manufacturers. As already mentioned, the extensive range of options can be confusing for the beginner. The following summary should assist both the novice and intermediate painter to make the selection process a little easier. Traditional oil paints come in two forms:

- Artists' Oil Colour: These paints are made using the highest level of pigmentation consistent with the broadest handling properties. The quantity and quality of pigment used ensures the best covering power and tinting strength.
- Student Colours: These are a more affordable range of oil colours made from moderately priced pigments, formulated for student and amateur artists or more accomplished painters requiring large volumes of colour within moderate cost limits.

In addition to the above modern technology offers a further choice, which may satisfy the needs of artists seeking faster drying times or an oil paint that allows thinning and cleaning with water.

- Griffin Fast Drying Oil Colour: Griffin oils have a far faster drying time compared to traditional oil colours. This means that the oil techniques of impasto and glazing can be done in considerably less time and a painting can be completed in a single session. These paints can be used in conjunction with traditional oils to accelerate drying time.
- Artisan Water Mixable Oil Colour: These paints have been developed by Winsor and Newton specifically to appear and work just like conventional oil colour.

The key difference between Artisan colours and conventional oils is the ability to thin the pigment and clean your brushes, palette and so on with water. Hazardous solvents are not necessary with Artisan so artists can enjoy a safer painting environment, making it ideal for those who share a work space, for use in schools or for painting at home.

Although this book does not cover the use of Oilbars, they do offer a quality oil colour in stick form, enabling you to paint and draw freely and directly onto your chosen surface. They are a unique medium because they provide a buttery consistency and the richness of oil colour together with the freedom and directness of pastels or charcoal.

Winsor and Newton Oilbars are fundamentally different from oil pastels or oil crayons due to their unique formulation. The fifty colours in the range are produced by combining artists' quality pigments with linseed or safflower oil, into which are blended specially selected waxes. To provide further flexibility, Oilbar sticks are available in three different sizes.

The following manufacturers produce a wide and varied range of reliable oil colours. (There are also numerous other manufacturers of oil paints aside from the examples here, including Michael Harding, Rembrandt, Sennelier, and so on, all of excellent quality.)

WINSOR AND NEWTON

Winsor and Newton manufacture all of the ranges mentioned previously in a variety of sizes of tubes/sticks. Their range of artists' oils have well over a hundred different colours, whilst the student oils, artisan oils and the Griffin alkyds have around forty different colours from which to select. 'Griffin' alkyds are a relatively recent formulation that uses an oil-modified alkyd resin to accelerate drying time. They are fully intermixable with traditional oils and handle in an identical way.

DALER-ROWNEY

Daler-Rowney Artists' Oil Colours are professional-quality paints, designed for durability and permanence using only the very best materials. They are available in 38ml tubes in eighty-three colours. Their student-quality Georgian oil colours are produced in 38ml tubes and come in fifty-four colours, having fine working qualities and a high degree of performance.

VASARI

These highly acclaimed, vibrant colours are, without doubt, one of the finest oil paints available. If price is not a factor but you demand a high-quality oil paint, using full-strength colour and no artificial fillers, then the Vasari range of colours are second to none. They are available in 40ml and 175ml hand-filled tubes in over ninety colours.

OLD HOLLAND CLASSIC COLOURS

These lightfast oil paints are another product of the highest quality. The extensive range of 168 colours offers the artist opaque and transparent colour, each with the highest possible brilliance (intensity) and clarity (cleanness) characteristics. They are available in a range of tube sizes.

Brushes

As with the oil paints themselves, there is a bewildering choice of brushes available to the oil painter, ranging from small to large and in a variety of shapes. The most common shapes are: Round, Flat, Bright, Filbert, Fan, Angle, Mop and Rigger. Besides the differences in size and shape, brushes are manufactured using natural hair, synthetic fibres or a blend of both.

The decision as to which shape or hair that you select is purely personal; however, in recent times the synthetic blended brushes have become extremely popular and in many cases they tend to keep their shape better than the traditional 'hog' brush. For the beginner, a mixture of flats, filberts and rounds would be recommended.

When purchasing brushes it is again advisable to buy the best that you can afford. Check that the hair is firmly attached inside the ferrule and that there are no loose or splayed hairs. The following manufacturers can all be recommended: Winsor and Newton, Rowney, Escoda, Pro Arte and Rosemary's Brushes.

A selection of brushes.

Supports and Grounds

The selection of a suitable support or ground is worth discussing in some depth as this has a great influence on not only the finished piece of work but also the painting process.

CANVAS

Traditional artist's canvas is made from linen, but less expensive cotton fabric has gained popularity. Although canvas can be glued to a rigid board, these days it is usually attached to a simple wooden frame called a stretcher. Proprietary canvases in numerous sizes and textures are available.

Some artists make their own stretched canvases by selecting canvas of a preferred weight and texture and buying it by the metre. The canvas is tensioned and attached to the stretcher using tacks or staples, then treated with size (a form of primer) to resist the acidic qualities of the paint. Suitable primers would include lead white paint, gesso (a mixture of glue and chalk) or acrylic gesso/primer.

Applying texture paste to MDF board.

BOARDS AND PANELS

Boards and panels have traditionally been used as a support for oil painting although canvas has generally been more popular since the sixteenth century. More recently, however, boards have made a comeback and are now probably more widely used than ever before. Modern materials such as Masonite[TM] and MDF (medium-density fibreboard) and a wide choice of rigid cards are thinner, lighter and less easily damaged than canvas, making them ideally suited for transporting and *plein air* painting. The following proprietary and home-made boards are worth considering.

- Canvas/cotton-covered boards in a wide variety of textures and sizes are available. Winsor and Newton and Daler-Rowney are probably the best known manufacturers.
- Smooth, prepared or unprepared panels can also be purchased from a supplier such as Jackson's (www. jacksonsart.co.uk).

- Many artists make their own boards using MDF, plywood or rigid card. Home-made boards can be created in any size, although boards exceeding 16 × 20in may need to be thicker to retain a workable rigidity. The panels can be treated with a variety of textures and finished with a primer to suit individual requirements. The following method could be adopted for making your own panels:
 1 Cut a piece of hardboard or MDF to the required size and lightly sand using fine-grade sandpaper to obtain a matt finish.
 2 Treat the board with one coat of white, acrylic primer (the drying time will only be a few minutes).

WORKING ON COLOURED GROUNDS

Coloured or toned grounds have been used by landscape painters for hundreds of years. Historically, artists worked on a grisaille (grey), a warm brown earth tone. This coloured ground helped the artist to achieve a convincing tonal balance in their paintings, preventing an overly light result when working on a white surface or an overly dark result by using a very dark surface.

Paintings are produced in response to what we see in front of us and any one mark made may appear dark on a light surface and light on a dark surface. Subsequently, all marks are seen in context and the artist should adjust accordingly. By painting on a mid-toned surface you will be more able to control the tonal range in your paintings. The choice of colour used for the ground will also play its part in the final results.

It may help to remember that everything is affected by that which surrounds it. In many cases this simultaneous contrast is extremely subtle and very difficult to observe, however with practice these observations become more apparent. When painting, notice how something may appear to take on the opposite of what surrounds it; it may appear lighter on a dark background, for example, darker on light, warmer on something cool or cooler on something warm. For instance, a seagull in full sunlight will appear light against a blue or cloudy sky; however, the same gull can appear dark against a lighter sky.

You will be able to use simultaneous contrast in many ways in your painting. For example, a painting with warmer tones will be produced by employing a warm-coloured ground. Every colour that you apply to the painting surface will look cooler – occasionally too cool – and you will automatically compensate by using a warmer mix. Subsequently, when the painting is complete, a warmer colour harmony will have been produced.

Daylight usually provides us with colours that are far warmer than we think. Subsequently, it is fairly common for an artist to become overly concerned with the localized colour of certain features, forgetting the influence of warm light throughout the scene. Look carefully and you will see that even the greenest or

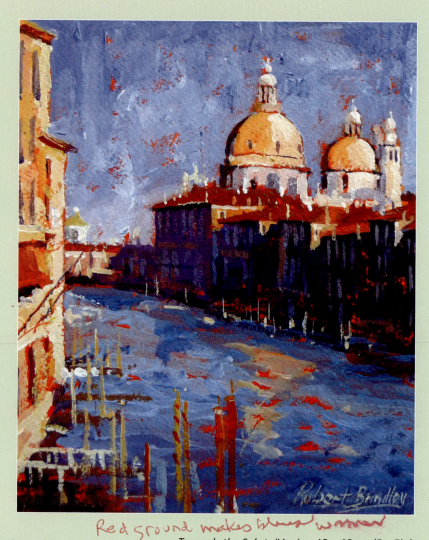

Red ground makes blues warmer

Towards the Salute/Venice, 13 × 18 cm (5 × 7in).

bluest of days are flooded with 'warm' light. The use of a warm ground will allow you to make compensations when working in situations where you could easily be overly influenced by what appears to be a cool light. The small sketch *Towards the Salute/Venice* was painted on a red ground, which makes all the blues used appear to be much warmer.

Although generally warmer grounds are used more frequently than cooler grounds, you will often come across subject matter that would benefit from the use of a cooler surface. In particular, sandy beach scenes work extremely well with a cooler ground. To find the most suitable support for yourself, experiment with as many varieties as possible to determine which ones suit your style of painting.

3 Apply a coat of texture paste or moulding paste to the board using a 25mm stiff brush, leaving random brush marks if desired (drying time will be approximately thirty to forty minutes).

4 Treat the board with another coat of white, acrylic primer.

The finished board can be left pure white or treated with a coloured ground of oil paint heavily diluted with turpentine or a similar solvent.

PAPERS FOR OILS

These days there are a variety of primed, textured papers that resemble canvas. They are available in fine or coarse grades, in either pads or blocks. These papers are convenient for sketching or practice; however, they tend to have a greasy, slippery surface on which it is difficult to work with oil paint.

Accessories

The following miscellaneous items may be required, although when painting *alla prima*, in a direct manner, you may not need the ones marked by an asterisk (*).

- Linseed oil:* Used to improve gloss, reduce consistency and slow drying time.
- Distilled turpentine:* Used to dilute oil and alkyd colours and for cleaning brushes.
- Low-odour solvent:* As above.
- Fast-drying oil painting medium: Used to accelerate drying

Wooden, thumb-hole palettes.

and for glazing and blending. Liquin light gel and Liquin fine detail are two examples.

- Turpentine substitute: Used to thin paint down to a watercolour consistency to apply a coloured ground to the support or to clean brushes.
- Texture paste:* A proprietary product used to introduce additional texture to the support.
- Acrylic/gesso primer:* Used in the preparation of your own panels/supports.
- Palette/painting knives:* A selection may be advisable unless you intend to use the knife only for paint-mixing purposes.

A selection of palette knives.

A plate glass palette.

- Mahlstick: A mahlstick is used as a support for steadying the hand or arm when undertaking detailed or controlled work. It has a long handle with a pad at one end and is rested diagonally across the canvas or board.
- Palettes: Today there are a great many palettes available to the oil painter. Probably still the most common and popular choice is the wooden thumb-hole palette, which can be purchased in a variety of different sizes and shapes. In addition to this, white, lightweight plastic or melamine palettes are widely available. These palettes are far lighter and more easily cleaned than the more traditional wooden palette. Many artists are of the opinion that a white or lighter-coloured neutral palette is preferable to achieve a more accurate assessment of tone and colour. Disposable, oil-proof paper palettes are lightweight and are also worth consideration.
- In a studio situation, it is worth considering working on a sheet of plate glass. Glass palettes are extremely easy to clean and can be cut to the required size. For safety, the edges of the palette can be ground, or the glass backed by a neutral-coloured card and framed to protect the edges.
- Dippers: These are small metal cups that clip onto the edge of a wooden palette to hold turpentine, painting medium, and so on.
- A palette scraper/cleaner.
- Picture varnish: Gloss or matt varnish are equally suitable, it depends on your preference.

Equipment

The following equipment may be considered; however, the choice is personal and determined by many factors such as the availability of studio space and the size of paintings on which you wish to work. Bear in mind that portability is also an important factor for the *plein air* painter.

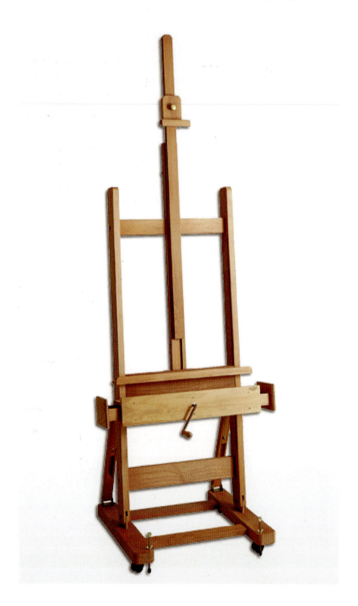

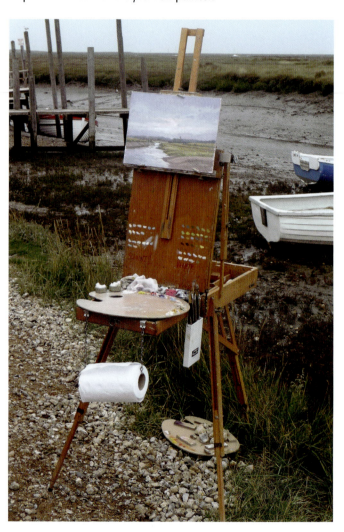

ABOVE: A French easel.

LEFT: A studio easel.

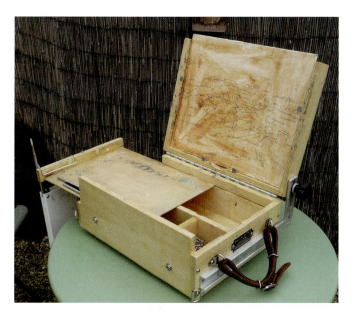

A 12 × 9in pochade box

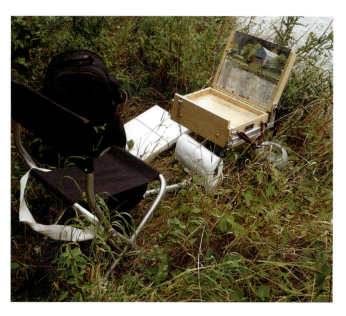

A plein air set-up.

EASELS

- A studio easel: Essential for any painter needing a sturdy, versatile easel capable of securely holding large or small paintings.
- A French easel: This compact, versatile easel is ideal for small-to-medium sized works, painted in the studio or *plein air*. It folds away and has adequate storage capacity for materials.
- A pochade box: This is a small sketching box/easel that can be worked on by either mounting the pochade on a lightweight, telescopic camera tripod or, when seated, directly from the knee. These boxes are available in a variety of sizes, depending on the size of board to be used. They have sufficient storage space for a limited number of colours, brushes, thinners and several painting boards. They are becoming more popular and are available from many good artist suppliers.

Setting Up a Studio

A peaceful, convenient working environment with good light is extremely beneficial to all painters. However, not everyone has a dedicated working space and some have to set up their easel each time they paint. If you are fortunate enough to have a spare room, or are considering acquiring a permanent space in which to work, the following considerations may prove useful.

Irrespective of size, one of the primary considerations for your work space should be the provision of adequate light and ventilation. Good lighting, whether it be natural or artificial, is absolutely essential. Ideally, the best form of constant, 'cool'

natural light is provided by a north-facing room (for those in the northern hemisphere) with either a large window or skylight. If you are not fortunate enough to benefit from north light, a thin gauze or cotton curtain can be used successfully to cool and soften a harsh, 'warm' light source.

When the only option is to work in artificial light you could experiment using 'cool' daylight fluorescent tubes or bulbs in conjunction with 'warmer' tubes or bulbs. Make the most of the available light by keeping all the walls, surfaces, furniture and so on as light in colour as possible.

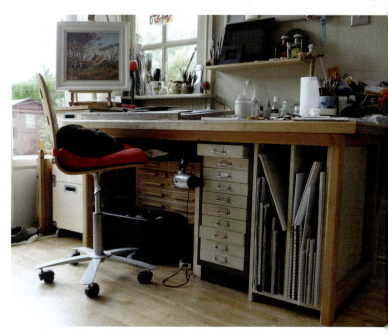

A studio workbench.

Hazy Light/Staithes, 30 × 25cm (12 × 10in).

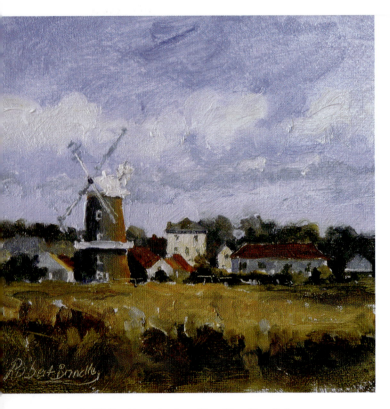

Windmill/Cley Next the Sea, 15 × 15cm (6 × 6in).

You will also need to consider how best to store all your boards and canvases. Generally speaking, to avoid warping these are best stored upright, in racks. Paints, pencils and other miscellaneous items can be stored in a small office cabinet. However, it is wise to sub-divide the drawers to ensure that everything remains in its own orderly place. Brushes are best stored ferrule-up in pots or jars, making their selection far easier.

Working surfaces should be of adequate size and easy to keep clean. Off-cuts of plain vinyl floor coverings make an excellent, cheap, easy-to-clean working surface. The workbench illustrated shows a set-up incorporating vertical stacking for boards and so on, a small metal cabinet of drawers, a good work area for the layout of materials and an adjustable working surface that enables boards or canvases to be worked on at a variety of angles.

The Selection of a Limited Range of Colours

For many artists, colour provides visual excitement and this is often the sole reason for wanting to paint. However, for the beginner, and sometimes even the more accomplished painter, the selection of a palette of colours and their subsequent mixing is often the most daunting aspect of the painting process. This problem can be remedied by gaining a basic understanding of the characteristics and interaction of colour.

There are only three colours that cannot be made by mixing other colours together. These basic colours – red, blue and yellow – are known as the primary colours. There are, of course, a wide variety of primary colour paints available. Common blues include Cobalt Blue, Cerulean Blue and Ultramarine. Reds include Alizarin Crimson or Cadmium Red, and yellows include Cadmium Yellow, Cadmium Yellow Light or Lemon Yellow. The decision as to which primary colours to use is purely personal, as each blue, red and yellow are different and subsequently produce quite different results when mixed. Probably the best advice would be to select a warm and cool version of each primary to work with. A palette could then be built up from, for example, Ultramarine/Cerulean Blue, Cadmium Red/Alizarin Crimson and Cadmium Yellow/Lemon Yellow.

Hazy Light/Staithes was painted as a demonstration to illustrate the variety of subtle colours that can be achieved by using a limited palette. These days, many *plein air* oil painters use a further reduced palette of just three primaries plus white. Personal experience has confirmed that the following Vasari colours work extremely well together: Permanent Bright Red, Ultramarine Blue and Cadmium Yellow Lemon. Many of the works illustrated in this book have been painted using the above three primaries and the use of this restricted palette will be covered in greater detail in the following chapters.

The oil sketch *Windmill/Cley Next the Sea* was painted on site using a limited palette of only Ultramarine Blue, Cadmium Orange and Titanium White.

I like to manoeuvre the paint on the canvas, which is something you can't do with acrylics [...] I like to see the brush strokes.

Helmut Langeder

Techniques and Developing Skills

All successful techniques are the end result of clear vision of the work to be created.

Richard Schmidt

Techniques

There are many different techniques and working methods available to the oil painter. It is only by experimenting and gaining experience that you will be able to select the appropriate techniques that suit both you and the selected subject matter. This book deals mainly with those techniques and working methods that permit a fairly rapid execution of the subject matter, both in a studio setting and *plein air*, whilst at the same time ensuring that the mood, atmosphere and sense of place is captured.

This direct method, which is sometimes referred to as *alla prima* (translated as 'at the first'), requires the painting to be completed in one session. In some instances the artist may dispense with a preliminary drawing entirely, preferring to 'block in' the main shapes rapidly in order to capture the essence of the subject in a loose, unrestricted manner. In many cases the paintings are undertaken with expressive brushwork, a limited palette and 'fresh' colour that has not been over-mixed. Painting *alla prima* requires confidence and a certain degree of experience; however, frequent practice will soon be rewarded.

This method, which involves the use of both traditional canvases and boards, with a variety of finishes and textures, will be discussed further in the following chapters and their step-by-step demonstrations.

Developing Skills

To ensure the continued development of your skills, a well-balanced, artistic exercise regime is essential. The following recommendations should help your development.

- Drawing is the foundation of any good representational painting. An artist may have many other skills, such as the ability to see colour and use expressive brushwork, but all the ability in the world will not solve a weak drawing. If possible draw something every day to exercise your hand–eye coordination. These doodles or simple sketches do not have to be finished pieces of work as they are intended to enable you to record accurately what you see in front of you.
- Carry out compositional thumbnail sketches before you begin a painting. The more experienced you become, the easier it is to ignore this basic design exercise – however, the benefits far outweigh the time involved.
- Strengthen your assessment of value by undertaking frequent greyscale exercises. By eliminating the distraction of colour the light and dark values are far more easily assessed, enabling you to manipulate form more creatively.
- Continue to study paintings and books of the artists who inspire you. It may help to return repeatedly to instruction books that deal with how the paintings are created, as each time you re-read one of your favourite books a little more knowledge is absorbed.

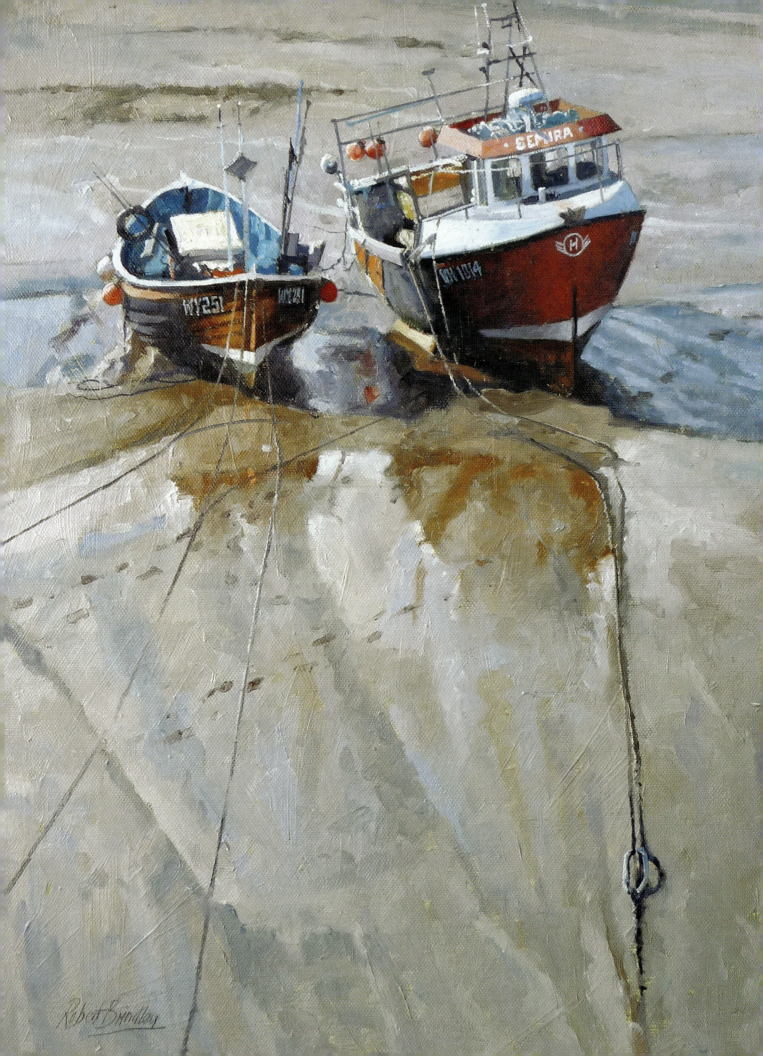

INSPIRATION, MOTIVATION AND DESIGN

The Moorings/Staithes Harbour was painted at low tide on a bright, sunny day. The two fishing vessels are positioned high in the composition to fully utilize the texture and reflections in the wet mud. The mooring ropes provide an excellent 'lead-in' to the composition.

INSPIRATION AND MOTIVATION

The production of any successful piece of work generally relies upon several vital factors, and not all of them concern the technicalities of the painting process. The most important factor must always be enjoyment – after all, what is the point of painting in the first place if your motivation is something other than enjoyment of the process? Painting for other reasons – solely for financial gain or for recognition, for example – will, in most cases, result in paintings that may look technically sound but lack that vital spark, sensitivity, energy or 'heart and soul'. You will occasionally come across a subject that has an immediate impact and has all the above essential ingredients to stimulate your desire to paint. Without this desire the resultant painting is unlikely to succeed.

It is through observation and perception of atmosphere that he [the artist] can register the feeling that he wishes his painting to give out.

Lucien Freud

Occasionally inspiration comes from unexpected sources and it may not always have an immediate impact. It may be that the subject has certain qualities, such as a stunning light effect, but lacks a convincing composition. In situations such as this, use your imagination, experience and knowledge to make any necessary adjustments. Minor adjustments are often all that is required.

To take full advantage of any inspiration that comes your way, whether immediate or less obvious, endeavour to be receptive at all times. Consider a variety of subject matter, maybe with unusual qualities, and never reject a promising subject that may only require minor adjustments. Remember, never doubt your first impressions: the subject under consideration may be fairly ordinary, but if the light, mood, atmosphere or colour is special to you, trust your original gut instincts.

The small painting *The Gate/Beck Hole* illustrates how a fairly ordinary subject can be transformed by light. The low evening light illuminated the field and trees beautifully, streaming through the gate and across the track. This painting is used for the step-by-step demonstration in Chapter 3.

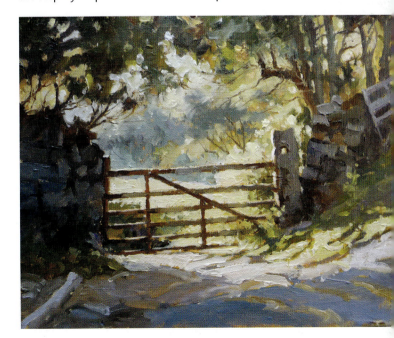

OPPOSITE PAGE:
The Moorings/Staithes Harbour, 30 × 40cm (12 ×16in).

RIGHT:
The Gate/Beck Hole, 30 × 25cm (12 × 10in).

Barges/St Jean de Losne/Burgundy, 20 × 45cm (8 × 18in).

Consider the fact that all forms of visual art rely on the communication between the artist and the viewer. The success or failure of any piece of artwork depends on the artist's ability to transmit their emotions to the viewer convincingly. This can be achieved in many ways – you may decide to focus on a certain light effect, mood and atmosphere, or vibrant colour and texture. Whatever you decide, keep your focus and never deviate from your original intentions.

Exhibitions, either solo or jointly with other artists, offer the opportunity to showcase your work. Unless an exhibition is themed specifically, it may be advisable to display works with variety in order to engage a greater number of viewers. Consider some of the following:

- works which are solely concerned with mood and atmosphere;
- works which may have a single, striking light effect;
- works which concentrate on colour, texture or a degree of abstraction;
- large vistas;
- cameo scenes such as The Gate/Beck Hole.

Exhibit a wide variety of shapes and sizes. Even buyers with a large collection of works will have room for a small painting they cannot resist. Square, tall and thin, or wide and narrow paintings offer variety from the usual rectangular formats. The tall, slender painting Barges/St Jean de Losne/Burgundy would add variety to any exhibition, for example.

Inspiration and motivation are the catalysts for all paintings. However, a sound knowledge of technique together with the skills necessary to handle and apply oil paint are essential; without a sound compositional base and structure a painting is likely to fail.

For many beginners subject selection, composition and simplification are major stumbling blocks. With experience, though, many seasoned artists develop an almost inbuilt judgement with regard to these elements; the experienced eye seems to readily select subject matter, simplify, crop, edit and compose at ease.

To assist and encourage the beginner or less experienced painter the following observations and recommendations may prove useful.

Drawing, Sketching and Observation

Good drawing forms the 'bones' on which a strong painting hangs.

Chris Bingle

The importance of drawing and sketching is often underestimated. An artist's ability to explore the subject through either a considered drawing or quick sketches is vital for the success of any landscape painting. Buildings in particular vary enormously in their characteristics, shape and size, and must be drawn accurately to be convincing. A poorly drawn building will never look right, reducing what might have otherwise been a successful piece of work into a failure.

The small sketch *Cottages/St Bernard/Burgundy* shows a row of derelict cottages viewed from the roadside verge. Buildings like these make wonderful, painterly subjects; the roof lines, windows and doors no longer conform to the rules of perspective as a new building would, which encourages a far looser handling of the drawing.

Street scenes with a wide variety of buildings make wonderful subjects and provide artists with a variety of challenging and demanding elements. A good working knowledge of perspective is vital for the successful rendering of such complex subjects.

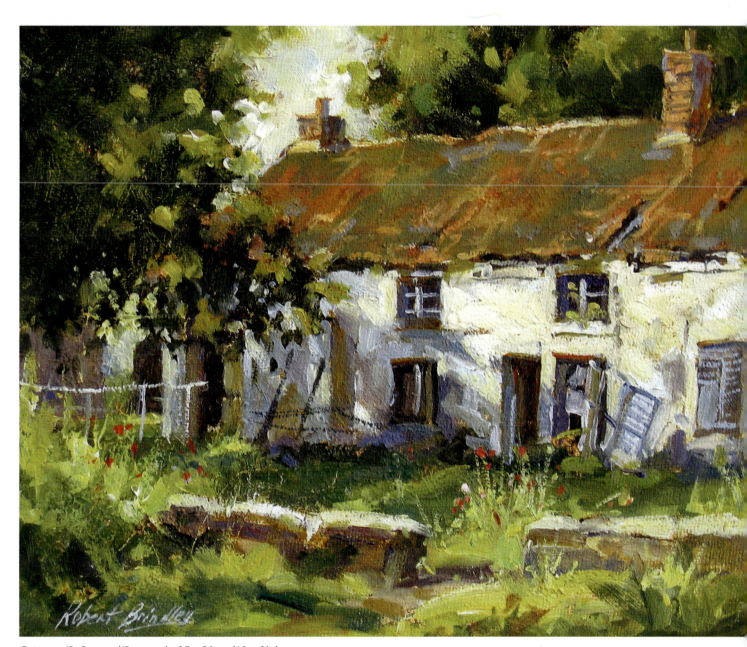

Cottages/St Bernard/Burgundy, 25 × 20cm (10 × 8in).

Perspective

Linear perspective is a method of portraying objects on a flat surface so that the dimensions shrink with distance. The parallel, straight edges of any object, whether a row of buildings, street lighting columns or a hedgerow, will follow lines that eventually converge at infinity. Typically this point of convergence will be along the horizon and is called a vanishing point.

Simple subject matter, such as a row of houses on a straight line and on level ground, will sometimes have only one vanishing point. However, more complex subjects, those viewed from a higher elevation and buildings positioned at various angles can have numerous vanishing points. For you to render subject matter such as this faithfully will depend on your ability to observe and draw extremely well.

High Aspect/Beck Hole was painted from an elevated situation overlooking this picturesque hamlet. Subjects such as this require an understanding of perspective and a sound drawing ability. (Sketching and the use of sketchbooks will be discussed in more detail in Chapter 3.)

Photography

Photographic images are a useful source of information and should be treated generally as memory joggers as they can be extremely misleading in terms of tone, colour and recession. Many artists paint from photographs in conjunction with sketches, small on-site paintings and their experience of painting in the field. (The use of photography will be discussed in more detail in Chapter 3.)

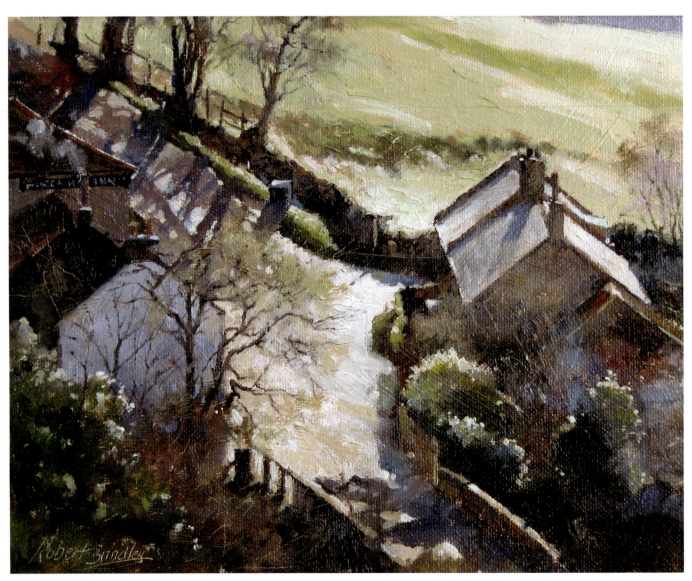

High Aspect/Beck Hole, 30 × 25cm (12 × 10in).

DESIGN

Composition

A landscape painting in which composition is ignored is like a line taken from a poem at random: it lacks context, and may or may not make sense.

Walter J. Phillips

With regard to painting, the term composition means 'putting together' a work of art. A good, well-thought-out composition, in conjunction with tone, colour and drawing, is an essential building block for any successful painting. The success of even the simplest of images is dependent upon a sound composition, which should emphasize your vision for the piece of work and at the same time provide balance and harmony together with a convincing focal point and lead-in.

Before commencing a painting, it is always prudent to take sufficient time to evaluate the subject matter with regard to composition. During this evaluation, the following criteria should be considered.

The Focal Point

The focal point is usually the main area of interest to which an artist wishes to direct their audience. There are often several secondary focal points within areas of lesser interest that lead the viewer through the composition, almost as stepping stones. Imagine that you are a film producer or director in search of the star (the main focal point) and the supporting cast (the secondary focal points). The star will carry the weight of the production and the supporting cast will support and enhance the star's role. By adapting this scenario to the painting process you will be able to plan the main area of interest followed by the lesser points that will provide movement and support to the area of interest.

Understanding how the human eye sees is helpful in learning how to handle the main and secondary focal points in your paintings. Our eyes only ever focus on one given area at a time and everything else is diffused. Only when we move our attention to another area does that area become sharper. This phenomenon, if used effectively, can be a very useful tool for the artist.

Before beginning any painting you must always have firmly fixed in your mind exactly what attracted you to the subject in the first place. It might be a dramatic, back-lit silhouette or sunlight on distant fields, for example; whatever the attraction was, it must be used as the basis and focus of your painting. By keeping your eyes fixed on your intended focal point, notice how everything else away from this focus has soft edges and reveals no detail at all. *This image is what you should be painting to achieve success.* Try looking away from your focal point and notice how the importance has shifted away from the focal point and on to what you are now looking at: your intended focal point will have no impact and neither will the resultant painting if you lose concentration. *By painting the entire subject in sharp focus there will be too many distractions and you will not achieve a successful piece of work.*

It may help you to make a list of the order of importance when establishing the area of interest and your secondary focal points. Bearing in mind your focal point, first develop the sharper edges, followed by value contrasts (lighter lights and darker darks) and, finally, stronger colour saturation (brighter, more intense colours).

Balance

Visual balance is extremely important. It deals with the satisfactory arrangement of all the various elements that make up any painting – for instance, tonal sequence, texture, line, masses and colour. A successful painting should engage and interest the viewer, avoid confusion and have variety and restraint.

Developing a composition is a creative process involving intuition and thinking more than following rules.

Alessandra Bitelli

Over time there have been many discussions and theories regarding how to achieve balance and harmony in paintings. Although there are a few simple guidelines that are useful as a basic starting point, the experienced artist with a good eye and many years of experimenting is able to bend these guidelines, or sometimes ignore them completely, to produce more visually engaging, dynamic pieces of work.

One of the most important of these basic guidelines is referred to as the 'golden section', a mathematical proportion accepted by Renaissance artists as having significant aesthetic significance. This theory states quite simply that any significant feature within a painting, such as a tree or figure, is best positioned approximately two-fifths of the way across the picture. Renaissance artists used this theory to create visually satisfying, balanced and harmonious paintings.

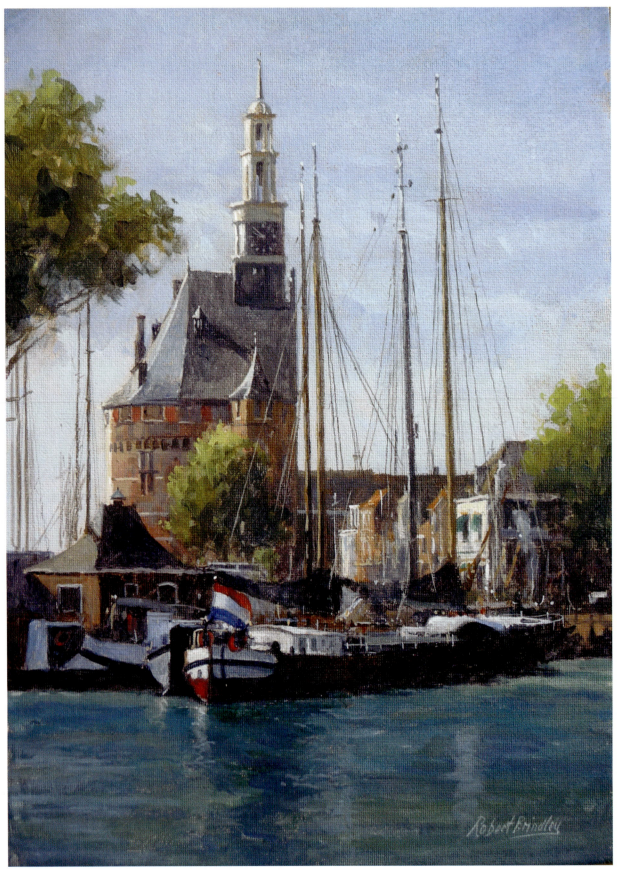

Barges at Hoorn/Holland, 25 × 36 cm (10 × 14in).

The Blue Sail,
25 × 30cm (10 × 12in).

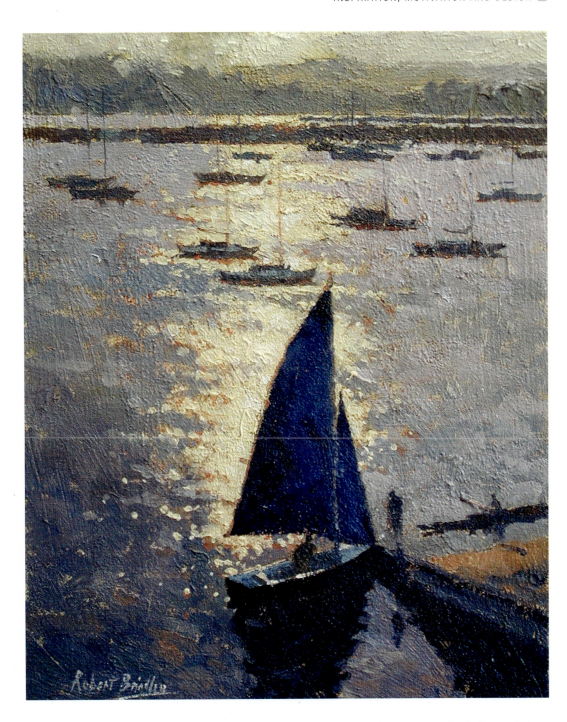

In the painting *Barges At Hoorn/Holland* the positions of all the elements are structured to ensure that the viewer's eye is directed to the focal point, or centre of interest. The main building has been positioned on the vertical golden section and the boats on the horizontal golden section. The bright colours and the light falling on the smaller buildings ensure that the viewer's eye is drawn into the focal point. In the main, the extremities of the painting have been treated simply, ensuring that there are no distractions to the harmony and balance of the piece as a whole.

In later times many artists bent or completely ignored these theories, basing their compositions more on intuition. Indeed, some paintings obey virtually none of the theories of composition and yet still work extremely well. A good example of this is the oil painting *The Blue Sail*. The boat and dazzling light has been positioned almost exactly in the centre of the picture, but the presence of the jetty and figure in the bottom right-hand corner ensures that the viewer's eye is drawn effectively to the focal point. Should you ever have a problem with composition, it is advisable to return to basic theory to help you work things out.

Edges as a Compositional Device

Painting is an illusion and how you handle the elements within the painting relate visually to the viewer, helping to communicate your intentions. Consequently, learning how to handle these elements is vital to the success of your work. The ability to manipulate edges effectively can be one of the strongest tools for conveying focus and form. The painter works on a flat surface and produces the appearance of form with the visual elements of shape, value, colour, and edge. You have to produce the illusion that everything in your painting is three-dimensional. The use of hard, sharp edges will produce a stronger focus and flatness. Soft, blurred edges will provide less attention and more depth of form. By combining both hard and soft edges effectively throughout your paintings you will be able to concentrate attention on a particular area and achieve depth.

The relative impact of edges throughout a painting is determined largely by you, the artist. A feature may appear to be extremely soft in one painting and yet appear hard in another; this depends on how the edges are handled comparatively. If you choose to work with mainly very sharp edges then anything slightly blurred will appear very soft. Conversely, if you mainly work with diffused edges then anything slightly hard will appear sharp. Generally speaking, by creating harder edges near the major focal point the viewer's eye will be led to that area and their attention held. Conversely, softer, more diffused edges diminish an area and make it appear less important.

Orchestration between hard and soft edges is a personal style choice and your understanding of the visual power of edges will, with experience, enable you to create the illusion of focus, depth and mass.

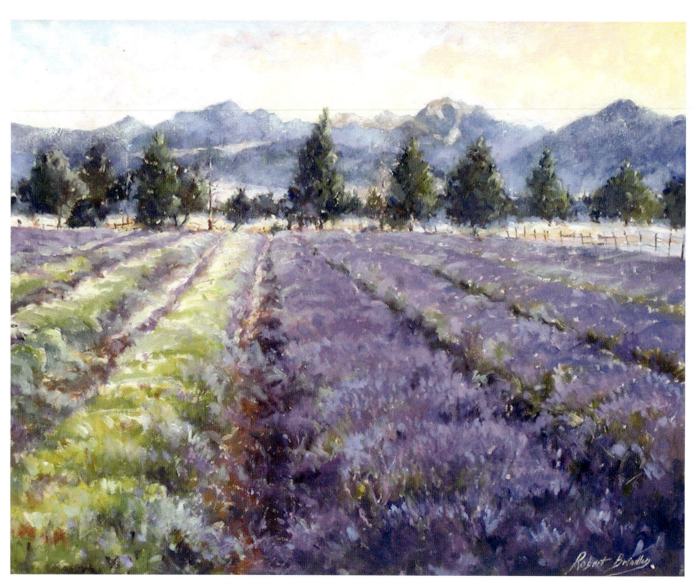

Lavender Fields/New Zealand, 50 × 40cm (20 × 16in).

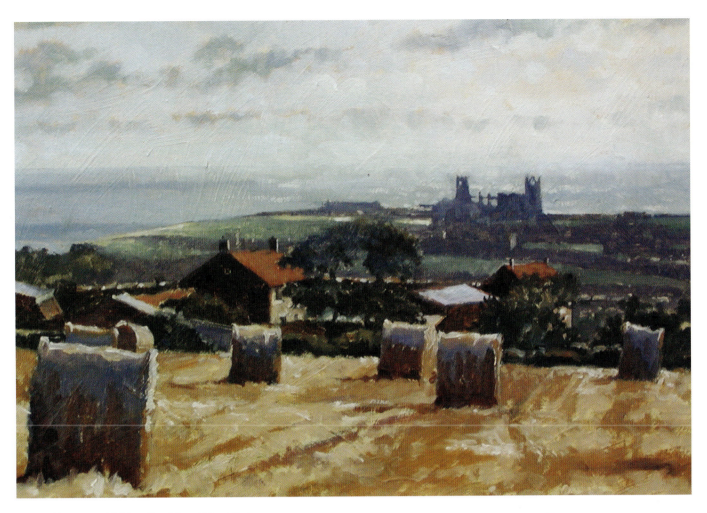

Haymaking near Whitby, 40 × 30cm (16 × 12in).

Lines as a Compositional Device

Actual lines rarely exist in landscape, but are often created when surfaces curve away from the viewer – as with tracks, hedgerows or furrows in a ploughed field which recede into the distance. These line-like elements are extremely important as they create a visual path that enables the eye to move through the painting. A line of trees, a fence line or a row of telegraph poles can be used to dramatic effect as a compositional device. In the painting *Lavender Fields/New Zealand*, for example, the perspective formed by the rows of lavender create a wonderful, dynamic lead-in.

Far more subtle lines can be observed, or created, which will have less influence on the viewer's gaze. In many cases less obvious lines are more desirable, as they encourage the viewer to move more slowly through the painting, hopefully taking in additional elements they might have otherwise overlooked. These less obvious lead-in features could be adjacent areas of differing colour or contrast, such as the 'lost and found' edge of a country track, a broken down wall, or a hedgerow. Features such

as this may be exaggerated or created for this purpose. The use of too many lines, however, will suggest chaos and may conflict with the mood the artist is trying to create.

Lines in landscape painting contribute to both mood and linear perspective, giving the illusion of depth. Oblique lines convey a sense of movement and angular lines generally convey a sense of dynamism and possibly tension. Lines can also direct attention towards the main subject of the picture, or contribute to its organization by dividing it into compartments. Some of the paintings shown here help to illustrate these points further.

HAYMAKING NEAR WHITBY

Once again we have an example of the use of subtle oblique lines, from those formed when cutting the hay, which together with the implied diagonal line formed by the bales create a convincing lead-in. Note also how the abbey has been positioned roughly on the upper horizontal and the right-hand vertical golden section.

VINEYARDS/MONTHÉLIE/BURGUNDY

The composition for this painting is strengthened by the use of the following devices:

- A gentle, foreground shadow, which keeps the eye within the picture plane.
- The focal point, the sunlit farmhouse wall, has been accentuated, which creates maximum impact by using high contrast against the dark trees.
- The diagonal line along the edge of the vineyards has been used to take the eye into the focal point and then further into the painting to the other building, which acts as secondary interest.
- Note how the outer edges of the painting are rendered simply and are almost out of focus, ensuring that there are no major distractions from the focal point.

Other Compositional Devices

There are numerous options for compositional layout; however, the following five examples are amongst the most widely used. They may seem obvious but notice that in any one of the examples there is often a combination of layouts used.

THE DIAGONAL LAYOUT

Autumn Light/Linton is a good example of the diagonal layout. The diagonal lines used for the top of the bank and edges of the stream lead the viewer's eye into the painting. Whenever you decide to use this layout be careful to soften any major diagonal lines as they move out of the painting. In this case the right-hand diagonal line formed by the top of the bank has been softened as it leaves the edge of the painting. This study also uses the large tree on the left hand side as a 'stopper', to prevent the eye from exiting on the left-hand side. The eye has been drawn to the focal point by using the darkest darks of the underside of the bridge against the light foliage of the shrubs on the side of the stream. The use of two figures also adds interest in or around the focal point.

TOP LEFT:
Vineyards/Monthélie/Burgundy, 25 × 20cm (10 × 8in).

LEFT MIDDLE:
Autumn Light/Linton, 25 × 20cm (10 × 8in).

BOTTOM LEFT:
Poppies near Malton, 25 × 20cm (10 × 8in).

THE 'L' LAYOUT

Poppies near Malton illustrates the 'L' layout. This shape is a very common compositional format and can be used in four different orientations. In this instance the 'L' has been laterally inverted.

THE INVERTED 'L' LAYOUT

The Red Sail/Whitby Harbour illustrates how the 'L' shape layout can be adopted successfully by inverting the 'L'. Here the yacht and sparkling light act as the vertical arm of the 'L' and the fishing boats and harbour buildings form the horizontal, inverted arm.

THE 'S' OR ZIGZAG LAYOUT

The 'S' or zigzag layout should never be too obvious. Ideally, the shape should flow smoothly through the painting, taking the viewers eye to the focal point at a leisurely pace. *Snow/Sleights* illustrates how this layout can be used with subtlety and to best effect if the 'S' or zigzag shape is lost and found as it weaves its way through the picture. The foreground shadow joins the fence line, which then leads the eye slowly into the painting. The large tree on the left hand side acts as a stopper and assists the eye to move into the centre of the painting.

RADIAL LINES WITH LEAD-IN

Radial lines are an extremely useful compositional device whereby any combination of lines at various angles can be used. Once again, however, it would be prudent to keep everything as simple as possible. *Thornham/Norfolk* uses the water's edge and the radial line formed by the top of the bank to lead the viewer's eye into the painting.

THE 'O' LAYOUT

Sheltering from the Sun/Dordogne loosely illustrates the use of the 'O' shaped compositional layout. The 'O' is found in the centre of the painting where the focal point, the cows, are located. It is formed by the vertical tree trunks, the horizontal line at the base of the foliage, the small bush to the right of the cows and the broken grass in the foreground. It is worth noting that this painting relies on the tonal contrast between the cows and trees against the light background.

Painting is still to a great extent dominated by a central image; corners in most cases are like uninvited guests at a party, uneasy and unattended.

Harold Town

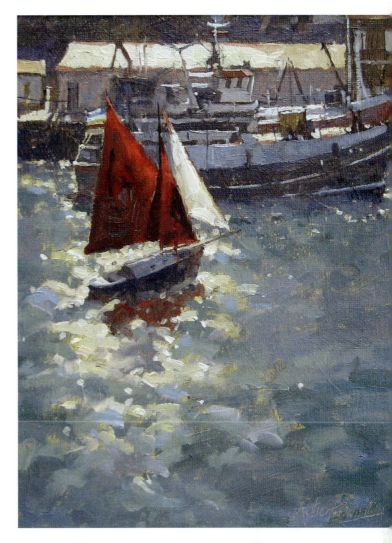

The Red Sail/Whitby Harbour, 25 × 30cm (10 × 12in).

Snow/Sleights, 30 × 25cm (12 × 10in).

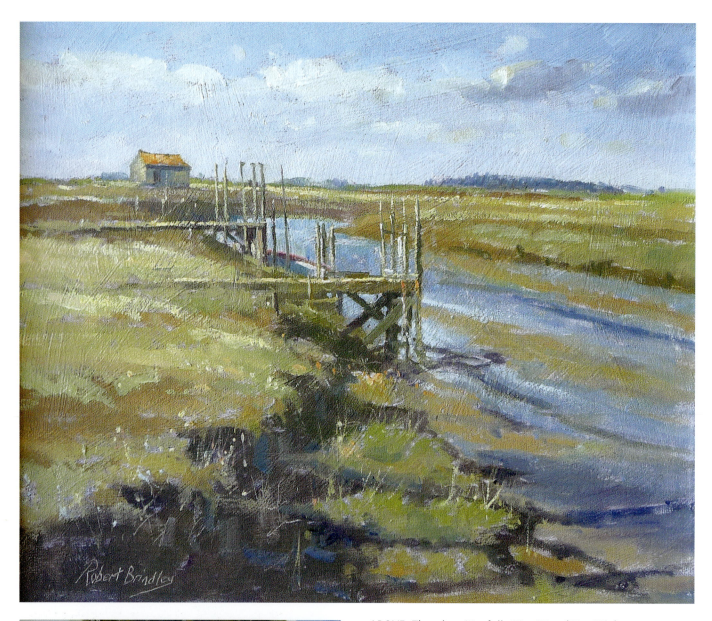

ABOVE: *Thornham/Norfolk*, 30 × 25cm (12 × 10in).

LEFT: *Sheltering from the Sun/Dordogne*, 30 × 25cm (12 × 10in).

You will reap the benefits of experimenting with composition by using the above devices and others. Try using more than one of these devices in your work to achieve variety and interest. Remember, a convincing focal point is extremely important to the success of any piece of work, so be careful not to over-elaborate in the corners or around the edges.

AERIAL PERSPECTIVE

There are two types of perspective that artists use when painting and drawing. The first form, linear perspective, which uses shrinking dimensions and the convergence of lines, has been discussed earlier in this chapter. Aerial perspective, by contrast, could be described as the use of gradations in colour, tone and definition to suggest distance.

How you observe the effect of aerial perspective depends on your relationship to the objects viewed and the relative distance involved. Generally, the heavier the atmosphere, the more pronounced the effect. When viewing your subject from a relatively low elevation, with a higher level of moisture in the air, the effect is easier to see. Conversely, the drier the atmosphere and the higher the elevation, the less apparent it becomes.

When observing anything in nature we are influenced by two elements: the 'warm' sun, the basis of all light, and the 'cool' veil of atmosphere that surrounds the earth. The earth's atmosphere cools and diffuses the warm light from the sun, producing a flat, even light over broad areas. Distant objects have more atmosphere between them and the viewer than nearer objects, so consequently they appear both lighter and cooler.

Artists have used aerial perspective to create distance in their paintings for centuries, often exaggerating diffusion and colour temperature to emphasize the effect. All you really need to bear in mind when painting convincing distances is to follow the simple rules: make things cooler (bluer), lighter in value and a little softer as they recede. *Morning Light/Watermillock* shows how the distance has been treated using cooler, lighter and softer tones. This painting was developed in the studio from sketches and photographic reference.

LIGHT

Light and the way it illuminates the subject is probably the primary stimulus for painting the majority of landscapes. Although it is virtually impossible to reproduce nature's light effects faithfully, the aim should be to interpret these effects as convincingly as possible by creating paintings that portray the light effect in conjunction with harmony, tone and colour. Different light effects create excitement, mood, atmosphere and emotion. These are vital to the success of your paintings, although often very difficult to capture.

Light is transient – subsequently, on many occasions, the stunning light effect that you wanted to capture disappears far too quickly. When painting *plein air* you must learn to accept this as normal and make rapid decisions and accurate observations to

Morning Light/Watermillock, 25 × 20cm (10 × 8in).

record vital information. The ability to make these rapid decisions effectively is an essential part of your development as an artist. This is especially so when painting in the UK, where the light and weather conditions seem to change more rapidly than in most other countries.

The Colour Temperature of Light

The ability to assess the colour temperature of light is extremely important for the artist. From infancy, we subconsciously compile and store masses of information for future reference. When we see something, our mind quickly refers to this stored information and identifies it. This produces a certain amount of bias and prejudice – for instance, that skies are blue and trees are green. What we tend to overlook is the colour temperature, or colour cast of the light. A car or van may be white, but the colour temperature of this white is influenced dramatically by the light striking it.

To become sensitive to the quality of light you will need to be patient as it takes time and practice to identify the subtleties often present. You will need to confront colour prejudices that have taken years to accumulate. To begin this learning process, try to be sensitive to the quality of the light; compare different areas to each other and look for subtle differences in any common colours. Ask yourself, does the white house across the street look the same as the white paper in my sketchbook? If the colour temperature of light continues to be difficult to identify, try placing a suitably sized, white surface outside near

your home and observe it at various times of the day during different seasons. Look for subtle colour shifts. Over time, you will see them. And once you do, it will become easier to identify the colour of the light in every situation, making your paintings more successful.

The Relationship between Light and Tone

The relationship between light and tone must be given careful consideration as the two go, it might be said, hand-in-glove. The tone of any object is always dependent upon the quality of light at the time and will sometimes be difficult to assess, especially in 'flat' lighting conditions. It may help you to assess

contrasts of light and dark by constantly asking yourself, how light is that shape against that dark? And vice versa. By doing this at regular intervals during the painting process you will soon gain an understanding of the importance of tone and its relationship with light.

Your inspiration may come from a variety of lighting conditions, from the subtle, atmospheric light of an early autumn morning right through to dazzling, low light reflected off a lake or river. In reality, the majority of your paintings will be painted in normal, fairly common lighting conditions where the subject matter may be the dominant motivation. However, on rare occasions a wonderful light effect will be encountered, where your sole purpose will be to capture the beauty of the scene. If you are extremely lucky you may come across a situation

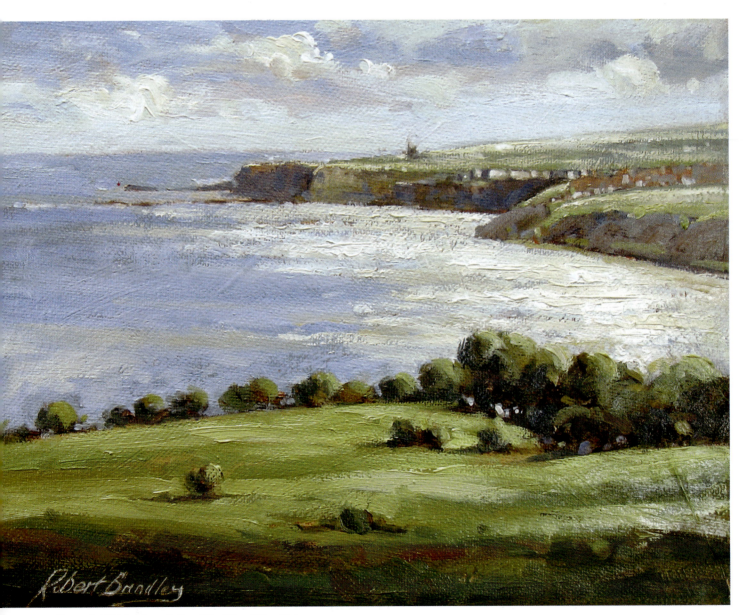

Towards Whitby from Lythe, 25 × 20cm (10 × 8in).

where the subject matter and light effect combine to produce perfection. Take full advantage of these situations as they do not occur very often.

It may be useful at this stage to discuss some of the more common lighting conditions you are likely to encounter. These conditions may not have the 'wow' factor of a special subject, but they are the artist's bread and butter and all offer many different challenges for you to be able to develop your skills.

Early Morning and Evening Light

Conditions in the early morning and evening, where low light is often present, can lead to the production of dynamic, exciting paintings. Low lighting conditions are normally encountered early and late in the day throughout the year. However, in the UK similar conditions also occur with regularity during the winter time, when the sun remains low in the sky.

Bright, low light produces long shadows that can be used creatively in the design and composition of your paintings. These shadows can be used not only to lead the viewer's eye to the focal point but also to form a visual cushion across the bottom of the painting, which prevents the eye from 'falling out' of the painting. *Towards Whitby from Lythe* shows how a foreground shadow can be used to keep the eye within the painting.

It is worth bearing in mind that by using a little artistic licence shadows can sometimes be moved, adjusted or completely invented to improve the composition or add movement/drama. You can use an invented shadow by imagining that there is a building or tree just outside of the picture area. However, whenever you decide to introduce a shadow to your work do ensure that the pattern of lights and darks used in the painting create a good compositional balance and that all the angles work convincingly with respect to the direction of the light. It may help to keep things simple, as uncomplicated, well-placed shadows always look convincing.

Low Light and Overcast Conditions

Many painters never venture out on overcast days, often preferring warm sunshine and bright light when the subject will be well illuminated. There is no doubt that working outside in warm sunshine and good light is an enjoyable experience. However, although 'flat' lighting conditions may not be as visually stimulating, and you may even have to wear another layer of clothing, you will have a constant, even light in which to work over a longer period of time. Flat lighting conditions offer a narrower range of tone and colour for you to work with, which, if used creatively, can add variety to your paintings.

Sunsets and Sunrises

Sunsets and sunrises can provide inspiration for wonderful paintings. However, at this time of day the light changes so rapidly that all but the most experienced of *plein air* painters will struggle to record the light effect in any detail. A rapid method of working is the only sure way of getting down the essentials – although unfortunately this may take many years to develop. The following suggestions may be of assistance:

- With some knowledge of the location and the anticipation of a promising situation, you may be able to set up early by drawing out the subject in advance of the ideal lighting effect. This should allow all but the most inexperienced painter to capture the bare essentials needed to complete the painting back in the studio.
- You could also take photographs as an aide-memoir. Do bear in mind, however, that the results of sunset photographs are very often disappointing when you refer back to them in the studio. Colour notes, no matter how rough, are usually of much greater assistance than a poor photograph.
- When deciding whether to paint a particular sunset or sunrise, don't be tempted by anything too spectacular or dramatic; a simple subject is usually more successful.

Contre-Jour Light

Contre-jour, a French expression for when something is 'against daylight', refers to images viewed directly toward the source of light. An alternative term is backlighting. This effect has long attracted artists and photographers alike and usually diffuses details, gives a stronger contrast between light and dark, creates silhouettes and emphasizes lines and shapes. The sun is often observed as either a bright spot or as a strong glare behind the subject. These dazzling light conditions, if captured successfully, produce stunning atmospheric images.

Although the observed image can appear to be quite simple, capturing the effect can prove surprisingly difficult. As you will be looking straight into the light you may have difficulty in identifying the correct tonal range as your eyes will not often be able to compensate for the brightness of the light. Photographs taken under the same lighting conditions are very often extremely disappointing; the dark tones tend to be completely lifeless and too dark and the dazzling light effect is reduced to a flat, burnt-out white containing little or no information.

These lighting conditions are often short-lived and can be likened to sunsets and sunrises; you will therefore again need to work rapidly when painting on-site. The following suggestions may prove helpful when painting in these conditions.

- A hat or cap with a broad brim will assist your assessment of the tonal range by protecting your eyes from the bright light.
- If possible, prepare your drawing in advance. This will allow you maximum time for the execution of the painting.
- Try to isolate the mid-tones and darks from the lights by using a viewfinder/isolator (*see* Chapter 3) or by using your hand as a viewfinder to eliminate the light. This will enable you to assess tonal relationships more accurately.
- When working from photographs taken into the light, remember that you will have to rely on memory or on-site sketches to reproduce accurate tonal relationships. Small sketches and colour notes are invaluable in situations such as these.
- When painting *contre-jour* it is extremely important to consider the edges where your darkest darks meet the lightest lights. It often helps to lose some edges completely, or to diffuse others slightly by using a warm transitional tone. Try different combinations of Cadmium Red and Cadmium Yellow Light if working with a limited palette. The painting *Fishing Boats/Scarborough Harbour* illustrates perfectly the treatment of edges in this manner.

Fishing Boats/Scarborough Harbour, 20 × 25cm (8 × 10in).

TONE

The most beautiful colours laid on at random, give less pleasure than a black-and-white drawing. *better*

Aristotle

For many beginners and painters of little experience the term tone and its importance is often misunderstood. The correct use of tone and its distribution throughout a painting is vital to its success. Without the correct use of tone the composition, form or mood and atmosphere will never be convincing.

Quite simply, 'tone' describes the relative lightness or darkness of any passage within the painting. However, interpreting tone in landscape painting can be a real problem, not only for beginners but also for more experienced artists.

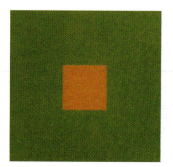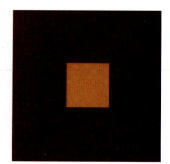

The relativity of colour.

It is all too easy to become distracted by the strong appeal of colour, with each one producing a variety of tones. How light or dark these are depends on each particular colour. It is important to realize that tones are relative and that how dark or light they seem depends on what is around them. A tone that is obviously light in one context may seem darker in another if it is surrounded by even lighter tones. Compare, for example, the two coloured squares shown here. The inner, smaller squares are in fact exactly the same colour. When surrounded by two different colours, however, they appear quite different. The orange square within the dark red colour appears brighter than the square surrounded by green.

The range of tones that can be produced is vast. Lighter hues (such as yellows) will produce a smaller range of tones than darker ones (such as blacks).

GREY SCALE EXERCISE

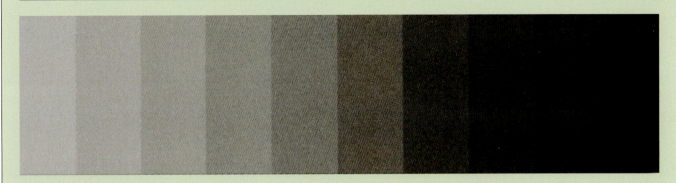

A tonal range of ten values.

To familiarize yourself with tone and value, paint your own tonal scale using black and white paint. Paint white at one end, black at the other, and gradually add a range of tones in between to produce a grey scale incorporating eight to ten tones.

To assist your evaluation of tone, it may help to keep a copy of this exercise alongside your paints in the studio and another with your outdoor painting gear. This exercise can be repeated using different hues, to create value scales for the colours you use most frequently.

Why is Tone Important?

When I have found the relationship of all the tones the result must be a living harmony of all the tones, a harmony not unlike that of a musical composition.

Henri Matisse

The above quotation by Matisse, made in his *Painter's Notes* of 1908, states the importance of getting tone right – otherwise it is just going to be visual noise.

To gain a better understanding of tone and tonal range it may help to undertake a few simple exercises by removing colour from the equation, creating a range of tones using only black and white. The two extreme tones or values are black (very dark) and white (very light). Recognizing the tone or value of a colour, rather than the hue, is important to a painter because successful paintings contain tonal contrast, or a range of values.

A painting with only mid-tones risks appearing flat and dull. Value or tonal contrast creates visual interest or excitement in a painting. A high-key painting is one in which the contrasts in value or tone are extreme, from black right through the range of mid-tones down to white. A low-key painting is one in which the tonal range is narrower.

Practically speaking, a realistic number of tones for the development of a successful painting would be eight or thereabouts, but certainly no more than ten. The tones used in any par-

ticular painting, however, very rarely incorporate a full range from the lightest light through to the darkest dark. Therefore, if adopting a tonal range graded from one to ten and applying it to a misty morning, the tonal range will be extremely limited; only tones four to eight may be present, for example. Conversely, a bright and sunny summer day may incorporate a more complete range of tones.

By carrying out the Grey Scale Exercise you will have found that the easiest way to lighten a colour is to add white. This is not always ideal, however, as by adding white the colour is slightly cooled and its intensity reduced. In such instances it may be preferable to lighten a colour by adding another colour of a lighter value. For example, to lighten a dark red you can add a little yellow.

You will learn exactly how colours react when mixed together through practice. By experimenting with your colour charts you may observe the following points:

- The addition of white creates a new, cooler colour.
- Intensely dark colours will be hard to identify until white is mixed with them. The addition of the smallest amount of white often reveals the characteristic of the dark colour.
- Some colours appear more intense in their mid-value range.

The range of tones from the darkest dark to the lightest light (irrespective of colour) is infinite and, therefore, can never be represented fully by the painter. Observe the complete tonal range in the colour and grey scale photographs of Linton in the Yorkshire Dales shown here.

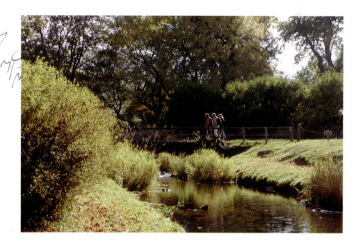

Colour photograph of Linton/Yorkshire Dales.

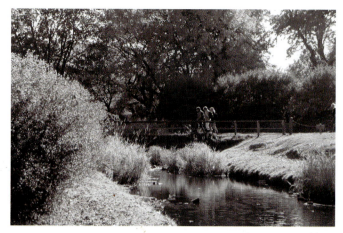

Grey scale photograph of Linton/Yorkshire Dales.

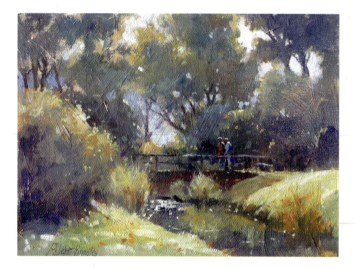

Linton in the Dales, 25 × 20cm (10 × 8in).

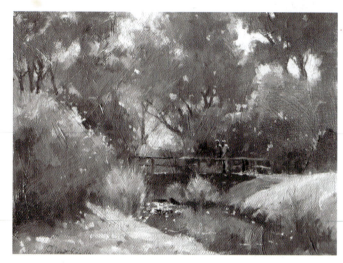

Grey scale *Linton in the Dales*, 25 × 20cm (10 × 8in)

The range of tones that can be readily reproduced by the painter is limited by the characteristics and properties of each individual colour – for instance, lighter hues such as yellow will produce a smaller range of tones than a darker colour such as red. Compare the small *plein air* sketch *Linton in the Dales* with its grey scale version, and also with the grey scale photograph, where the tonal range has been reduced and colour adjusted to simplify the subject.

A simple painting using just three tones (or more if required) from dark to light can be made using any colour plus white, or black plus white. To experiment with this method all you need to do is mix the three or more tones graded from light to dark and apply them to your sketch, starting with the darkest tone and finishing with the lightest. When a painting does not seem to be working out well, check the tonal range: you should have used your darkest darks and lightest lights, together with a full range of intermediate values. If this is not the case, you will need to adjust the tones accordingly. Note that when painting

on the coast you will often observe greater extremes of tone, due to the reflection of light off the sea in conjunction with the clearer atmosphere.

A successful tonal composition should have a convincing balance of tones. The following ideas concerning the design and distribution of tone may prove to be useful.

- The first and most obvious use of tonal distribution employs the full range of tones from light to dark. Although usually effective, you will need to ensure that the spread of extreme lights and darks is well designed and not over-used. Too many distracting shapes in your painting will disrupt the viewer's eye from moving freely through it, thus destroying the focus.
- Try using a relatively narrow range of tones, for instance: light and mid-value lights, a range of mid-tones, and finally mid-value darks and darks.
- Try using combinations of tone in a proportion of two to one; for instance, by grouping the light and middle values

together against a dark value. You might also try grouping the dark and light values together against the middle value (using these two opposites together can be difficult to orchestrate but produces dramatic results). Finally, try middle and dark values against a light value.

- Experiment by using isolated accent tones, such as the lightest light or darkest dark in or around the focal point. By keeping the rest of the painting relatively easy on the eye, a powerful focus can be created.

The correct order for placing the tones has been debated repeatedly over the years. Some painters start a painting with the highlights, some with the extreme darks, or even a combination of the two. The rationale is that by establishing these extremes at an early stage it becomes much easier to fit all the remaining tones somewhere in between.

Probably the safest method for beginners or less experienced painters is to paint the darks first, followed by the mid-tones and finally the lights. This considered build-up of tone based around the darkest dark is far more readily adjusted as the painting progresses; it is far easier to lighten a dark than to darken a light. It is also a fact that a light area can be 'cut into' a dark area far more easily than the reverse.

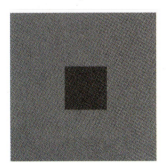

Relative values.

An exact evaluation of tone can sometimes be extremely difficult; any observed tone is relative to what is alongside it. In the example above, the inner squares are the same tone, however when surrounded by lighter or darker tones they appear to be very different.

To assist your evaluation of tone, it may help to get into the habit of squinting your eyes at your subject. By doing this, the level of detail you see will be reduced and the light/dark areas and main masses will be emphasized. Mid-tones will prove more difficult to assess, so compare them to the adjacent tones in the subject and also to the lightest or darkest tone. The more you squint, the less light enters your eyes and the simpler the image becomes in every respect. Practise this constantly, as it will prove to be your most valuable aid. If you struggle with this, a monochrome filter will help you to distinguish tones or value in a subject. Always focus on tone rather than colour in the painting.

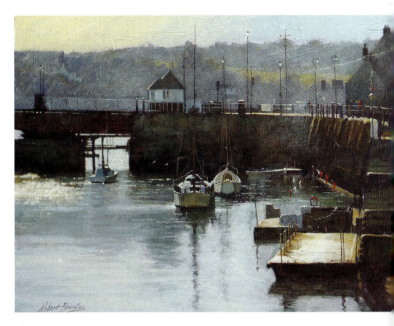

Winter Light/Whitby Harbour, 40 × 30cm (16 × 12in).

Counterchange

Counterchange involves the placing of light shapes against dark, or vice versa. It is used widely by many artists, creating contrast to produce lively, interesting paintings. It can also be used to give movement and rhythm by directing the viewer's eye around the painting.

The phenomenon of counterchange can be observed everywhere when evaluating tonal relationships. In some instances counterchange will not be apparent immediately; however, experience and instinct will enable you to use counterchange to solve many problems concerning not only tone, but also how convincingly the three-dimensional properties of objects are painted.

A subtle interpretation of counterchange can be seen in *Winter Light/Whitby Harbour*, where it appears in several places. Observe, for instance, where the masts and rigging have been painted lighter against a dark background and darker against a lighter background. Counterchange has also been used in other features in this painting; see, for example, the treatment of the handrails on the floating pontoon in the bottom right-hand corner.

Once you have started a painting, you may find it useful to be asking yourself constantly, 'Is this tone light enough or dark enough against the surrounding tones?' Even more importantly, 'Does this tone fit the overall tonal sequence of the painting?' If the answer to either of these questions is no, then make any necessary adjustments to your painting.

DEMONSTRATION: *January Snow/Richardson's Row/Newholm*

This snow scene was painted from on-site sketches and photographic reference using a limited palette of three colours and white. It should demonstrate many of the points discussed in this chapter regarding the importance of tone.

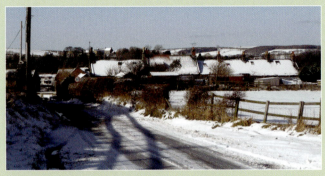

Photographic reference for *January Snow/Richardson's Row/ Newholm*

MATERIALS

Support

A 40 × 30cm (16 × 12in) canvas, a proprietary canvas board, or an MDF board treated as follows:

- Cut a piece of MDF and sand down both faces and all edges using fine sandpaper.
- Apply one coat of texture paste with a 25mm hog brush.
- Apply one coat of white acrylic primer to each side of the board to prevent warping.
- Apply a second coat to the chosen working surface.

Note: For this demonstration the painting was carried out directly onto the white board without a coloured ground.

Brushes

- Nos. 4, 6 and 8 Eclipse, Filbert brushes by Rosemary and Co.
- A no. 3 round sable or Pro Arte, Acrylix Rigger.

Colours

For this demonstration a limited palette of three primary colours and alkyd Titanium White were used: Permanent Bright Red, Cadmium Yellow Lemon, Ultramarine Blue (all by Vasari) and Alkyd, Titanium White (by Winsor and Newton). The alkyd white accelerates the drying time. Three greys were then mixed from the above primaries and white:

- Grey 1: A warm, light-toned grey.
- Grey 2: A cool, light-toned grey.
- Grey 3: A dark neutral grey.

Additional Items

- Turpentine, a low odour solvent or white spirit (for cleaning the brushes only).
- A 2B pencil.
- A palette knife.
- A copious supply of kitchen towel.

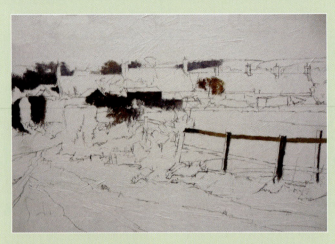

Step 1.

Step 1: Drawing Out and Commencing the Block-In

Use a 2B pencil to draw a simple outline of the subject. Next, begin to block-in some of the main darks in the composition. The three greys can be used here and the colour adjusted by using the three primaries.

Note: A really good, strong dark can be mixed by using a combination of the three primaries. Use predominantly Ultramarine Blue with a little Permanent Bright Red. You may want to experiment by adding a little yellow or white, or a combination of both to fine-tune the tone and colour.

Step 2: Continuing the Block-In

Looking carefully at the subject, squint your eyes to decide on the major shapes to continue the blocking in of all the darks and mid-tones. Even at this early stage you should ensure that everything painted from this point on falls between the lightest light and the darkest dark.

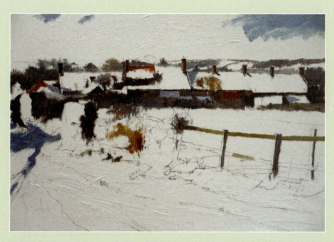

Step 2.

At this stage an accurate rendering of colour and detail is not necessary, but the painting must be fairly accurate regarding tone. Use warm and cool grey mixes (the pre-mixed greys will enable you to achieve these mixes far more quickly). (See 'What is Meant by "Warm" and "Cool" Colour?', in this chapter.)

Experiment with your mixes, as there are numerous ways to achieve the required colours from this limited palette. Always be aware that by adding too much white to your colours you run the risk of cooling the mix too much, or of making the mix appear chalky.

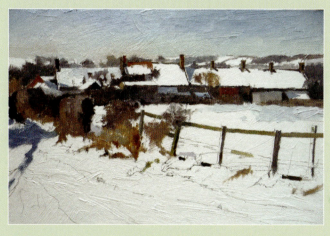

Step 3.

Step 3: Developing the Block-In and Painting the Sky

Continue to develop the overall block-in by introducing a few lighter tones and, at the same time, turn your attention to the sky. As the sky is only a narrow strip at the top of the painting, playing no major part, it should be kept extremely simple. Note that the colours in the left-hand side of the sky are slightly warmer, indicating that the sun is situated to this side. The following mixes should enable you to achieve similar colours and tones:

- Top of the sky/right-hand side: Ultramarine Blue, with a touch of Permanent Bright Red and a smaller amount of Cadmium Yellow Lemon plus white.
- Top of the sky/left-hand side: Ultramarine Blue, slightly more red and an equal amount of yellow plus slightly more white.
- Bottom of the sky/right-hand side: White, Ultramarine Blue, with a touch of yellow and red.
- Bottom of the sky/left-hand side: White, a touch of red, yellow and less Ultramarine Blue.

Alternatively, you may find that by using the warm and cool greys you are able to speed up the process slightly. Try to paint the foliage masses in an abstract manner with a combination of warm and cool colours and 'lost and found' edges.

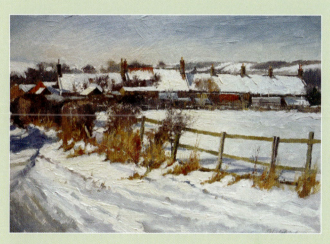

Step 4.

Step 4: Completion and Final Adjustments

Complete the block-in of all the mid-tones as described previously and at the same time begin to pay more attention to detail.

You can now start to consider all the lighter tones and, finally, the highlights. Because these lighter tones contain more white, be especially careful to avoid the mixes becoming too chalky or cool. To prevent this you may have to pep up the colour slightly using extremely small amounts of red or yellow.

When painting shadows always make the colour a slightly bluer version of the surface over which it is cast; in this case, see how the shadow side of the hedges are a bluer version of the sunlit sides. The shadows cast across the snow are very blue because the snow, being white, has little colour. To add realism and variety these snow shadows should contain subtle warm and cool colour changes. Always look for the presence of reflected light, which is often bounced into shadow areas from adjacent objects.

DEMONSTRATION: *January Snow/Richardson's Row/Newholm* (continued)

When studying the illustration for Step 4 notice how the snow has been painted. The paint has been applied thickly, using impasto to create texture and the feeling of deep, fresh snow. This works especially well in the foreground where the snow is rutted, having been disturbed by traffic. Final details such as chimneys, fence lines, branches and twigs can now be added; however, keep the painting 'loose'.

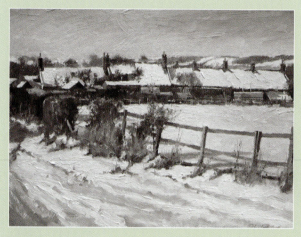

Step 4: grey scale.

Now is the time for reflection. Study your painting from a distance and ask yourself a few questions:

- How do the tones relate to each other? Consider the tonal balance for the painting as a whole, not just the adjacent blocks of tone. It may help to take a digital photograph of your painting at this time and convert it into grey scale, as shown. This will allow you to assess your painting with regard to the tonal relationships, balance and the effect of tone on the focal point.
- Does the focal point of the painting work? The areas around the edge of the painting should not detract from the centre of interest, which should be the cottage with the red roof, just left of the centre.
- Do any of the edges in the painting carry too much weight? If so, you will need to soften them.
- Finally, try looking at the painting through a mirror. This will draw your attention to any imbalance or glaring errors in your work.

COLOUR

Reds, yellows and oranges conjure up sunlight and fire, while the blues and blue-greens evoke snow and ice, sea, sky and moonlight.

Anonymous

Choice of colour is a very personal matter and the artist has free rein when consideration is given to its use. This freedom of choice is largely responsible for any emotion and excitement translated to the viewer. There is no doubt that colour, if used correctly, has an immediate and striking effect; for these reasons, some artists consider it to be the most important element of their work. However, for other artists colour is much less important.

Whatever your view on colour – its relative importance, or how it is used – there is little doubt that good composition, the correct use of tone and skilful drawing remain paramount for the success of any painting.

The small oil painting *Grand Canal Nocturne* has a combination of warm oranges, yellows and deep blue-purples, painted on a rich, dark background. The background was painted using Ultramarine Blue, Cadmium Red and Burnt Sienna and proved to be not only a perfect foil for the warm colours used in the buildings but also for ensuring that the lights have real impact.

To use colour freely and with conviction, a basic knowledge of colour theory is extremely useful. This knowledge will help you in developing an understanding of how colour can be used to create a successful, harmonious piece of work.

Hue and Chroma

The words hue and chroma can give rise to confusion and many beginners incorrectly assume that they mean the same thing.

WHAT IS HUE?
Quite simply, hue is the actual colour of a pigment or object. Judging a hue is the first step in colour mixing as it identifies what tube of paint to reach for.

WHAT IS CHROMA?
Chroma is the measure of the intensity of a colour, that is, how pure or bright it is. The higher the chroma, the purer and brighter the colour will be compared to a colour that has been diluted with white, darkened by black or grey, or thinned by being a used as a glaze.

Grand Canal Nocturne, 25 × 20cm (10 × 8in).

Primary Colours

Primary colours are the three basic colours that cannot be made by mixing any other colours together: red, yellow and blue. Beyond this, you could be forgiven for assuming that colour mixing is relatively straightforward. However, things are complicated quite significantly by the fact that there are many different versions of these three primaries. The following are just a few:

- *Reds:* Cadmium Red, Alizarin Crimson and Permanent Red Light, for example.
- *Yellows:* Cadmium Yellow, Cadmium Yellow Light and Cadmium Lemon, for example.
- *Blues:* Ultramarine Blue, Cobalt Blue and Ceruleum, for example.

This vast, bewildering array of colours often leads to the question, what colours do I use? Unfortunately there is no definitive answer, as each blue, red and yellow is different and subsequently produce quite different results when mixed. Probably the best advice would be to select a warm and cool version of each primary. For example: Ultramarine Blue/Cerulean Blue, Cadmium Red/Alizarin Crimson, Cadmium Yellow/Lemon Yellow.

Many oil painters use a further reduced palette of just three primaries plus white. Painting with a limited palette is discussed in more detail later in this chapter and also in several of the step-by-step demonstrations throughout the book. *Cottages/ Cley Next the Sea* was painted using three primaries plus white and illustrates the subtlety and variety of colour that can be obtained using a limited palette.

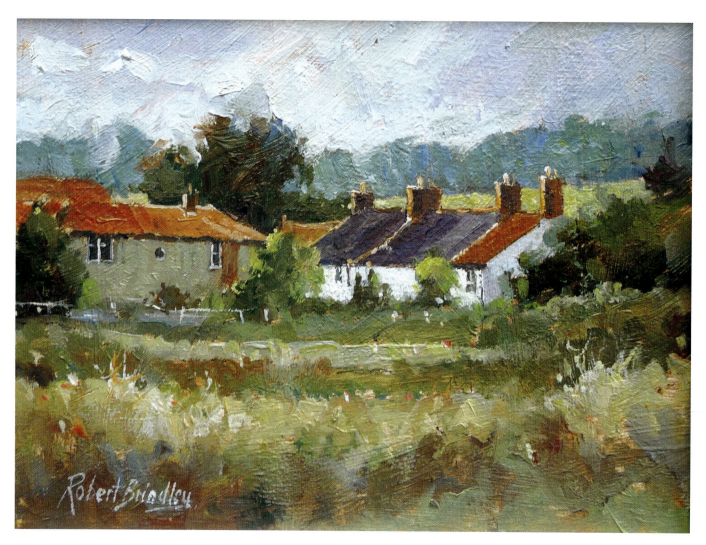

Cottages/Cley Next the Sea, 20 × 15cm (8 × 6in).

Secondary Colours

Secondary colours are made by mixing any two primary colours together. For example: blue and red make purple; red and yellow make orange; yellow and blue make green. Consequently, the purple, orange and green produced are termed secondary colours. The exact hue of the secondary colour you mix depends on which variety of red, blue or yellow you use and the proportions in which you mix them.

Complementary Colours

The complementary colour of a primary colour (red, blue, or yellow) is the colour obtained by mixing the other two primaries (their secondary colour). So the complementary colour of red is green, of blue is orange and of yellow is purple.

Conversely, the complementary colour of a secondary colour is the primary colour that was not used to make it. So the complementary colour of green is red, of orange is blue and purple is yellow.

Complementary colours are extremely versatile and can be used in many creative ways to create emphasis or neutralize other colours. The following observations may prove useful.

- To enhance one element against another, or to create colour contrast: Experiment by placing complementary colours side by side, or by using a complementary 'under painting' or ground. You will soon discover that certain colours work together better than others to provide the desired result. Red works well under or against green, for example. The colour combinations of yellow and purple or orange and blue work in a similar way.

COMPLEMENTARY COLOURS AND NEUTRALS

Look carefully at the complementary colour swatches shown here. Notice how, when placed side by side, the complementary colours heighten the visual intensity of one to the other. When the same two complementary colours are fused or mixed together they have the reverse effect, cancelling each other out and producing a neutral colour.

Complementary colour swatch 1.

Complementary colour swatch 2.

Complementary colour swatch 3.

- To create depth: Adding the complement to any colour will reduce its intensity. These reduced-intensity colours are more neutral, which affects how they advance or recede visually. When surrounded by neutral colours, high intensity colours appear to come forward. Conversely, more neutral colours surrounded by brighter colours appear to recede.
- To add interest and variety to shadow areas: Look for the subtleties, for instance, where the shadow cast by a red object could contain some green, or vice versa. It is important to train your eye to observe these subtleties.

Tertiary Colours

If you mix any three primary colours together, or a primary colour with its complementary one, a tertiary colour is obtained. Tertiary colours could be described as a series of 'colourful

greys'. By experimenting with the proportions of colour used, you will soon realize that an infinite number of subtle browns and greys can be produced.

To mix brown, use a primary colour with its complementary colour. For example, add blue to orange, yellow to purple or red to green. White can be used to lighten the mixes. Experiment by trial and error to determine how many subtle browns you can create. A 'blue' grey can be created in a similar way, but include more blue in the mix and experiment with the quantity of white used.

If your results are disappointing, or the mixes look 'muddy', you may be mixing too many colours together. In instances such as this, never keep adding more colour. Instead start again using only one of each of the primary colours. There are numerous compatible primary colour combinations. Try Ultramarine Blue, Cadmium Red and Winsor Yellow or Ultramarine Blue, Permanent Bright Red and Cadmium Yellow Lemon, for example.

Using Black and White

I would have artists be convinced that the supreme skill and art in painting consists in knowing how to use black and white … because it is light and shade that make objects appear in relief.

Leon Battista Alberti

Warm/cool temperature: example 1.

Black and white can never be created by mixing together other colours, although a good strong dark that is very close to black can be created by mixing three suitable primaries. Black is a controversial colour, generally only used by a few artists and frowned on by many others.

If you add white to a colour you lighten it and if you add black you darken it, and by mixing the two together various shades of grey are produced. However, to get anywhere near the perfect harmony present in nature the diverse range of greys, classed as tertiary colours, are far superior to the lifeless, mechanical greys produced by mixing black and white.

Warm/cool temperature: example 2.

What is Meant by 'Warm' and 'Cool' Colour?

The terms 'warm' and 'cool' are used frequently by artists to describe colour, either by word of mouth to students, or personally, when assessing the colour temperature of certain elements within a subject or painting. These terms often cause confusion, as the temperature of colour is not always obvious to the untrained eye; it is more often than not subtle and therefore difficult to assess. However, colour temperature is an important element to be aware of when mixing colours as it has a real influence on any painting.

Every colour has a certain bias, towards either warm or cool. Generally speaking, reds and yellows are considered to be warm colours and blues cooler. However, by comparing different reds, yellows or blues you will see that there are warm and cool versions of each, relative to each other. For example, Cadmium Red is much warmer than Alizarin Crimson, although Alizarin Crimson is infinitely warmer than a blue.

The differences in colour temperature can be either dramatic or subtle, as illustrated by the three warm/cool colour swatches shown here.

- In the first swatch, the difference in colour temperature between the yellow and blue is immediately obvious.
- In the second, the orange/red swatch, the temperature of both colours is warm, with less obvious difference. In this

Warm/cool temperature: example 3.

instance the red mixed with Alizarin Crimson is slightly cooler than the orange, which contains Cadmium Red and Cadmium Yellow.
- The third swatch shows a warm green on the left, mixed with more yellow and red than the cooler, right-hand colour, which was mixed using more blue and less red.

It is extremely important for the painter to be able to recognize differences in colour temperature, no matter how subtle, but also to incorporate these changes effectively in their paintings. The following observations may prove useful when colour mixing.

- By mixing two warm colours together a warm secondary colour results and, conversely, if you mix two cool colours together a cool secondary colour will be achieved. To take this a little further: by mixing Cadmium Yellow with Cadmium Red Light a warm orange will be created; and by mixing Lemon Yellow with Alizarin Crimson a cooler, greyer orange will be created.

- The same comparisons can be made for cooler colours. By mixing Ultramarine Blue with Cadmium Red a warm blue-purple will be created, and a cooler blue-purple will be obtained when mixing Cerulean with Alizarin Crimson.

Therefore, when mixing secondary colours you need to be aware not only of the proportions in which the two primaries are mixed but also what effects the different reds, yellows and blues produce.

Painting with a Limited Palette

Using a limited palette has many advantages. The colours used vary greatly from artist to artist, depending each individual's preference. Some use very few, and others up to ten or more. However, if you want to take full advantage of working with a limited palette just three primary colours plus white are all that is required. You may occasionally feel like adding a few more colours to this restricted palette; if you do, try expanding your selection to include a warm and cool version of each primary, as discussed earlier. A few of the advantages of working with a restricted palette are listed here.

- Colour harmony is easier to achieve.
- Learning to manipulate and mix just a few colours is easier than trying to master a wide range of colours. It makes it easier to arrive at a desired colour, hue and value.
- You do not need to carry around as many tubes of paint when travelling.
- Palette preparation is quicker.
- Mixing various greys from three primaries is relatively simple. In addition, the colour harmony of the resultant greys is consistent as it contains only the three primaries on your palette. These convenient, pre-mixed greys can then be used to carry out many small, quick adjustments: a mix can be lightened or darkened, or the colour temperature adjusted from cool to warm (or vice versa), ensuring that you find the exact hue, value or colour temperature required.

If you are not convinced by the validity of working with a limited palette, try a simple experiment. Lay out the three basic primaries and white as suggested, then add a selection of other colours that appeal to you – you might choose Yellow Ochre, Burnt Sienna, and so on – as many as you want. Now try to mix these additional colours from just the initial three primaries and white. With a little practise you will be amazed how accurately you are able to reproduce these additional colours. Given time, you will become ever more familiar with using a limited palette and your confidence will grow accordingly.

REUSE YOUR COLOUR

At the end of any painting session you will very often have unused colour mixes on your palette. To avoid wastage, scrape these colours together and mix them into a variety of greys. These mixes can then be stored for future use in empty oil tubes. As these greys have been mixed only from your primaries, they will be in harmony with them.

Unused mixes after completing painting.

Mixing three greys with a palette knife.

Filling an empty paint tube.

THE PALETTE AND COLOUR LAYOUT

A 50 × 40cm (20 × 16in) glass palette.

The layout of colour.

A large palette may prove to be beneficial for colour mixing. As mentioned in Chapter 1, for studio painting a plate glass palette is easy to keep clean, can be cut to any size and can be backed by a neutral colour of your choice.

The 50 × 40cm (20 × 16in) glass palette illustrated was made from plate glass, backed by a piece of neutral grey card and then framed. A neutral grey backing was used because it has no colour bias, making it far easier to mix and assess the required subtle greys and subsequent colours.

It will be to your advantage if your paint is laid out the same way every time and in a logical order. The illustration here shows the colours laid out along the top edge of the palette, from warm to cool, with the greys down the left-hand edge. In this particular instance the colours selected include a warm and cool version of each primary.

The colours used are, from left to right: Titanium White, Permanent Light Red, Alizarin, Cadmium Yellow Lemon, Winsor Lemon, Ultramarine Blue and Cerulean. The greys, from top to bottom are: Warm Grey, Cool Grey and a Neutral Grey, all mixed entirely from the above primary colours.

The Vasari colours Permanent Bright Red, Cadmium Yellow Lemon and Ultramarine Blue work extremely well together. Ultramarine Blue is a warm blue, Permanent Bright Red is very warm and Cadmium Yellow Lemon is a versatile, mid-range yellow. Another reliable selection of' primaries, this time using two yellows, are: Cadmium Red Light, Cadmium Yellow Medium, Cadmium Yellow Lemon and Ultramarine Blue. Cadmium Yellow Medium is a warm yellow and Cadmium Yellow Lemon is cool. Having a warm and a cool yellow will give you a little more flexibility when adjusting the colour temperature of your mixes.

MIXING GREYS

Mixing greys using the above primaries is a fairly straight forward process, although a few key pointers will be helpful. By mixing approximately two parts Ultramarine Blue with one part each of Cadmium Yellow Medium and Cadmium Red light, a neutral dark grey will be produced. By adding white a 'higher keyed' tone will be obtained. The resultant colours can then be modified by adding either blue, red or yellow to achieve a range of warm and cool greys. These greys can then be used to modify the intensity, colour and value of the primaries.

If you would like a little more flexibility, three cooler primaries could be added to the palette, which may result in a little more subtlety and variety; Alizarin Crimson, Winsor Lemon and Cerulean are just three of the many options available to you.

Should you decide to work with this system of colour mixing, you will soon be able to manipulate and adjust colour far more quickly and accurately than ever before. It is really a simple adjustment process.

IN THE SPOTLIGHT

Scarecrow/Whitby Allotments, 25 × 20cm (10 × 8in).

The small sketch *Scarecrow/Whitby Allotments* was painted on a hazy, early autumn day. The subject has all the characteristics of a typical British allotment, with sheds in various states of disrepair, greenhouses, colourful screening and in this case a scarecrow.

Evaluation

This painting achieved everything that was intended for a spontaneous small oil sketch and captured the subject exactly how it was on the day. The orange and blue screening work extremely well, lifting the colour of a fairly grey autumn day.

Composition

The composition could have been improved upon if given a little more consideration before starting to paint. The following changes could be considered if a further, studio painting was undertaken:

- The scarecrow is not ideally positioned and could be moved backwards and to the left, to the edge of the cabbage patch and in front of the shed. This repositioning of the main element in the painting would draw the viewer's eye more effectively to the focal point. The rest of the composition works extremely well; the gentle diagonal, formed by the cabbages in the foreground, leads the eye into the shed and then through the painting via the orange screen to the large building on the skyline.
- The only other minor change could be to subdue the tone of the shed on the extreme left. As it is here it carries a little too much importance and tends to draw the eye to the edge of the painting.

Tone and Colour

The tone and colour work perfectly well and I would not change anything in this regard in a future painting.

SUBJECT SELECTION

Boats at Workum/Holland was painted from sketches and photographic reference gathered on a painting trip to Holland.

The diversity of different landscapes is vast; consequently, for many beginners and inexperienced painters the selection of a suitable subject to paint is sometimes a little daunting. It is entirely understandable that any inexperienced painter, when situated within the landscape, will be overwhelmed by not only the scale and magnificence of what lies before them but also the decisions to be made before the painting process even begins.

Extreme observation serves artists very well – perhaps it is the best teacher.

Cynde Roof

There are no hard-and-fast rules laid down to assist this decision-making process, although it is hoped the following suggestions may be helpful.

- Always be guided by your initial response to the subject in front of you; this response has invariably been triggered subconsciously by your inner feelings and emotions, which are also likely to be transmitted through your painting to any future viewer.
- The inspiration for the painting may have been a special light effect, an entire vista, a small cameo scene, the texture on a wall, trees or rocks or even a sky study. Never ignore these first impressions by becoming distracted or seduced by the 'bigger picture'.

- It may help the decision-making process to have some prior knowledge of the location to be visited. This knowledge can be invaluable and give you some ideas, not only with regard to exactly what you want to paint but also as to when the light will be most advantageous.
- Before you begin to paint a subject, always take a little extra time to look for any possible problems. These may only be small, but even the slightest problem can result in the painting failing at some level. It may be that all you need to do is to move a tree slightly to the left or right, or introduce a shadow to enhance the composition. Whatever it may be, never leave the solution of a problem until later; always make these decisions at the outset.

When planning the composition of the *plein air* painting *Henhouses/Fylingdales Moor* the decision was made to reposition the tree. It was moved from outside of the picture frame onto the golden section. The repositioned tree provides a vertical element to the composition and its shadow forms a solid base and subtle lead-in. No imagination was necessary for this alteration, as it was just a matter of repositioning the tree visually.

Henhouses/Fylingdales Moor, 25 × 20cm (10 × 8in).

OPPOSITE PAGE:
Boats at Workum/Holland, 25 × 36cm (10 × 14in).

Outbuildings/Château de Brâ, 13 × 18cm (5 × 7in).

DIVERSITY OF SUBJECT MATTER

As mentioned previously, the diversity of landscapes is vast, providing the painter with many constant challenges and a seemingly endless variety of subject matter. Should you have the desire and imagination to seek out new and inspiring subjects you will find them in abundance.

The diversity of landscape painting ensures that there is something for everyone; consequently it remains as popular as ever with painters worldwide. Just a few of the numerous subjects for consideration are listed below, all of which will be covered in more detail in later chapters.

- Rural landscapes, featuring trees, lakes and rivers, farms and their associated buildings. The small *plein air* painting *Outbuildings/Château de Brâ* illustrates just this type of subject matter.
- Villages, towns and cities encompass a wide range of structures from the humble cottage to larger country houses and estates, through to the skyscrapers of our major cities. Within these environments a further choice of subject matter can be found, such as village greens, parks and leisure areas. *St Margaret's House/King's Lynn* features a fine Georgian mansion close to the town centre.
- Coastal scenery encompasses beaches, cliffs, harbours and much more. The panoramic painting *Towards Whitby from Sandsend* illustrates this type of subject matter perfectly.
- More intimate studies, or cameo scenes, can be made featuring trees, water, skies, animals and figures. These may either be used, to a lesser degree, in larger landscapes or given more consideration as the main subject matter based on their own merits. See the small, *plein air* painting *Cottages/Sandsend* for one such example.

In addition to the above, the scope widens enormously when these subjects are painted in different light conditions or, more importantly, in different seasons. Snow scenes make wonderful subjects, for instance. *Snowy Evening/Egton* was painted as the sun went down after an afternoon winter walk. The colours of the sunset were echoed in the landscape, giving a wonderful warm glow to the painting.

St Margaret's House/King's Lynn, 20 × 15cm (8 × 6in).

Towards Whitby from Sandsend, 40 × 15cm (16 × 6in).

Snowy Evening/Egton, 25 × 20cm (10 × 8in).

Cottages/Sandsend, 15 × 20cm (6 × 8in).

REFERENCE MATERIAL

Plentiful and good-quality reference material is essential for any painter working either entirely in the studio or finishing off *plein air* paintings in the studio. Reference material can be gathered in many forms; some artists prefer to work entirely from photographs, whilst others work only from sketchbooks and/or small on-site paintings. Probably the most flexible system is to work from a combination of all of these. This way you will be sure that you have everything you need when painting away from the subject.

Photography

The decision regarding whether to use photographic reference or not is purely personal; many artists shun the use of photographs completely, relying only on their memory, sketches and *plein air* paintings for reference. If this method of working suits you, then additional photographic reference is not needed.

There are, however, a number of reasons why either the sole use of photographs or a combination of sketches supported by photographs are relevant. Some painters may not be able physically to paint outdoors and others may have extremely busy lives where time is an important factor.

Whatever your view regarding photographic reference, there is no doubt that photographs are an invaluable aid for capturing many of the more transient elements used in landscape painting. For instance, unless you are very experienced, have excellent recall, or the ability to work very quickly, it is extremely difficult to paint figures, animals, passing cars, fleeting light effects, and so on. In these instances a camera, especially a digital one, is a wonderful tool to have at your disposal.

Before using photographic reference material on a regular basis, it may help to discuss the three basic reasons why a photograph may differ from our perception. Understanding these will allow you to make better use of photographic reference.

First, value ranges will be exaggerated. Film and now digital images have limitations on their ability to record the full range of light and dark values visible to the human eye. The quality of the digital image is continuing to improve rapidly and future advances will make it more accurate, but for the time being it still has its limitations. Most photographs are exposed for the light, consequently the shadow areas are often underexposed and lacking visible information and texture. Should you expose for the darker areas, the lights would be overexposed, showing too little detail. To compensate for this you may decide to take one exposure for the shadows and another for the lights. By using both photos as reference, it becomes far easier to see the details within the dark and light areas.

Second, the colour may be inaccurate, especially when using film, often having a warm or cool colour bias. With digital photography the white balance (or colour bias) is the key to accurate colour representation. As the camera does not know what you are taking a picture of, it averages out everything in the viewfinder unless you manually override it. Your camera's manual will help you make the necessary adjustments for white balance, enabling you to take far more accurate images.

Third, the depth of field can alter the focus by allowing only one upright plane to be in sharp focus. Everything in front of as well as behind that plane will be blurred. Depth of field may also be manipulated to produce sharp focus from the tip of your toes to the horizon. The human eye sees in a focused cone, and everything around that area of focused attention will become softer and more diffused. So do not be fooled by the results of a manipulated depth of field in your photographs.

Whatever your views, it is important to remember that nothing comes close to working directly from nature, one on one. Processing information gathered through the eye, analyzed by the brain and felt by the heart is an integral part of being a representational painter. Always bear in mind that a photograph is an artificial representation, easily manipulated and limited by its physical restraints.

Ruswarp Fields was painted entirely from photographic reference. Should you decide to paint exclusively from photographic reference the following observations may prove to be of use:

- Try to only work from your own photographic reference. It is almost impossible to interpret details accurately and perceive mood and atmosphere effectively from someone else's photographs.

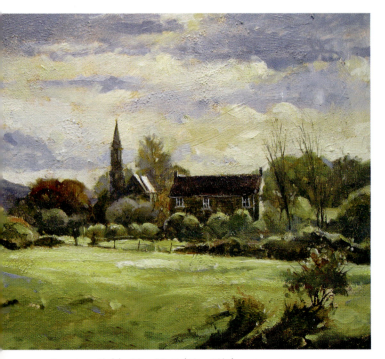

Ruswarp Fields, 30 × 25cm (12 × 10in).

- When taking photographs to be used for reference purposes, take as many shots of an exciting subject as possible. Take shots from a variety of viewpoints and elevations. Try zooming in or out, bending down or gaining a little more height – even moving just a few feet to your left or right will give you more choice when deciding what to paint later in the studio.
- At the time of taking the photographs, especially when taking shots directly into the light, jot down a few notes regarding any subtle colour and tonal changes or texture and hidden detail within the shadows. These subtleties are often overlooked by inexperienced painters and the camera, more often than not, will not record them. It is a well-known fact that *contre-jour*, or 'into the light' photographs, which are often taken far too quickly, are extremely inaccurate with regard to the true balance between light and shade. In situations such as this it may be useful to zoom in on some of the shadowy areas and take detail shots. These should provide you with a better reference of what was present within these areas.
- Try to rely on your photographs as little as possible; treat them as a memory jogger or just for drawing out. Remember that colour and tone is likely to be inaccurate to some degree. It is also worth bearing in mind that if you have used the zoom facility on your camera any true depth and scale will be likely to be extremely distorted, as the lens compresses the distant and nearer features, giving the appearance that they are far closer together. The greater the zoom used, the worse the distortion.

Before moving on it may be helpful to discuss some additional, probably less obvious, benefits that can be gained by the use of digital photography. Over recent years, digital photography has really taken off, to such an extent that most people now own a small digital camera. One of the reasons for this boom is that it has become so affordable; literally thousands of images can be taken, stored temporarily on the camera's memory card and transferred later to the computer. The resultant images can be stored efficiently in files and viewed at leisure. Selected images are easily erased, copied, sent by email, or printed at the touch of a key. In addition to this, by using readily available software, the images can be edited in numerous ways; they can be adjusted in tone or colour and cropped to any chosen size. Cropping will be discussed in more detail later in this chapter.

Sketching as a Form of Reference

Photography, as discussed above, is undoubtedly an extremely useful tool. Nevertheless, a far better way to be more creative in your studio work is to make use of sketches, colour notes and any small paintings that you have made on-site.

Sketchbooks provide a readily available supply of drawing paper in a convenient format. They can be purchased in a wide variety of shapes, sizes and types of paper. It is good practice to carry a small sketchbook around with you at all times. You only have to think about all the times that you sit on a train, in a café or on the beach when you could be practising your drawing and observational skills, and at the same time building up a very useful source of reference. You will be amazed at just how quickly this reference material accumulates.

A small, hardback pocket-sized sketchbook.

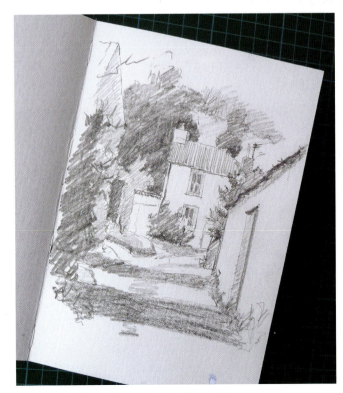

An example sketch drawn with a 2B pencil.

DRAWING TIPS

When drawing or sketching outdoors, always remember to establish the horizon line first. This can be achieved by holding your pencil horizontally, immediately in front of your eyes. Where the pencil cuts through the view will be the horizon line.

The next step is to establish all the radiating lines of perspective. Tackle them one at a time by using your pencil (this time at arm's length) to align it with the tops and bottoms of buildings, harbour walls or other key features. Keep your pencil fixed at each aligned angle and transfer this line to your drawing. This can be very tedious in a complicated scene, but with practice it becomes instinctive and rapid progress will be made.

It is important to select a sketchbook that contains a suitable paper for your intended purpose. The pocket-sized sketchbook shown is hardbacked, of good quality and has fairly lightweight, smooth paper that is ideal for pencil sketching but would be unsuitable for watercolour sketching. There are numerous excellent sketchbooks available, differentiated by weight and tooth, suitable for a wide variety of techniques such as pencil drawings, watercolour sketches or pen and ink, to name just a few. Sketchbooks/pads of acrylic primed canvas are also available, coming in a variety of sizes and textures. The sketch illustrated was drawn in the sketchbook described using 2B and 4B pencils.

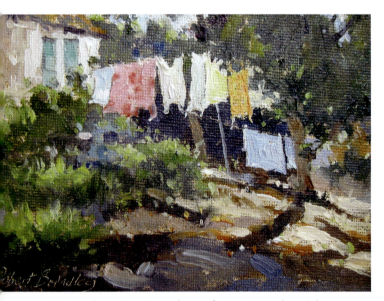

The Washing Line/Sinarades/Corfu, 18 × 13cm (7 × 5in).

Many artists undertake sketches merely to record something seen briefly, such as the setting sun, or the attitude of constantly moving figures on the beach. Others take a little more time over their sketches, producing far more detail and often working in full colour. These sketches provide all the necessary information and detail to undertake studio paintings; in some cases they may have sufficient merit to justify framing. Occasionally sketches are more successful than the completed, more considered studio piece.

The small oil sketch *The Washing Line/Sinarades/Corfu* was painted on-site, in just over an hour. On reflection, back in the studio, it was decided that the painting had captured the essence of the location and nothing further could be achieved by painting a larger studio version.

PLEIN AIR PAINTING

Working *plein air* provides many challenges. The light can change rapidly, the terrain may be treacherous, midges and flies are sometimes a constant bother, and passers-by are sometimes annoying and may interrupt your concentration. Even considering all these negatives, the benefits of painting face-to-face with nature are unequalled.

Frequent *plein air* painting is therefore recommended for all artists who have both the opportunity and desire to do so. There is no doubt that direct interaction with the subject matter can be not only stimulating but rewarding on many levels. For the inexperienced painter, painting outdoors can be a real challenge and the results desperately disappointing. However, by being patient and continuing to paint outdoors on a regular basis you will soon overcome the many difficulties encountered and find that you are able to analyze the subject more effectively, observe it more accurately and paint it in less time. All of these factors are vital for achieving successful *plein air* paintings.

As tempting as it may be to take the contents of your studio with you, it is best to pare down your equipment to the bare essentials when preparing for a *plein air* painting session. The decisions on which colours to take can be based on your previous experience and personal preferences, or you may decide to adopt a limited palette of colours as discussed in Chapter 2.

Stability is another major concern when working outdoors. The oil palette needs to be level and secure when attached to an easel. If you prefer your palette in front of you while painting, a French easel (as discussed in Chapter 1) works well. The open drawer acts as a support for your palette, which can be made more secure by using an elasticized bungee cord. Tripod easels are also widely used and can easily be attached to the bottom of a pochade box (*see* Chapter 1). The more stable the tripod, the more secure your palette and painting will be. Whatever system

you employ, it is wise to anchor it in case of wind, the biggest enemy of the *plein air* painter. A plastic shopping bag filled with rocks picked up at the scene or water bottles and supplies can provide the necessary weight. Hang the bag from the easel/ tripod, as close to centre as possible.

When painting outdoors, or just information gathering, train yourself to analyze the subject. Look carefully into shadows and be aware of the subtlety of colour and tonal changes, which are often overlooked, even by some fairly experienced painters.

Evening/The Valley/Sandsend was painted *plein air* on a warm summer evening in approximately one and a half hours. Experience of painting in the field proved to be especially advantageous in this instance, where changing light demanded quick decisions and a rapid application of paint, essential for the successful execution of the painting.

Art demands constant observation.

Vincent van Gogh

There are several considerations regarding subject matter and its execution that are useful to be aware of when planning a *plein air* trip. First, when arriving at a promising painting location it always pays dividends to take a little time over subject selection. Never settle for the first subject that appeals unless you have prior knowledge of the location and have plans laid for painting a set subject. A little time taken to absorb all the possibilities will often be rewarded by better subject matter. Having said this, bear in mind that the perfect subject comes along very rarely and over-deliberation and indecision will result in wasting valuable time. When you think that you have found the right subject quickly check for a more suitable viewpoint, as quite often, by moving only a few feet the subject can be improved compositionally.

Always ask yourself what attracted you to the subject in the first place because these initial impressions are vital to the success of the painting. In many instances this impression is lost as the painting progresses; it is therefore essential to keep it at the forefront of your mind throughout its execution. Never attempt to incorporate too many elements – by doing so you will be in danger of losing focus. Keep it simple and remember that sometimes less is more.

Of the many issues that can arise when working on location, whether to work in shade or full sunlight is one of the most frequent. Start by identifying in which direction the sunlight will be travelling. If possible, turn your easel so that the direct sunlight will not creep onto the painting as time goes by. This will prove extremely helpful, as you will probably be working in the same location for a considerable amount of time. The painting surface and palette ideally need to be in the same light, otherwise

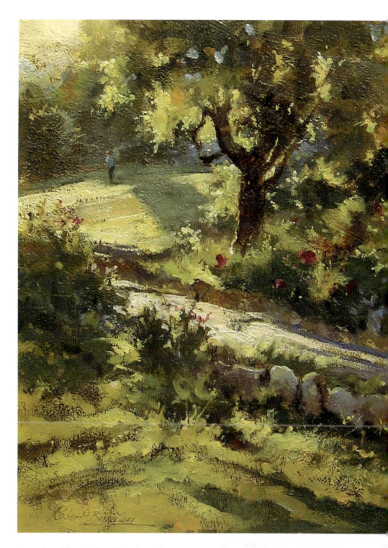

Evening/The Valley/Sandsend, 20 × 25cm (8 × 10in).

your colours and subsequent mixes will appear completely different once they are on the painting surface, causing confusion and the need for constant colour adjustment. Although it is not always possible, at least try to position the easel so the painting surface is in shade. The open palette can be shaded by using a neutral-coloured artist's umbrella, which can be attached either to the easel or tripod.

When it is not practical to position your painting and palette in constant open shade, or when the surrounding area is extremely bright, working in full sunlight is the only remaining option. Since individual colours and mixes will look lighter and brighter in this scenario it is imperative to bear this in mind and carry out the necessary compensations. It may be helpful to take the painting down at regular intervals to look at it in a different light. As bothersome as this sounds, it could save the time taken to correct the painting at a later date if colour and tone have been incorrectly assessed.

DEMONSTRATION: *The Gate/Beck Hole*

This small *plein air* painting was undertaken over a period of approximately one and a half hours in rapidly changing evening light.

MATERIALS

Support

Treat a 30 × 25cm (12 × 10in) proprietary canvas-covered board as follows:

- Apply one coat of texture paste with a 25mm hog brush.
- Apply one coat of white acrylic primer to each side of the board to prevent warping.
- Apply a second coat to the chosen working surface.
- Paint the prepared board with a variegated, coloured ground using 'turpsy' washes of Cadmium Yellow, Ultramarine Blue and Permanent Bright Red.

Brushes

- Nos. 4, 6 and 8 Eclipse, Filbert brushes by Rosemary and Co.
- A no. 3 round sable or synthetic Rigger.

Colours

For this demonstration a limited palette of six primary colours (a warm and cool version of each primary) and an alkyd white were used: Permanent Bright Red, Alizarin Crimson, Winsor Yellow, Cadmium Yellow Lemon, Ultramarine Blue and Cerulean Blue. Alkyd Titanium White was used to speed up drying time. As for previous demonstrations, three greys were mixed from the above primaries and white:

- Grey 1: A warm, light-toned grey.
- Grey 2: A cool, light-toned grey.
- Grey 3: A dark neutral grey.

Additional Items

- Turpentine, or a low odour solvent.
- White spirit (for cleaning the brushes only).
- A 2B pencil.
- A palette knife.
- A copious supply of kitchen towel.

Step 1.

Step 1: Drawing Out and Commencing the Block-In

Use a 2B pencil to draw a simple outline of the subject. Next, begin to block-in some of the dark trees in the composition. Ultramarine Blue plus Alizarin and a touch of one of the yellows will make a good dark colour that can be adjusted if necessary by the three greys. Try to mix a variety of warm and cool darks.

Step 2: Continuing the Block-In

Looking carefully at the subject, squint your eyes to decide on the major shapes and continue the block-in by using darks and mid-tones. Slightly lighter blue-greys, both warm and cool, can be mixed for the wall. Take advantage of your pre-mixed greys to achieve these tones.

At this stage begin to mix a few mid-toned and dark greens for the foliage in the overhanging trees. Once again use the mixed greys, which can be adjusted using the primaries. Paint the foliage masses in an abstract manner, with a combination of warm and cool colours and 'lost and found' edges.

For now, accurate rendering of colour and detail is not necessary, but the painting must be fairly accurate with regard to tone. To further the learning process, always experiment with your mixes as there are numerous ways to achieve the required colours from this limited palette. Remember that by adding too much white to your colours you run the risk of cooling the mix too much, or of making the mix appear chalky.

Step 3: Developing the Block-In Further and Starting the Distant Foliage

Continue to develop the overall block-in and at the same time begin to introduce a few lighter, bluer tones to the distant trees and bushes. By using these cooler tones you will be able to create a feeling of recession in the painting.

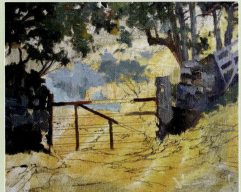

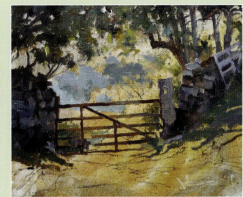

Step 2. Step 3. Step 4.

Step 4: Beginning to Paint the Mid-Tone Greens in the Foreground

You can now move your attention to the dark and mid-toned shadowy greens in the foreground. To enhance the shadowy feel to these greens try introducing a subtle purple-grey to give a broken, textural effect. Pay particular attention to the transitional area where the wall meets the grass. This area should be carefully blended, ensuring a soft transition that does not attract the eye.

Use a few slightly lighter-toned greens to paint the overhanging foliage. These greens can be mixed with combinations of Ultramarine Blue, Winsor Yellow with a touch of Permanent Bright Red plus white for the warmer greens. For the cooler greens try using Cerulean Blue, Cadmium Yellow Lemon with a touch of one of the reds and white. The gate can now be worked on, along with further wall details.

Step 5: Completing the Painting

Before paying any attention to the lighter tones, highlights and final details, the foreground block-in can be completed. By now you should have a wide range of colourful grey mixes to work from, any of which can be adjusted using either the pre-mixed greys or the primaries.

You can now begin to paint all the lighter tones and the final highlights. Because these lighter tones contain more white, once again be especially careful to avoid the mixes becoming too chalky or cool. To prevent this you may have to pep up the colour slightly using extremely small amounts of red or yellow. To create the feeling of sunlight, the lighter greens can be mixed with a predominance of yellow. A range of lighter yellowy greens can be mixed with a combination of both of the blues and yellows together with white. (Note: These lighter, purer, sun-struck areas will need to be mixed only from the primaries and should be fresh and clean looking.) Always look for the presence of reflected light, which is often bounced into shadowy areas from adjacent objects.

When studying the finished picture ('Step 5'), notice how the highlights have been painted. The paint has been applied thickly, using impasto, creating texture that subsequently enhances the light effect. Look at the use of impasto in the foreground where the light streams through the gate. It is also very apparent in the highlights on the gate and gateposts.

The final details such as the twigs and branches can now be added. Be careful to keep the painting loose and not to overdo these details. Before you clean down your palette and pack up, take a little time to make sure that all the edges read well; you should have a pleasing combination of soft and hard edges, which will ensure that the viewer's eye travels through the painting in a pre-determined, controlled manner. Also take a final look at the tonal sequence of the painting, which should read convincingly.

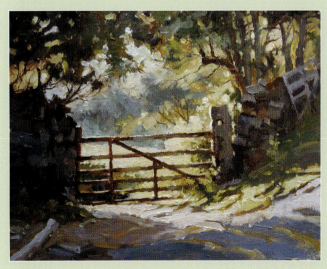

Step 5.

A valuable tool for aiding subject selection and assessing composition is a viewfinder. The viewfinder can be used to scan over the chosen subject, moving it towards or away from your eye to compose your painting. In effect you are using the tool to edit or crop the image. Cropping is a valuable compositional aid and will be discussed in more detail later in this chapter.

You could either make your own viewfinders from stiff card, each having a different aperture cut to suit a variety of board sizes, or purchase a ready-made one. The picture below shows two different viewfinders: one is home-made, from a piece of stiff, black card cut with an aperture in direct proportion to a 10 × 12in canvas or board. The other is a proprietary 'View Catcher', made by ABS Plastic, which is fully adjustable to most popular proportions. It also has a small hole in the centre of the slide, which is used for making tonal comparisons.

Another useful tool for the *plein air* painter is the value finder; the one illustrated is made from stiff card and was a free gift that came with a pochade box purchased from the USA. It would be very easy to make your own, however, from a piece of white, stiff card and tubes of black and white acrylic paint – just mix a series of greys from black to white. Although the value finder illustrated has ten tones, five or six would be adequate.

Once you have settled on a subject to paint and are confident regarding the focus of your painting, try to downgrade the rest of what you see. Throughout the painting process concentrate your mind on this focus and try not to become distracted or flustered, stay in control and do not work too quickly. Do not be too concerned if you are unable to complete the painting on-site; it is far better to take away a well-observed piece of work that has some quality. An incomplete, well-executed painting is far more rewarding and valuable than a rushed, poorly executed completed piece of work.

Planning a painting trip is always important, especially with regard to any factors that may affect the painting process. Consider the lighting conditions, the weather and available time. Ideally, you will need fairly constant conditions during the execution of the painting. Make sure that you have a right to paint at certain locations, as there is nothing worse than being moved on by irate landowners when you are well into the painting process.

When painting coastal subjects, remember the importance of tide times. It can be extremely frustrating when you start to paint boats in a creek or harbour where the tide is out and then, half an hour later, the same boats are beginning to float. Always do your research beforehand. If you are aware of the tide times in advance you will save valuable time vital for the execution of the painting. This knowledge also reduces the risk of becoming trapped by incoming water!

Weather is an important factor for consideration, so if the forecast is poor, an umbrella could be useful to cover your board and palette. If heavy rain and wind is forecast, plan to paint from some form of shelter. You may be able to paint from your car using a small pochade box, find a conveniently positioned bus shelter, or get permission from a farmer to paint from one of his outbuildings.

When dealing with rapidly changing lighting conditions, or when really bad weather threatens to intervene, always resist the temptation to rush your work. More often than not mistakes will be made, more time will be lost and, worst of all, panic can take over. Stay calm and maybe take a few photographs, as often the painting can be completed back in the studio. Better still, you could return to complete the painting when similar lighting conditions prevail.

Two viewfinders.

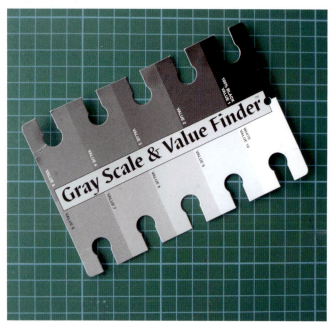

A proprietary value finder made from stiff card.

CROPPING, SIZE AND PROPORTION

On occasions you may find that insufficient consideration was given to the subject matter with regard to what should have been included or, more importantly, omitted. It may have been that you were too impatient to start or felt pressured by a shortage of time. Whatever the reason, cropping should always be considered, whether for a photograph (as mentioned earlier), sketches or even a completed *plein air* painting.

Cropping Photographs

Try selecting a handful of reference photographs. Look carefully at each one and you will probably discover that within many of them lies more than one subject. An easy way to isolate certain areas of a photograph is to use two pieces of L-shaped card. These can be used together to form an adjustable mount, often revealing a variety of different shapes and compositions for consideration. When you have decided on your composition you may find it useful to use masking tape to isolate the selected area whilst painting. A good-quality masking tape can easily be removed from the photograph on completion of the painting.

The photograph titled *Ruswarp Mill* was one of many taken to provide back-up reference material whilst sketching on location. This photograph was selected to illustrate cropping as it provided several completely different compositional arrangements. (See illustrations 'Crop 1' to 'Crop 4'.)

Cropping is also an extremely useful means of editing completed paintings or drawings that on reflection do not quite work. There are many reasons for this; the composition may be weak, or one particular area of the painting may have been poorly executed, for example. It can often be extremely difficult to assess just what is wrong with a particular painting. However, by using the cropping tool you will be able to isolate different areas of the painting and hopefully locate any problems.

Size and Proportion

Before commencing any new painting, along with the usual considerations such as composition, focal point and so on, some thought should be given to the size and proportion of the completed piece.

PROPORTION

For many years, paintings were created generally in standard sizes and proportions, usually determined by fundamental mathematical theories (one of these being the golden section).

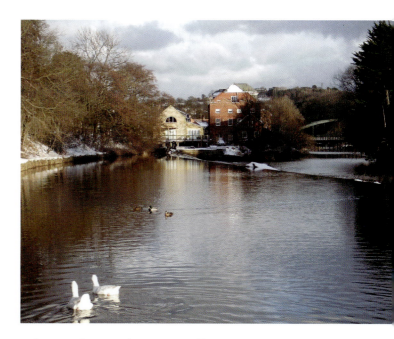

Reference photograph: Ruswarp Mill.

In modern times, however, many artists have broken away from these restrictions, preferring to use boards or canvases that offer far more scope.

When designing the composition of a painting the four most important lines you will choose are the outside edges. This choice sets the stage for the appearance of the whole piece. There are four main formats: the horizontal rectangle, horizontal vertical, horizontal oblong and the square.

- The horizontal rectangle, or landscape format (3:4, 4:5, 4:6), is the most traditional, and is by far the most popular format for painting landscapes.
- When turned vertically, the rectangle is commonly referred to as the portrait format. This format encourages the eye to move up and down within the design.
- When the rectangle is elongated (1:2) beyond the standard rectangle, a panorama is created, where the eye tends to pan back and forth across the design.
- The square (1:1) is the most unusual and creates a visual tension.

It is important for your development that you experiment with these formats to help you gain an insight as to how they can be utilized to strengthen and give variety to your work. Carry out an exercise by painting a particular scene and composing it in each of the above formats. You will soon discover that certain elements of the composition will need to be altered to accommodate the change in format. You may also be surprised as to which format stimulates you artistically. This is not to say that one is better than the other, you will just relate to each one in a different way.

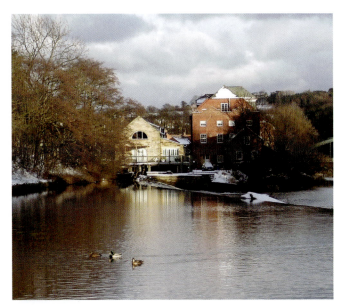

Crop 1.

Crop 2.

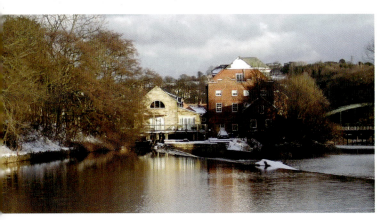

Crop 3.

There is no doubt that a wide variety of shapes and sizes look good on the wall of any exhibition and offer any proposed buyer far more choice.

WORKING LARGE

Cameo scenes, studies or subject matter that has been cropped fairly drastically are likely to be more effective if painted on a smaller scale. However, generally speaking, wide vistas or subject matter with lots of detail will be more effective when painted on a larger scale. Most artists work within a range of painting sizes that suits their own personality, creating a comfort zone for their work.

By working small you will strengthen your compositional eye because things have to be simplified or else they look overstated and cartoon-like; detail becomes secondary to a solid painting structure consisting of shapes, values and colour harmony. By working in a large format the likelihood is that your work will develop, becoming more expressive, due to the additional space that needs filling.

Whether you prefer to work small or large there is always something to be gained by working outside your comfort zone. Give it a try and see where it leads.

Crop 4.

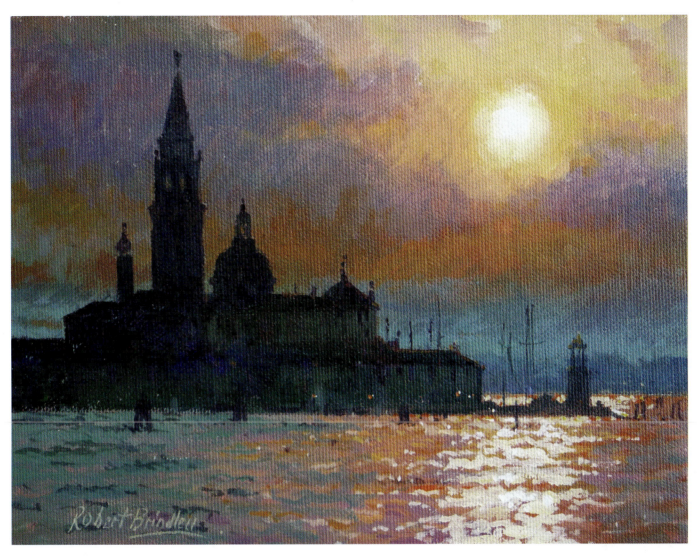

Sunset/San Giorgio/Venice, 20 × 15cm (8 × 6in).

LIGHT, MOOD AND ATMOSPHERE

The ability to capture mood and atmosphere effectively is an extremely difficult skill. Very few painters are able to reproduce this element at will; many painters frequently fall short in one respect or another and any successes remain a hit-and-miss affair.

To capture mood and atmosphere in your work you will need to be able to assess not only the quality of the light, but also how it influences the masses, tones, colour and edges within the subject. Whenever you come across an atmospheric subject, or admire a successfully executed painting, notice how the detail and colour are reduced, the masses simplified and that the tones invariably have little contrast, with subtle, gradual transitions. The edges may also appear to be generally soft, with the exception of the ones in and around the focal point.

The painting *Sunset/San Giorgio/Venice* has all the these elements, which are vital to the creation of an atmospheric painting. Notice how there is very little detail and colour change in the silhouette of San Giorgio. The sky and sea masses have been painted using gradual, soft transitions. The only exception to the above treatment is the path of light across the sea, which provides a lead-in to the painting.

Although there is no magic formula available for capturing mood and atmosphere, it should prove invaluable to assess carefully all the above elements (masses, tone, colour, detail and edges) in conjunction with the quality of the light.

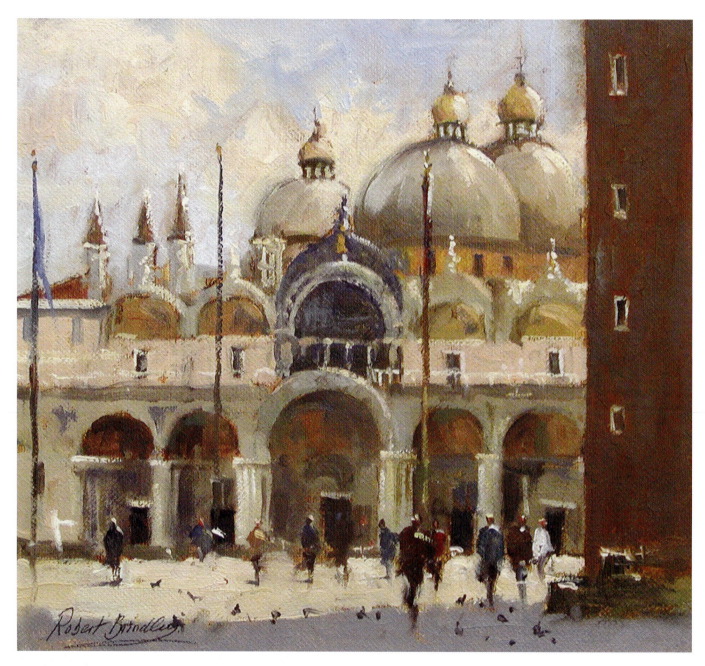

The Basilica, San Marco/Venice, 20 × 20cm (8 × 8in).

INTERPRETATION OF THE CHOSEN SUBJECT

There are certainly no formulas for interpreting your chosen subject, whatever it may be. Any formulaic approach to painting, by using either technique alone or other methods, is immediately apparent and its continued use will prove to be extremely limiting.

Painters have been compared to illusionists, as they trick the viewer's eye into believing that the painting surface is something real. From birth our brains gather, analyze and store detailed information. This information carries far too much detail for the inexperienced painter to handle and instead of interpreting elements, such as the leaves on a tree, in a simple way we start to paint far too literally, with too much detail.

Before commencing any painting, it may help to squint your eyes and try to see things in terms of abstract shapes and masses

Perceptive observation is seeing with your brain, feeling with your eyes, interpreting with your heart.

Robert Wade

carrying no detail. Try to forget that you may be looking at trees; instead, endeavour to make each individual shape or mass relate to each other to form a balanced, convincing composition. By adopting this practice you will be more able to blot out the over-abundance of detail and concentrating on the masses will hopefully produce a clearer, more concise impression of the chosen scene. The more confident you become, the less information you will tend to include in your paintings.

USING FIGURES IN THE LANDSCAPE

Many paintings can be improved quite substantially by including figures. They add interest, life and movement, providing that their importance and placement has been well considered. Ordinary subject matter can be greatly enhanced by including a few carefully composed figures. The correct placement of figures in a painting is critical to its success, as composition and balance can be affected drastically by incorrect positioning. Never

decide to use figures just for the sake of it; they are an integral part of the painting when used correctly and an unnecessary distraction if they are not needed.

You may find the following points useful when considering including figures in your paintings.

- Figures can be extremely useful for scale comparison. The height of a figure is related easily to any element in the landscape, creating distance and perspective in your work. The painting *The Basilica, San Marco/Venice* illustrates how figures can be used to create a sense of scale.
- Decide at an early stage exactly where to place major figures in your paintings. Small figures can often be incorporated fairly late in the painting process, or even after the painting has been completed if necessary. However, larger figures or groups need to be given much greater thought.
- Consider why you are using any figures. If you are concerned only with adding a little life to your painting by including one or two distant ones, then provided they are used sensibly there are not too many pitfalls. If this is the reason,

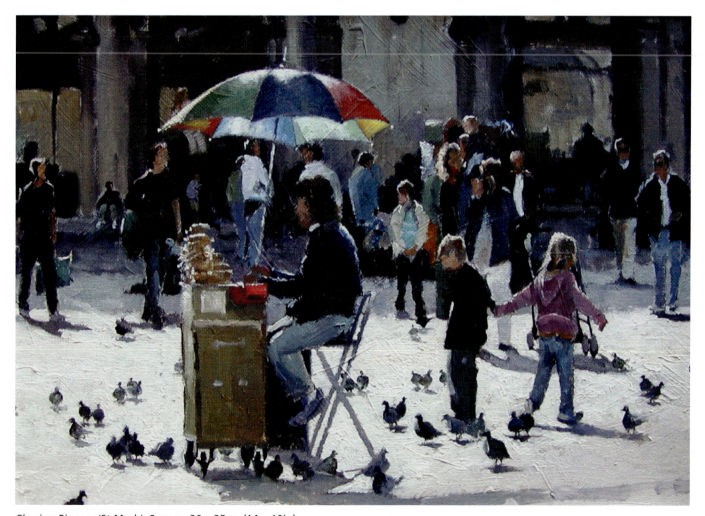

Chasing Pigeons/St Mark's Square, 36 × 25cm (14 × 10in).

ensure that they are not given too much importance and that they take nothing away from the overall feel of the painting. Incorrect tone, scale or colour can also ruin an otherwise successful piece of work. If the focal point of your painting is not working effectively, remember that a well-placed figure can be used for emphasis. Never be tempted into using a poorly positioned, brightly coloured figure (especially in red), which may be too intrusive.

- Figures can often be an integral part of your composition; if so, make sure that you give sufficient priority to the chosen individual or group only. When drawing or painting foreground figures, careful observation is needed and a little more information required. However, be wary of over-detailing. The painting *Chasing Pigeons/St Mark's Square* illustrates how priority has been given to selected figures. Notice how they have been painted, using positive brush marks and little detail.

- Occasionally you may come across just one or two figures that would make a wonderful subject on their own. It could be a simple study of a child playing in a rock pool, or a couple sat in a café – whatever captures your attention. Vital information for

this type of subject matter can be gathered by quick sketches and photographs, but always be considerate by not disturbing or intruding on any individual's privacy.

- *Waiters/St Mark's Square/Venice* was painted from sketches and photographic reference and illustrates how figures can be used as the main subject matter. Once again, notice how the figures have been painted, using positive brush marks and little detail.

- Remember that figures can be used as a compositional device, to lead the viewer into and through your painting.

- When using groups, always be aware that odd numbers work better than even numbers, so use three, five, seven and so on. Overlapping shapes also work better, as numerous, evenly spaced individual figures are never as aesthetically pleasing as composed groups. The overlapping group used in the painting *Rio Della Misericordia/Venice* works far better than single figures would have done.

- Many extremely competent paintings are spoiled by either poorly drawn or badly conceived figures. Always remember that loose does not mean sloppy and, conversely, well drawn does not necessarily mean tight or over-detailed. Try not to

Waiters/St Mark's Square/Venice, 25 × 20cm (10 × 8in).

Rio Della Misericordia/Venice,
25 × 30cm (10 × 12in).

paint figures that appear to be rigid or wooden; they should be painted with a combination of confident, acceptably loose brushwork in conjunction with just the right amount of detail. Try not to over-elaborate when painting heads, hands or feet – after all, we are not concerned with portrait painting.

A successfully drawn figure should be correctly proportioned and, at the same time, the stance and attitude must be totally convincing. To obtain a feeling of movement, especially in distant figures, do not attempt to paint the feet. Rather, try to blur the legs slightly, just above the ground. Look carefully at any figure you have drawn: if necessary, view the painting through a mirror, or ask someone you trust to be honest with their opinion. If any figure looks lifeless, too rigid or out of proportion, changes should be made.

It is often extremely difficult, even for the more experienced painter, to render fleeting figures in their work. Even if you feel confident enough to include quick and accurately painted figures in your *plein air* work, it is still advisable not to rush the process by trying to paint an individual who passes by. Instead, take your time and be patient, as on many occasions your patience will be rewarded and a suitable figure will come along and settle down for a while, giving you the opportunity to include them in your painting or take a number of reference photographs.

Over a period of time most experienced painters develop a shorthand method that enables them to include figures in their work. Until you develop this ability, take your camera everywhere and always carry a small sketchbook for making quick studies. These sketches will be invaluable for future reference.

IN THE SPOTLIGHT

The Red Umbrella/St Mark's Square/Venice, 30 × 25cm (12 × 10in).

The Red Umbrella/St Mark's Square/Venice was painted on a hot summer morning before the majority of the day trippers arrived. The inspiration for the painting came from the colour and movement provided by the figures, set against the shadowy façade of St Mark's.

Evaluation

This painting captures the bustling atmosphere in St Mark's Square. The figure groups work particularly well; even the risky placement of the large foreground figure entices the viewer into the painting.

Composition

Composition has always been a contentious topic with regard to painting. As a painter, you are never on safe ground compositionally unless you conform to the basic formulas that ensure balance within any piece of work. This painting uses a few of these basic rules to ensure that there is an underlying balance. However, as stated above, the risky placement of the foreground figure could cause debate amongst a group of artists as to whether or not it should have been included.

Observe the digitally altered version of *The Red Umbrella/St Mark's Square/Venice*, where the large figure has been removed

Digital alteration of
*The Red Umbrella/
St Mark's Square/Venice.*

digitally, to enable you to form your own opinion as to whether or not it should have been included.

The following observations may prove useful for whenever you are analyzing your own paintings with regard to composition.

- The horizon line, formed approximately by the base of the Basilica, has been positioned safely on the horizontal golden section. The main group of figures and red umbrella, which form the focal point, have also been positioned safely, this time on the vertical golden section.
- The white, diagonal line that runs obliquely into the painting serves as a lead-in to the focal point. An additional, subtle lead-in is provided by the large foreground figure, which takes the viewer's eye gently to the main group of figures.
- The figures used in this painting are composed of pleasing groups that overlap and are randomly placed, as discussed earlier in this chapter.

A digitally altered tonal study of *The Red Umbrella/ St Mark's Square/Venice.*

Tone and Colour

The tone and colour work perfectly well and nothing would be changed in any future painting. To evaluate whether or not your tonal values are working correctly, try converting the image into greyscale using computer software.

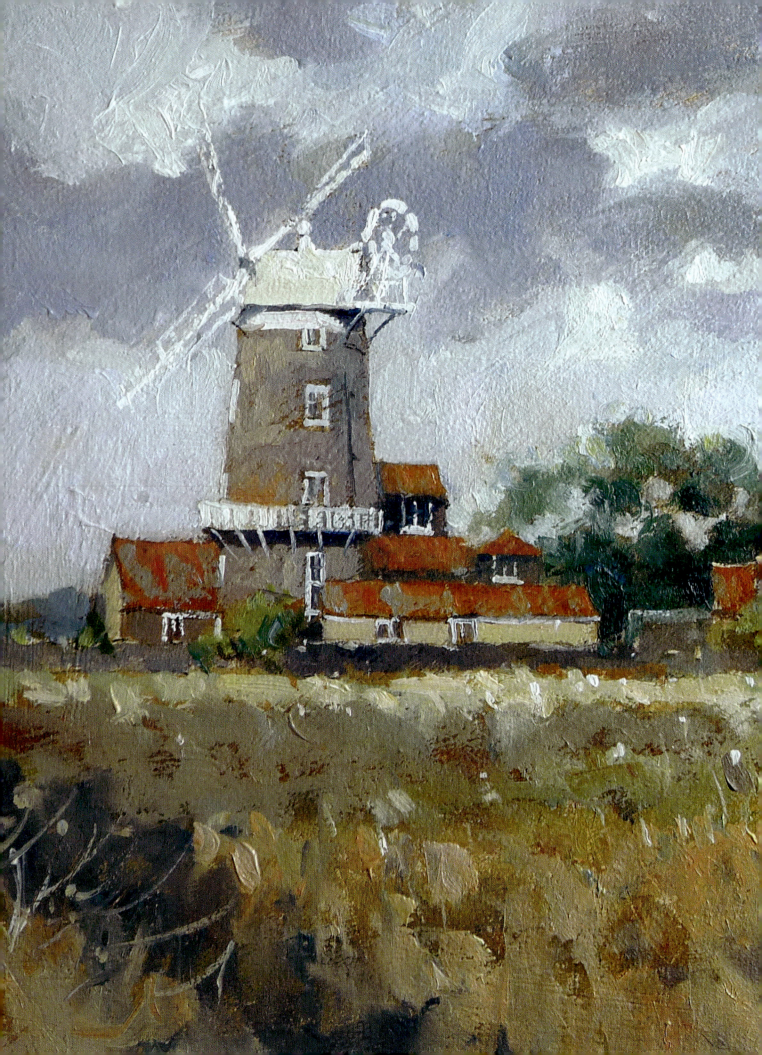

SKIES

Blustery Day/Cley Next the Sea was undertaken on a painting trip to Norfolk. Although the weather was generally fine the wind was extremely blustery, making it very difficult to control the brush. However, over the three days the ever-changing, fast-moving skies were a joy to paint, giving each painting movement and energy.

The sky is the soul of all scenery. It makes the earth lovely at sunrise and splendid at sunset. In the one it breathes over the earth a crystal-like ether, in the other a liquid gold.

Thomas Cole

The sky is the key to most types of landscape painting, reflecting the conditions and moods of nature. Even in subject matter where greater attention is given to the land mass, the sky as the light source will be a great influence on what is observed. Consequently, it is highly likely that the sky's effect on the subject will be entirely responsible for its initial appeal. The artist should always acknowledge the importance of the sky, making every effort to interpret its influence by responding in a sensitive and creative manner.

Having set out on a painting trip to Staithes, the magnificent sky in *Sunrise Over Whitby* was observed. The subject was so appealing that a small sketch was undertaken before continuing north.

For a variety of reasons many artists seem to have little interest in the sky, favouring the landscape itself as the main theme in the majority of their paintings. Others may decide that the sky on a particular day was fairly ordinary and would not contribute to the overall effect of the painting. A few painters shy away from painting any interesting or complicated sky, settling for an easy option: either an ordinary, graded blue backdrop or just a thin strip of sky at the top of their paintings.

If you are reluctant to include the sky in your paintings, whatever the reason, it may help to study the works of John Constable or, more recently, Edward Seago and Edward Wesson. These artists had a passion and great ability for capturing the sky in all its moods. Constable and Seago painted all their lives in their native counties of Suffolk and Norfolk respectively, where the landscape is flat and the skies vast.

To be able to paint the sky convincingly, many hours of practice will be required. It is therefore essential that you spend as much time as possible studying different skies by making numerous small *plein air* studies to hone your powers of observation and speed up your execution. A number of sky sketches and step-by-step demonstrations can be found later in this chapter.

Sunrise Over Whitby, 30 × 30cm (12 × 12in).

OPPOSITE PAGE:
Blustery Day/Cley Next the Sea, 25 × 30cm (10 × 12in).

Vapour Trails/Villy-Le-Moutier/Burgundy, 40 × 30cm (16 × 12in).

Vapour Trails/Villy-Le-Moutier/Burgundy illustrates how a dramatic sky can be used as the main feature of a painting, whilst at the same time showing its effect on the landscape below.

TYPES OF SKY

It may prove useful to have a certain amount of knowledge regarding the types of skies and cloud formations you will encounter. You will not need to be an expert on the classification of clouds but a little background knowledge will only add to your appreciation and interpretation of their form.

Daybreak/Mulgrave Woods was painted on a 30 × 15cm (12 × 6in) heavily textured board. The sun was just breaking through and it was decided that the stunning sky with a just few skeletal trees would make a wonderful subject. Notice

how the branches that pass across the sun are 'burnt out' by the light and painted in a lost and found manner.

There are various names for different types of cloud – cirrus, cumulus and nimbus, to mention a few. A cloudless or solid overcast sky will usually present no particular problems for the painter; however, try to adhere to the basic ground rule that the intensity of a blue sky is always at its greatest towards the zenith and that this intensity is gradually reduced as the sky drops towards the horizon. With a little practice, by adding carefully measured amounts of yellow, red and white you should be able to paint a convincing clear blue sky. Solid grey and clear blue skies rarely offer excitement or interest to most painters, so remember to use these skies where the main interest lies in other areas.

Whenever you are outside, painting or not, make a conscious effort to study the sky. Notice the recession within the sky and how more distant clouds are generally smaller than the ones overhead. This one observation alone will assist in creating a real

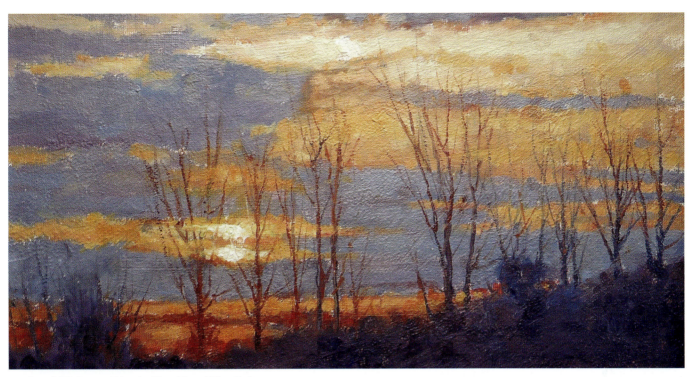

Daybreak/Mulgrave Woods, 30 × 15cm (12 × 6in).

Snow/Roseberry Topping, 20 × 15cm (8 × 6in).

feeling of depth within your paintings. Cloud shadows, often scudding across the landscape, are also extremely important. They can be used effectively to divide large expanses of the landscape into smaller areas, providing you with a wonderful, flexible compositional element. Try using cloud shadows in a creative fashion to add drama to your paintings, as in the painting *Snow/Roseberry Topping*, where a cloud shadow has been used in the immediate foreground and middle distance, to accentuate the thin slivers of light on the fields. These flashes of light help to draw the viewer's eye into the painting.

The following suggestions may stimulate your imagination and creativity and are only a few of endless possibilities.

- It may help to create drama by using light creatively. Try using a brightly lit foreground against a background that is completely in shadow.
- Other arrangements can be experimented with by painting the foreground in deep shadow and the middle distance and/or far distance as sharply illuminated (see the small *plein air* sketch *The Windmill at Workum/Holland*). Think of yourself as a director on a film set where all options are available to you. Imagine pointing a powerful spotlight anywhere you like within the boundaries of your painting. A brightly lit area, or areas such as this, can be used to direct the viewer's attention exactly where you want it.

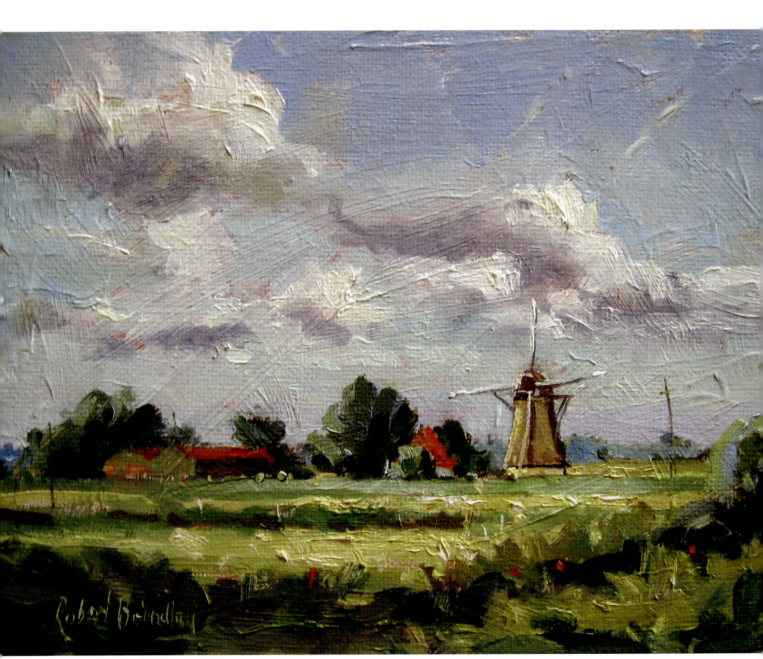

The Windmill at Workum/Holland, 20 × 15 cm (8 × 6in).

Cumulous Clouds/Corfu, 20 × 15cm (8 × 6in).

• Remember that all clouds are subject to perspective and subsequently the largest clouds will always be in the foreground or overhead. As the sky recedes to the horizon the clouds generally become gradually smaller.

Clouds are wonderful to paint, floating near to earth, at tremendous heights and sometimes hanging across the earth, as in the case of fog or mist. They are free-moving, making the sky a place of constant change, creating wonderful patterns on a backdrop of ever-changing gradations of colour. Scenes such as this should inspire any artist.

Always compare the relative colour value of clouds and the land; by doing so you will be more able to capture their lightness in a more convincing way. When considering the value of clouds, never paint even the darkest of clouds darker than earth values. Remember that dark clouds obstruct the light that would otherwise fall upon the landscape, causing the earth value to become darker than usual. Many painters fall into the trap of painting clouds too darkly and by doing so the clouds in their paintings appear to be almost too heavy to remain suspended in the air.

Occasionally, however, when there is a storm approaching, you will observe a sky that appears extremely dark and threatening against a brightly illuminated landscape. This light effect can be used to create paintings of high impact and drama. Nevertheless, even in these instances the sky remains the source of light and you should never paint it too dark, otherwise you will exhaust all means of producing the intensity and range of values needed in the rest of the painting.

As stated previously, consideration should be given to the gradation in the sky, which begins overhead at the zenith with quite a strong blue (Cobalt or Ultramarine with a touch of red or ochre seem to work quite well), lightening and warming progressively towards the lower part of the sky, often with a hint of green. The sky at the horizon often takes on a warmer, pearly-grey haze, sometimes with a hint of yellow or pink.

Further careful observation will reveal not only a vertical gradation of the sky but also subtle lateral colour gradations. These tonal and colour variations, though only slight, will recede in value as they move away from the light source. If the light source is warm, there will be a cooling of the tones and vice versa.

Cumulous Clouds/Corfu was painted to demonstrate how to paint a cumulous sky, however, it also serves to illustrate a clear blue, graded sky. Notice how there is a lightening of the sky from top to bottom and also how the sky changes in colour from a fairly strong, warm blue immediately overhead, turning progressively lighter and cooler further down and, finally, even lighter and warmer towards the horizon. This painting is included as a step-by-step demonstration later in this chapter.

REFLECTED LIGHT FROM THE EARTH

To help you identify some of the more subtle colours in the sky, look carefully for any reflected colours from the land. These colours make a tremendous difference to any painted sky. For instance, where you may have large expanses of oil seed rape, a great deal of this yellow may be reflected into the sky and, in a similar way, the colour of the sea is often reflected into the sky and vice versa.

REFLECTED LIGHT FROM THE SKY

Reflected light from the sky can often be difficult to detect. Observe, however, that where you see a brilliant sunset there will often be a warm orange glow cast over the landscape. By

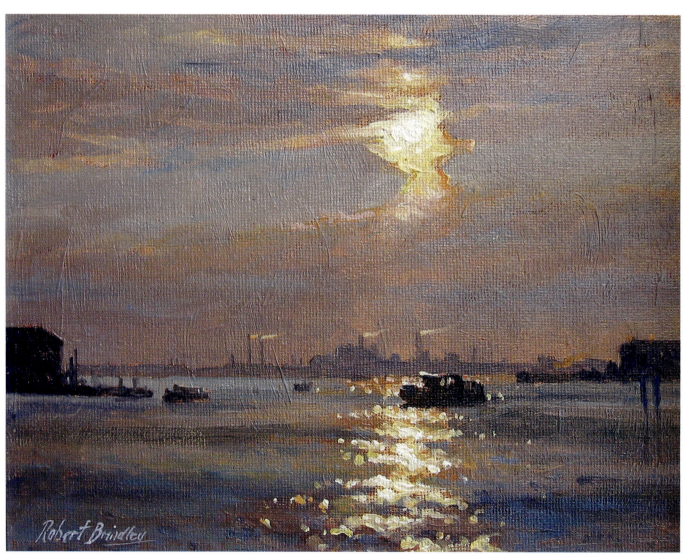

Evening/Giudecca Canal/Venice, 25 × 20cm (10 × 8in).

EACH SKY IS UNIQUE

A cautionary note with regard to painting formulaic skies should be made at this point. Never reproduce a successful sky from a previous painting, no matter how pleased you may be with it. These so-called 'stock' skies very rarely work when reproduced in another painting, often resulting in a 'mannered' appearance, which should be avoided at all cost. Always paint your interpretation of what is actually before you and never settle for a formulaic 'safe' option.

Approaching Storm/Oxford, 20 × 15cm (8 × 6in).

studying these more obvious examples of reflected light from the sky you will be more able to identify and paint the more subtle influences. The painting *Evening/Giudecca Canal/Venice* illustrates how a warm glow from a sunset can influence the colour of the entire painting.

Reflected light from the sky becomes a little more complex when related to the sea, rivers, streams or lakes. The effects of reflected light on water depends largely on the amount of movement in the water. A flat expanse of water, wet sand or any wet surface generally will be highly reflective and probably greatly influenced by the colour of the sky. The amount of reflective influence the sky has on any plane depends upon how the plane relates to the viewer's eye and also the reflective capacity of the plane. For example, dry surfaces have a low reflective capacity and little sky colour will be reflected. However, when the same surface passes into shadow, the sky colour is reflected more strongly. This explains why shadows always appear cooler on sunny days.

Waves and indeed any moving water can be wonderful to paint on a bright, sunny day as any horizontal planes will reflect the sky colour whilst all other planes, depending on their relative angles to the sky, will reflect the corresponding degree of colour.

Winter Morning/Egton, 60 × 50cm (24 × 20in).

SKY STUDIES

Should you have difficulties painting skies it is highly recommended that you dedicate as much time as possible to not only observing but also painting quick reference studies. These quick studies, however small, will enable you to interpret and paint skies far more effectively on site, especially in rapidly changing conditions when time is at a premium.

The following studies were painted especially for this book to demonstrate the value of small studio-based paintings. They were all painted from photographic reference using a limited palette of colours and taking no more than one hour each. Never be too precious regarding the outcome of these sketches;

work accurately and as spontaneously as possible to get down the necessary information. By painting as little as two studies such as these per week you will soon begin to reap the rewards from your efforts.

Approaching Storm/Oxford shows how a dark, threatening sky can be used effectively. The drama in this small painting is enhanced by the bright sunlight illuminating the buildings, playing against the dark backdrop of the sky.

DEMONSTRATION: *Sunset Towards Egton*

MATERIALS

Support

A 20 × 15 cm (8 × 6in) MDF board treated as follows:

- Apply one coat of texture paste with a 25mm hog brush.
- Apply one coat of white acrylic primer to each side of the board to prevent warping.
- Apply a second coat to the chosen working surface.
- Paint the prepared board with a variegated coloured ground using 'turpsy' washes of Ultramarine Blue and Permanent Bright Red.

Brushes

- Nos. 4, 6 and 8 Eclipse, Filbert brushes by Rosemary and Co.
- A no. 3 round Pro Arte, Acrylix or sable Rigger.
- An old, worn no. 5 sable watercolour brush to be used for blending wet paint (optional).

Colours

Example palette of colours.

For this, a limited palette of six primary colours (a warm and cool version of each primary) and an alkyd white were used: Permanent Bright Red, Alizarin Crimson, Winsor Lemon, Cadmium Yellow Light, Ultramarine Blue and Phthalo Blue. Alkyd Titanium White was used to speed up drying time. Before commencing the painting, three greys were mixed from the primaries and white:

- Grey 1: A warm, light-toned grey.
- Grey 2: A cool, light-toned grey.
- Grey 3: A dark neutral grey.

Additional Items

- Turpentine, or a low odour solvent or white spirit (for cleaning the brushes only).
- A 2B pencil.
- A palette knife.
- A copious supply of kitchen towel.

This small painting was undertaken in approximately one hour. It shows a combination of stratus and cirrus clouds against a clear blue sky.

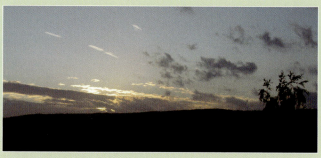

Photographic reference for *Sunset Towards Egton*.

Step 1.

Step 1: Drawing Out

Use a 2B pencil to draw a simple outline of the subject.

Step 2: Commencing the Block-In

Begin to 'block in' some of the dark, distant hills and the lower stratus clouds. Ultramarine Blue, a touch of Alizarin or Permanent Bright Red and smaller amount of Cadmium Yellow Light will make a good cloud colour that can be adjusted in tone by adding white. Do not be satisfied with just one mix; instead mix a variety of warm and cool versions.

Use the same colours for the distant hills but this time use a little more yellow in some of the mixes. Remember, there are many ways of achieving suitable alternative mixes that will work just as well. Try experimenting by using different primary colours and the pre-mixed greys to achieve a workable harmony.

Step 2.

At this stage an accurate rendering of colour and detail is not necessary, but the painting must be fairly accurate with regard to tone.

Step 3.

Step 3: Developing the Block-In Further

Continue to develop the block-in by painting the cirrus clouds, which are found slightly higher in the sky. The cloud mixes already on your palette can be used, although slight adjustments to both colour and tone will be necessary. Try using a little more white for any tonal adjustments. A touch of Alizarin Crimson and yellow can be added carefully to provide subtle colour changes. By adding yellow, the clouds will take on a slightly green tint caused by reflected light from the landscape.

The graded backdrop of sky can now be started at the zenith by mixing Phthalo Blue with a touch of Alizarin and White.

Step 4: Finishing the Block-In and Completing the Painting

Before the sky was completed in this painting, adjustments were made to the tone and colour of the sky in the top left-hand corner. It became apparent that the sky was far lighter and slightly greener at the zenith. When you have made any similar alterations that may be necessary you can begin to block-in the lower area of the sky. Use ever-increasing amounts of white, Alizarin Crimson and yellow to your mixes as you get nearer to the horizon (be careful not to use too much white, however, as your mixes may become chalky).

Now is the time to capture all of the warm light in the sky. For this you will benefit from experimentation. Try slightly different, subtle combinations of Permanent Bright Red, Alizarin Crimson, yellow and white for mixing a variety of yellows and oranges. The pink-grey at the horizon can be achieved by adding measured amounts of Alizarin Crimson to one or two of your previous blue-grey mixes.

At this stage you may need to turn your attention to the edges. All convincing skies have a combination of soft 'lost and found' edges, so you will need to be fairly selective and use either a clean finger or an old sable watercolour brush to carry out the necessary blending.

Paint in the wind-blown tree by mixing a dark blue-grey. The Rigger brush can be used for all the twig details.

You can now apply the highlights to the clouds using white with a very small amount of yellow. Notice how the highlights have been painted. The paint has been applied thickly, with impasto, creating texture that enhances the light effect.

Before you clean down your palette take a little time to make sure that all the edges read convincingly and that you also have a well-balanced painting with regard to tone and colour. Make any necessary changes.

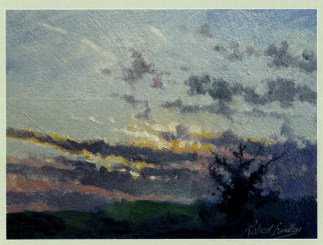

Step 4.

DEMONSTRATION: *Cumulous Clouds/Corfu*

This study was undertaken from photographic reference of the beach at Agios Gordios on a hot September afternoon. The clouds had been stacking up for several hours, threatening a much-needed rain shower.

MATERIALS

Support
A 20 × 15cm (8 × 6in) MDF board treated as follows:
- Apply one coat of texture paste with a 25mm hog brush.
- Apply one coat of white acrylic primer to each side of the board to prevent warping.
- Apply a second coat to the chosen working surface.
- This board was prepared with a variegated coloured ground using 'turpsy' washes of Ultramarine Blue and Permanent Bright Red. Experiment with a different coloured ground of your choice.

Brushes
- Nos. 4, 6 and 8 Eclipse, Filbert brushes by Rosemary and Co.
- A no. 3 round Pro Arte Acrylix Rigger.

Colours
Once again, a limited palette of six primary colours (a warm and cool version of each primary) and an alkyd white were used: Permanent Bright Red, Alizarin Crimson, Winsor Lemon, Cadmium Yellow Light, Ultramarine Blue and Phthalo Blue. Alkyd Titanium White was used to speed up drying time. Before commencing the painting, three greys were mixed from the above primaries and white:
- Grey 1: A warm, light-toned grey.
- Grey 2: A cool, light-toned grey.
- Grey 3: A dark neutral grey.

Additional Items
- Turpentine, or a low odour solvent or white spirit (for cleaning the brushes only).
- A 2B pencil.
- A palette knife.
- A copious supply of kitchen towel.

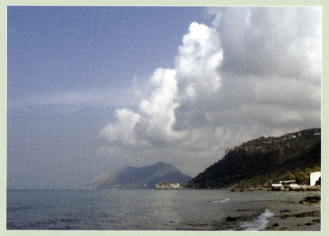

Photographic reference for *Cumulous Clouds/Corfu.*

Step 1: Drawing Out
Use a 2B pencil to draw a simple outline of the subject.

Step 1.

Step 2: Commencing the Block-In
Begin to block-in some of the dark, distant hills and the middle distance hills. Ultramarine Blue, a touch of Alizarin Crimson or Permanent Bright Red, a smaller amount of Cadmium Yellow Light and white will make a suitable mix for the distant hills. The warmer colour can be made from Winsor Lemon, Permanent Bright Red, a touch of Ultramarine Blue and white. To give variety, mix a range of warm and cool versions of each colour.

For the middle distance hills a combination of Ultramarine Blue, Cadmium Yellow Light, Permanent Bright Red and white can be used to create several slightly different mixes, giving variety

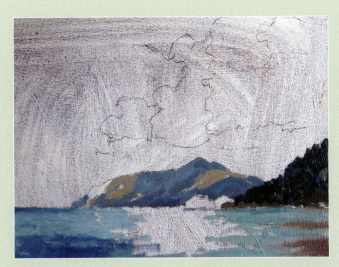

Step 2.

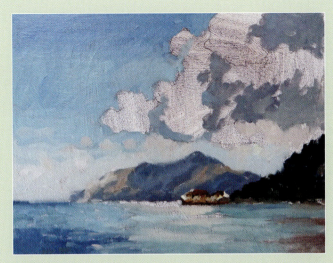

Step 3.

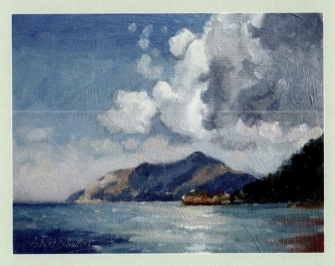

Step 4.

and interest. Once again, experiment with the other colours and the pre-mixed greys on your palette. You will achieve slightly different mixes that can be just as valid.

The sea can be painted using various combinations of Phthalo Blue, Alizarin, Winsor Lemon and white. To reflect different depths of water and the way the light catches it you will need these mixes to be varied: warmer, cooler, lighter and darker. The strip of beach can be mixed from Winsor Lemon, Permanent Bright Red, a touch of Ultramarine Blue and white.

At this stage keep your brush marks spontaneous and loose; an accurate rendering of colour and detail is not necessary but the painting must be fairly accurate with regard to tone.

Step 3: Developing the Block-In Further

Continue to develop the block-in by painting the sky and the cumulus clouds. Note the gradation in the sky, how it is a deeper, warmer blue at the zenith, gradually lightening and cooling as it recedes into the distance, where it becomes much lighter still with a touch of warmth. The clouds themselves appeared to be greyer and more neutral in colour than any of the blue-greys used previously. By adding small amounts of the primary colours to the pre-mixed greys you will be able to mix the colours fairly easily.

A variety of colours for the rocky outcrop can be mixed with Winsor Lemon, Permanent Bright Red, a touch of Ultramarine Blue and white.

Step 4: Finishing the Block-In and Completing the Painting

Complete the sky by adding all the mid-tones and highlights, which can be found by making slight adjustments to the mixes you will already have on your palette. Use thicker impasto paint

for the lightest clouds. A word of caution here: never use pure white for the highlights on the clouds, as they will look too artificially light. A touch of yellow, accompanied occasionally with a smaller amount of red should work. Once again, pay particular attention to the edges in the sky. As stated previously, skies have a combination of soft, 'lost and found' edges, so you will need to carry out any necessary blending.

Complete the sea by lightening and adjusting the mixes that you have on your palette. Make sure that you keep the painting fresh and spontaneous by using loose brushwork.

Finally, take a little time to make sure that all the edges read convincingly and that you also have a well-balanced painting with regard to tone and colour. Make any necessary changes.

DEMONSTRATION: *Dawn Near Pickering*

This atmospheric study was painted from photographic reference taken at sunrise on a frosty January morning. The hazy distance, vapour trails and birds add to the tranquillity of the subject.

MATERIALS

Support
A 20 × 15cm (8 × 6in) MDF board treated as follows:
- Apply one coat of texture paste with a 25mm hog brush.
- Apply one coat of white acrylic primer to each side of the board to prevent warping.
- Apply a second coat to the chosen working surface.
- Paint the prepared board with a variegated coloured ground using 'turpsy' washes of Ultramarine Blue and Permanent Bright Red or, try using a different coloured ground of your own choice.

Brushes
- Nos. 4, 6 and 8 Eclipse, Filbert brushes by Rosemary and Co.
- A no. 3 round Pro Arte Acrylix Rigger.
- An old, worn no. 5 Sable watercolour brush to be used for blending wet paint (optional).

Colours
A limited palette of three primary colours and alkyd white were used: Permanent Bright Red, Cadmium Lemon, Ultramarine Blue. An alkyd Titanium White was used to speed up drying time. Before commencing the painting, three greys were mixed from the above primaries and white:
- Grey 1: A warm, light-toned grey.
- Grey 2: A cool, light-toned grey.
- Grey 3: A dark neutral grey.

Additional Items
- Turpentine, or a low odour solvent or white spirit (used for cleaning the brushes only).
- A 2B pencil.
- A palette knife.
- A copious supply of kitchen towel.

Step 1.

Step 1: Drawing Out
Use a 2B pencil to draw a simple outline of the subject.

Step 2.

Step 2: Commencing the Block-In
Begin the block-in by painting the dark hedgerow using Ultramarine Blue, Cadmium Lemon and a touch of Permanent Bright Red and white. The mid-distance and far distant hedgerows can be blocked in next using a cooler mix of Ultramarine Blue, Permanent Bright Red, a touch of Cadmium Lemon and more white. Complete this step by painting the lower, warmer band of sky using Permanent Bright Red, Cadmium Lemon, a touch of Ultramarine Blue and white. Once again, experiment with the pre-mixed greys on your palette to achieve slightly different mixes, which can be just as valid.

The tonal values are of most concern: even at this early stage these values must be accurate. Keep your brush marks spontaneous and do not be too concerned with detail and accuracy of colour at this stage.

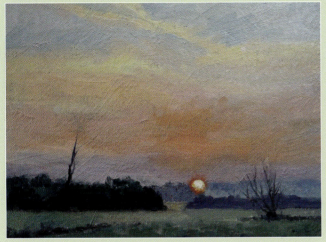

Step 3.

Step 3: Developing the Block-In Further

Continue to develop the block-in by painting the sky, sun and foreground. Notice how the sky has been painted using soft transitions of colour from the zenith right down to the horizon. All of the three primary colours and white were used to paint the sky, although there are many small shifts of tone and colour present which will provide a useful exercise in colour mixing for the more inexperienced painter. The colour at the zenith has a bias towards blue and consequently was mixed from Ultramarine, a touch of Permanent Bright Red, a smaller touch of Cadmium Lemon (this will grey the mix slightly) and white. The central area of the sky is much warmer and was painted with several combinations of Permanent Bright Red, Cadmium Lemon, a very small touch of Ultramarine Blue (once again to slightly grey the mix) and white.

The sun was painted from Cadmium Lemon, Permanent Bright Red and white. For impact paint the lightest part of the sun using impasto paint.

For the field, try mixes of Ultramarine Blue, Cadmium Lemon, a very small touch of Permanent Bright Red and white. Notice how the small patch of field at the horizon has been influenced by the sun and is therefore lighter and warmer. Generally speaking the field gets progressively darker and cooler as it comes towards you. When painting the field create an ever-increasing degree of texture, using spontaneous brush marks. This will give a greater feeling of depth.

Start to paint the bushes and trees with the Rigger, using any of the darker mixes available on your palette.

Step 4: Completing the Painting

Complete the sky by painting the vapour trails using mainly Cadmium Lemon and white. A sky like this will always have an influence on the landscape. You may, therefore, decide to increase the warmth in the central area of the field. For this you can use some of the warmer sky colours from the palette.

The trees, bushes and birds can be completed using a variety of warm and cool darker mixes available from your palette. Notice how the branches have a gradual taper, ending in very fine marks achieved by a flick of the Rigger. These brushes are very useful for painting features such as this; however, if you are not familiar with its use you may need to practise on a scrap of card before painting your trees.

As previously, take a little time to make sure that all the edges read convincingly and that your painting is well-balanced with regard to tone and colour. Make any necessary changes.

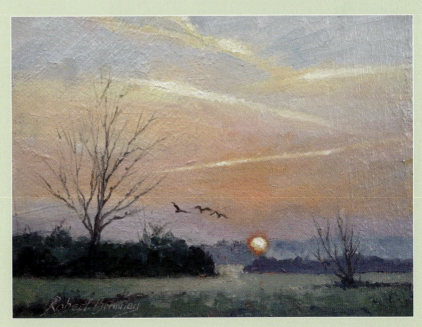

Step 4.

Winter Morning/Egton was painted from a small watercolour sketch that was inspired by the wonderful soft, warm light. Notice how the warmth from the sky seems to influence the entire painting, dropping veil-like over the distant fields and reflecting in the foreground snow.

Winter Sunrise near York shows weak winter sun filtering through thin, low cloud. This subject illustrates how structural elements such as the trees and bushes work well against the hazy backdrop of the sky. Particular attention was given to the blending of the sky, as it was essential that soft transitions of tone and colour were used. Although essentially a simple subject, the tonal relationships have to be spot-on, otherwise the impact of the trees against the sky will be ineffective.

Although not a landscape painting, the large painting *Mustang* was a demonstration piece that illustrates an interesting and varied sky which here acts as a perfect backdrop to the aircraft.

The breaking early morning light was the inspiration for the painting *Morning Light/Morston Quay*. It was painted on-site, between seven and eight o'clock on a glorious August morning, and brings back many memories of several days painting along the north Norfolk coast. Atmospheric skies such as this should not fail to inspire; they are the bread and butter of any landscape painter.

TOP LEFT: *Winter Sunrise near York*, 20 × 15cm (8 × 6in).

MIDDLE LEFT: *Mustang*, 60 × 50cm (24 × 20in).

BELOW: *Morning Light/Morston Quay*, 30 × 15cm (12 × 6in).

IN THE SPOTLIGHT

Sunrise/Tower Bridge, 25 × 20cm (10 × 8in).

The sketch *Sunrise/Tower Bridge* was painted from photographic reference taken on a trip to London. This amazing sunset illuminated the entire sky with an array of oranges, yellows and soft blue-greys.

Evaluation

The reference photographs for this painting were cropped dramatically in order to improve the composition. The subtle diagonal formed by HMS *Belfast* was used to lead the viewer's eye towards Tower Bridge, which is the focal point.

Composition

Although the composition works fairly well, the eye tends to bounce between the two towers without really settling. On reflection, it might have been better to have moved the small boat on the extreme left into the centre of the painting. This would have been just enough to strengthen the centre of interest.

Tone and Colour

The tone and colour work perfectly well and nothing would be changed in any future painting.

PAINTING COASTAL SCENERY

East Row Beck/Sandsend shows the beck running down across the beach at low tide. The meandering path of the beck provides a perfect lead-in to the painting, while the reflections of the sunlit gable ends of the cottages add further interest.

PAINTING WATER AND REFLECTIONS

Water provides the landscape painter with one of the most exciting elements to paint, although many artists have great difficulty capturing it successfully. The ability to capture the gentle movement and reflections of a slow-flowing river, or the turbulence of a fast-flowing river or wild sea can challenge even the most accomplished of artists.

Water changes continually, whether it is a river, a stream or the sea. These changes can be either subtle or dramatic, and are brought about by several factors. The weather in particular creates changes in the volume and more importantly the movement of the water. Prevailing light conditions also play a major part, often changing the colour and transparency of the water.

Even standing or fairly still water, as found in ponds, lakes, slow moving rivers and rock pools, is subject to many changes: evaporation will take place, it will be disturbed by wind and rain, and probably most important of all it will reflect the prevailing lighting conditions.

The sections that follow give due consideration to the many different types of water found in the landscape.

Afternoon Light/Bassenthwaite, 40 × 25cm (16 × 10in).

Still Water

Afternoon Light/Bassenthwaite was painted as a demonstration and depicts a fine summer day where the water surface was occasionally disturbed by a light, warm breeze.

Many artists are attracted to painting still water because of its mirror-like, reflective quality, sometimes capturing shape and colour to perfection. You will gain a little more understanding of how reflections are created by spending as much time as possible studying and sketching them.

Reflections/Ullswater was painted from on-site sketches and reference photographs. The water surface is almost mirror-like, reflecting the surrounding hills almost perfectly. The viewpoint for this painting was the water's edge. Consequently, an almost exact duplication of the subject has been reflected. However, when a subject is painted from a slightly elevated position the reflection will be subject to some distortion.

OPPOSITE PAGE:
East Row Beck/Sandsend, 30 × 40cm (12 × 16in).

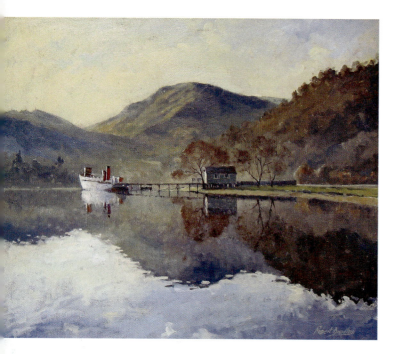

Reflections/Ullswater, 40 × 30cm (16 × 12in).

The photograph *Harbour Reflections/Kassiopi/Corfu* illustrates this point. By looking carefully at the centre boat you will see that the reflections of the bow are far deeper than its actual depth, giving the appearance of having been stretched.

When looking across an area of water in a harbour or similar setting, study the reflections of boats, harbour walls, jetties and so on. Notice how any feature or object very close to the edge will be reflected. However, objects that are set a little way back from the water's edge will either be partially reflected or not reflected at all. By studying the photograph *Reflections/Corfu Town Harbour* you will see that the boats nearest have been reflected, but the superstructures of the boats slightly further back, together with the distant trees and bridge, have not been reflected at all.

You could be forgiven for thinking that colour and tone would be reproduced exactly in a reflection; however, colour more often than not appears to be slightly greyer. Tone is affected to a greater degree, resulting in a narrowing of the tonal range. Subsequently, lights are reflected slightly darker and darks slightly lighter in their reflection. Although greatly exaggerated, this can be seen in the photograph *Harbour Reflections/Kasiopi/Corfu.*

Harbour Reflections/Kassiopi/Corfu.

Reflections/Corfu Town Harbour.

A perfectly flat water surface will generally produce an almost perfect reflection, but by introducing a slight disturbance to the water surface movement and design will be introduced to the painting, removing the possibility of the painting having a static quality, often in evidence in many picture-postcard views.

Transparency is another factor to consider when painting still water. In ideal conditions rocks and other underwater features will be visible, presenting the opportunity for you to include them in your work. This transparent effect is best achieved by painting the bottom of the water first, followed by the suggestion of a slightly disturbed water surface over the top.

Once again, it is important to look carefully at the scene in front of you, especially when the sky is reflected in the water surface, or when you are looking across the water surface from a low angle. On these occasions it is common for all transparency to be lost. On other occasions, when you look directly down into the water from the river bank or from the edge of a rock pool, the transparency of the water will be revealed for you to paint.

At low tide there is often the possibility of studying broken or subtle reflections in wet sand. The small study *High and Dry/ Staithes* presented just this type of subject matter: the wet sand immediately beneath the coble produced an extremely subtle reflection, whilst the small area of standing water revealed a much crisper one.

Moving Water

An exciting opportunity to paint moving water was offered in the painting *The Weir/River Esk/Ruswarp*.

Painting moving water presents additional challenges to the painter, although once again by studying and making small sketches you will be able to introduce the added dimension of movement to your work. *The Bridge at Starbotton* illustrates a gently flowing stream where the disturbed water surface is reflecting the light from the sky.

Moving water comes in many forms. On some occasions its surface may only be slightly broken by wind action whereas, in the other extreme, a fast-moving river in full flow after heavy rain reveals a far greater degree of disturbance.

The disturbed surface of the water in the painting *Sparkling Light/San Giorgio/Venice* reflects dramatic light in a threatening, stormy sky. Generally speaking, disturbed water conforms to the same rules as still water with regard to reflections. However, when painting outdoors, observe how the constantly changing planes of the water surface result in broken, disturbed reflections. These constantly changing planes partially reflect the sky and other objects above the water surface, as previously discussed. Disturbed water will also respond to other factors, often bouncing light back from the river bed below, creating further nuances of tone, shape and colour for your consideration.

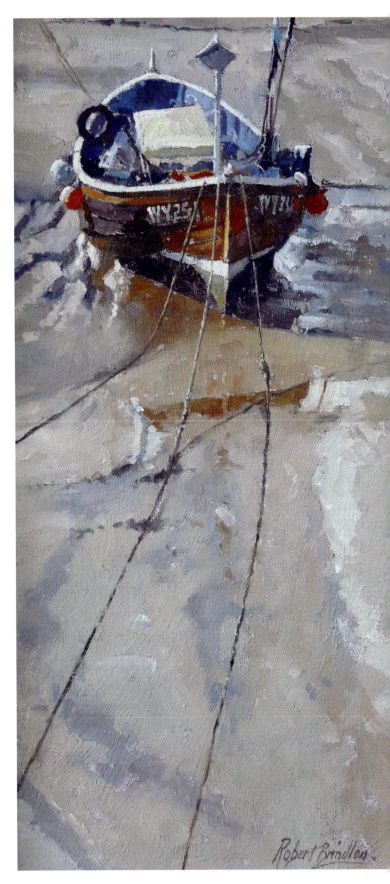

High and Dry/Staithes, 20 × 40cm (8 × 16in).

89

The Weir/River Esk/Ruswarp, 30 × 25cm (12 × 10in).

The Bridge at Starbotton, 30 × 25cm (12 × 10in).

Sparkling Light/San Giorgio/Venice, 50 × 40cm (20 × 16in).

The gently moving surface of the water in the painting *The River Esk at Glaisdale* reflects the tree trunks and river banks and also reveals colour and tonal change reflected up from the river bed.

A final cautionary word regarding the confusion between reflections and cast shadows: many painters believe that they are painting reflections in their work when in fact they have been painting a cast shadow. In some instances, depending on the direction of the light source, a shadow can be completely coincidental with a reflection or, more likely than not, cutting across a section of the reflection. Where the two coincide you will notice a darkening of the tone and often a loss of transparency. The greatest problem is encountered where a shadow cuts across part of the reflection resulting in three different areas for you to resolve: one for the reflection, one for the shadow and, finally, the area where the two elements coincide. In each of these areas there are likely to be changes in tone, colour and transparency that should be observed and interpreted accurately.

Never be daunted by the prospect of painting moving water; look upon it as an exciting challenge, which, if captured convincingly, will enhance your piece of work.

The River Esk at Glaisdale, 30 × 30cm (12 × 12in).

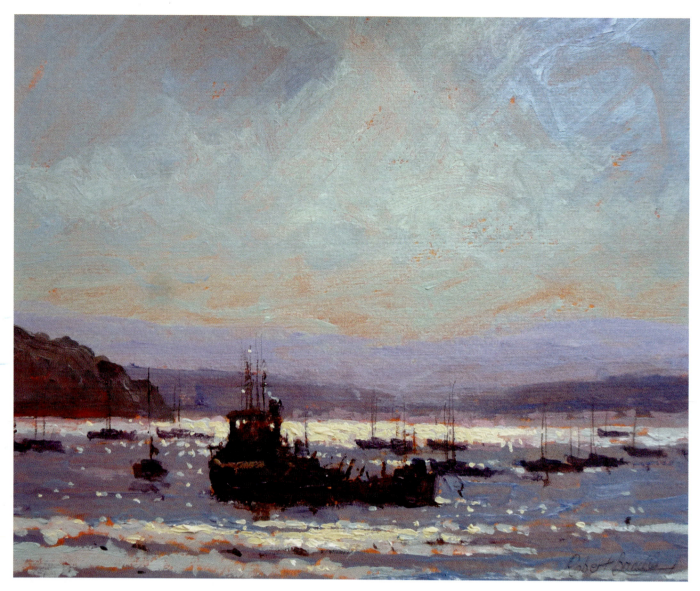

Evening Light/Barmouth, 20 × 15cm (8 × 6in).

Morning Light/Burnham Overy Staithe, 30 × 23cm (12 × 9in).

COASTAL LANDSCAPES

Evening Light/Barmouth hopefully captures the soft, warm light across the estuary just before sunset.

Coastal scenery offers the landscape painter a wide range of wonderful and challenging subject matter. In England alone the coastline is extremely diverse, from the relatively flat beaches and creeks of the South East to the wild, rocky coastlines and secluded beaches of Cornwall and Scotland. You will be able to paint large, elevated coastal vistas, deserted or bustling beach scenes, harbours and much more. The *plein air* study *Morning Light/Burnham Overy Staithe* was painted early on a September morning with soft breaking light.

British artists have always had an affinity with the coast and this is reflected in numerous works by noted painters throughout

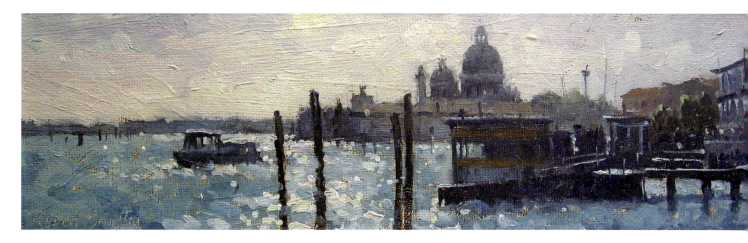

Vaporetto Stop/San Zaccaria/Venice, 30 × 10cm (12 × 4in).

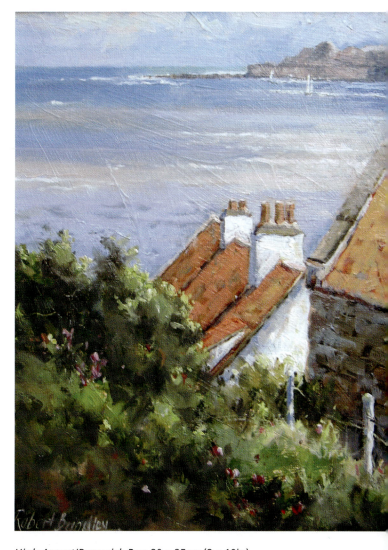

High Aspect/Runswick Bay, 20 × 25cm (8 × 10in).

our history. Turner, one of England's greatest ever watercolourists, featured the sea in many of his better-known works. Painters such as Edward Seago, Edward Wesson and more recently David Curtis and Trevor Chamberlain continue to paint coastal scenery of stunning quality.

Overseas travel will also provide you with a further exciting array of subject matter. When transient light effects, the time of day and different weather conditions are taken into account, the possibilities are endless. *Vaporetto Stop/San Zaccaria/Venice* is a rapidly executed *plein air* sketch aimed at capturing the sparkling water and transient light conditions. A small, heavily textured, tinted board was used for this subject. The texture and chosen colour worked perfectly for this particular painting. Some tidying up was undertaken back in the studio, but care was taken to ensure that any freshness and spontaneity were not lost.

The paintings included in the following discussions reflect many of the attributes described above. The inspiration for painting them, together with an analysis of the completed painting, will be discussed where applicable.

Coastal Scenes

High Aspect/Runswick Bay was painted on location in warm summer sunshine. The elevated position was adopted to incorporate the cottage rooftops to provide added interest and a lead-in to what could otherwise have been a fairly ordinary subject.

First Light/Morston Quay was undertaken on location for an instructional DVD on painting *plein air* oil sketches. The painting was executed fairly rapidly on a glorious, hazy September morning as the sun broke through the early mist. A limited palette of three primaries and white were used and it was painted on a textured, warm blue-grey ground.

Soft Afternoon Light/Thornham was painted *plein air*, in just under two hours, for the same DVD. However, the lighting conditions

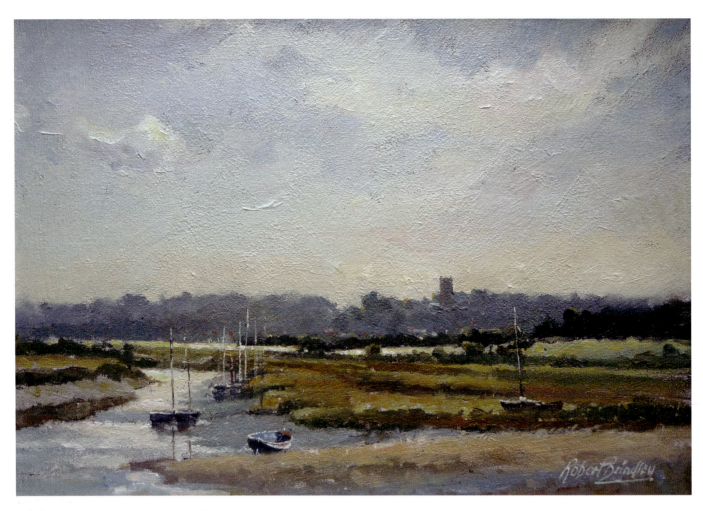

First Light/Morston Quay, 30 × 25cm (12 × 10in).

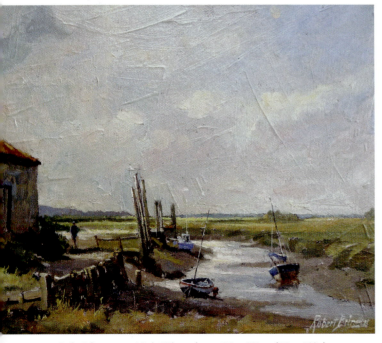

Soft Afternoon Light/Thornham, 30 × 25cm (12 × 10in).

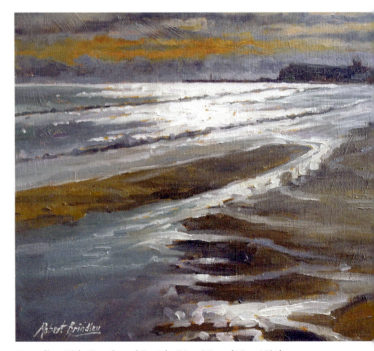

Receding Tide/Sandsend Beach, 30 × 25cm (12 × 10in).

RIGHT: *Sunset Over the Salute*, 20 × 15cm (8 × 6in).

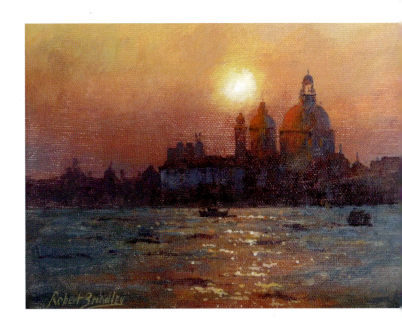

were far more stable throughout the painting process. As time was at a premium the boats and final details were added back in the studio from pencil sketches and photographic reference.

The small *plein air* study *Receding Tide/Sandsend Beach* was executed rapidly, in order to capture the sparkling light on the water before the sun moved round too far. Although fairly sketchy, the painting worked very well once a little tidying up was undertaken back in the studio. This additional work was carried out whilst the subject was still fresh in the mind. Once again, a limited palette was used.

The small Venetian sunset studies *Sunset Over the Salute* and *Sunset/San Giorgio* capture the warm, transient light across the waters of the lagoon. These were also painted with just three primary colours. Notice how the sparkling water has been painted using heavily applied impasto paint.

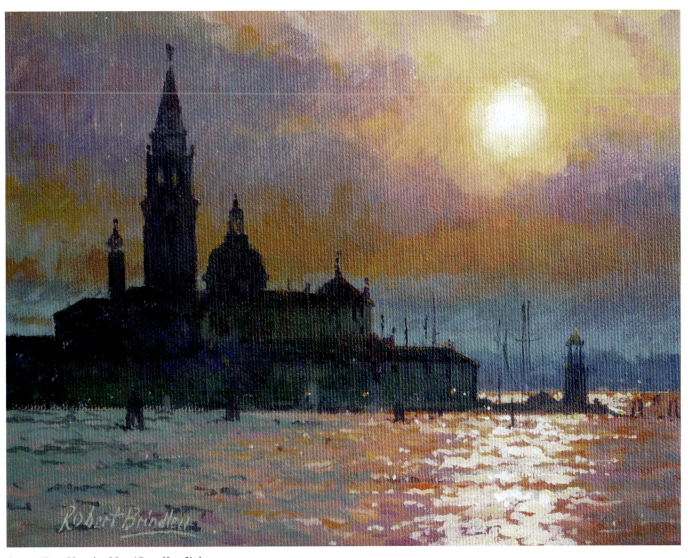

Sunset/San Giorgio, 20 × 15cm (8 × 6in).

DEMONSTRATION: *Winter Light/Sandsend*

This demonstration of soft winter light was painted from photographic reference and sketches taken on a cold January afternoon.

MATERIALS

Support
A 35 × 25cm (14 × 10in) textured MDF board, under-painted with a 'turpsy' wash of Ultramarine Blue and Permanent Bright Red.

Brushes
- Nos. 4, 6 and 8 Eclipse, Filbert brushes by Rosemary and Co.
- A no. 3 round sable or synthetic Rigger.

Colours

A limited palette of six colours and white.

For this demonstration a limited palette of six colours (a warm and a cool version of each primary) and alkyd white were used: Permanent Bright Red, Alizarin, Cadmium Yellow Lemon, Winsor Lemon, Ultramarine Blue, Phthalo Blue and alkyd Titanium White (to speed up drying time). Three greys were also mixed from the above primaries and white:
- Grey 1: A warm, light-toned grey.
- Grey 2: A cooler, light-toned grey.
- Grey 3: A dark neutral grey.

Additional Items
- Turpentine, or a low odour solvent or white spirit (for cleaning the brushes only)
- A 2B pencil.
- A palette knife.
- A copious supply of kitchen towel.

Step 1.

Step 1: Drawing Out
Use a 2B pencil or 'turpsy' oil paint and a small brush to draw a simple outline of the subject.

Step 2.

Step 2: Commencing the Block-In
By using the pre-mixed greys you will be able to block in some of the main dark and mid-toned dark masses in the distant landscape and foreground beach. Notice how a combination of warm and cool greys have been used.

Step 3: Developing the Block-In and Painting the Sea and Sky

Continue the block-in by switching your attention to the sea and sky. Notice how a similar, although wider range of warm and cool greys have been used here. Remember that, at this stage, an accurate rendering of colour and detail is not necessary, but it is essential that all tonal relationships are accurate.

It may prove to be beneficial for you to experiment with your colour mixes, as there are numerous ways to achieve the required colours from this limited palette. Try mixing the colours directly from the three primaries and white instead of using the pre-mixed greys. Remember that by adding too much white to your colours you run the risk of cooling the mix too much, or of making it appear chalky. If this occurs, carefully add a little more of the dominant primary to lift the colour.

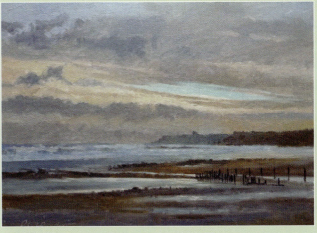

Step 4.

Step 4: Completing the Block-In and Adding Highlights and Details

Complete the block-in of the sky with the colours used for the previous steps. The sliver of blue sky was mixed using a combination of Phthalo Blue, a very small touch of Winsor Lemon and white. The timber groynes can be painted using a series of darks mixed from Ultramarine Blue, Permanent Bright Red, a very small touch of Cadmium Yellow Lemon and white. Once again, mix warm and cool versions of these darks.

Finally, the subtle highlights on the water can be added using thick impasto paint to increase the light effect. As usual, be careful to keep your brush marks loose and expressive and never get too carried away by adding too much detail.

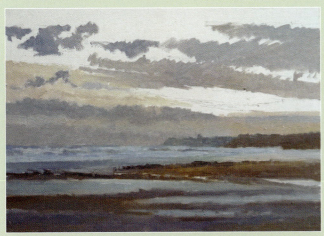

Step 3.

Take a little time for assessment. Never settle for any errors; if you feel something is not right, find the solution and make the necessary changes.

Beach Scenes

Beaches have always provided artists with a rich source of subject matter. Many people have an attraction to water, sometimes having a strong association with times gone by – maybe childhood memories of playing in rock pools and making sandcastles or, for parents, the memory of their own children at play.

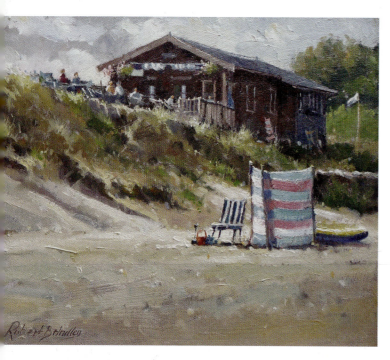

Gone for Lunch/Sandsend Beach, 30 × 25cm (12 × 10in).

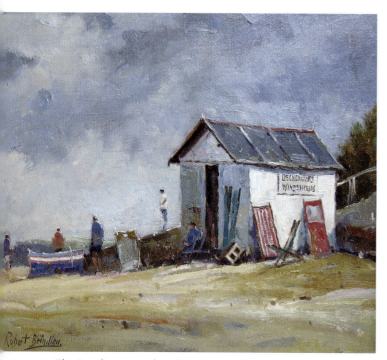

The Beach Hut/Sandsend, 30 × 25cm (12 × 10in).

Beach scenes offer the landscape painter the opportunity to observe and paint the human figure at leisure. Bustling summer beaches with colourful beach huts, deckchairs, windbreaks and children playing with buckets and spades can provide wonderful source material. Equally, the lone figure walking their dog on an otherwise empty beach can make a good subject.

Gone For Lunch/Sandsend Beach depicts an early summer's day around noon. The family who had been enjoying the beach and the shelter of their windbreak had just gone to the café for lunch. Windbreaks make wonderful subjects, especially when viewed into the light.

The Beach Hut/Sandsend was a favourite subject of mine, painted on numerous occasions until the huts disappeared just a few years ago. Huts such as these can be found in many locations around the coast and make wonderful subject matter. When painting a subject such as this it may be worth considering several different viewpoints to determine the best composition. One or two simple tonal pencil sketches could prove beneficial. A warm blue-grey textured board was used for this painting, complementing the warmth of the sand.

Harbours and Boats

HARBOURS

Smoke and Light/Whitby Harbour was painted from sketches and photographic reference and features Whitby Harbour and the swing bridge, from an elevated viewpoint above the town. This wonderfully atmospheric subject was painted from a limited palette of three colours and white mixed to produce a series of almost colourless greys. The colours used were Ultramarine Blue, Permanent Bright Red, Cadmium Yellow Lemon and Titanium White.

For any landscape painter wishing to add a little variety to their repertoire, harbours offer a wealth of interesting and challenging subject matter. Whether it is a small, quiet harbour, such as those found around the coast of Devon and Cornwall, or a major port such as Southampton, Portsmouth or Liverpool, you will be sure to find an inspiring subject to paint. To add even more variety and colour to your work you may consider painting harbour scenes whilst on holiday outside the UK.

The painting *Evening Light/Whitby Harbour* is a favourite subject of mine and has been painted on many occasions, from a variety of viewpoints and in different lighting conditions. When painting harbour scenes such as this your viewpoint is extremely important and your selection of the best one may be vital to the success of the painting. With this in mind, never start to paint from where you first became interested in the subject; consider what the subject might look like from a variety of different angles. For instance, it may look better when viewed from the water level or from a more elevated situation. Often moving only a few feet to the left or right, up or down can make an enormous difference. The light

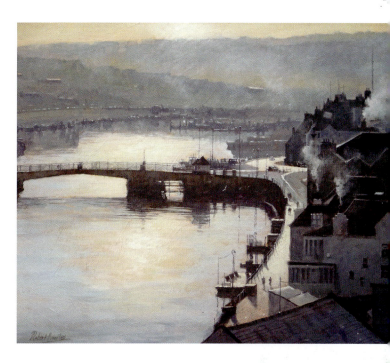

that illuminates the subject is an important factor, too; once again by adjusting your location, sometimes only slightly, you may be able to view the subject in more exciting light.

The shapes created by the Whitby swing bridge and harbour wall can be viewed from many vantage points, and there are always different boats moored below the harbour wall. When the time of the day and ever-changing light conditions are also taken into consideration, the possibilities are endless.

The studio watercolour painting *Hazy Light/Whitby Harbour* shows late afternoon light filtering through a smoky haze and was painted from the small *plein air* study *The Swing Bridge/ Whitby*. This illustrates one of the many benefits of painting in several different media, where one piece can be painted from the other.

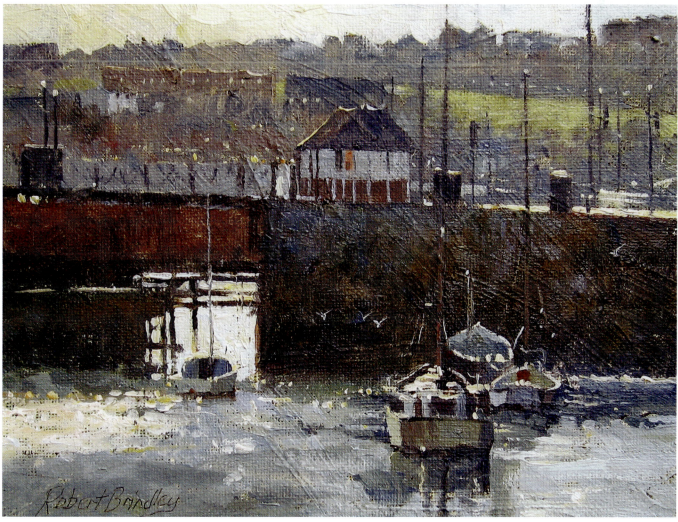

Evening Light/Whitby Harbour, 20 × 15cm (8 × 6in).

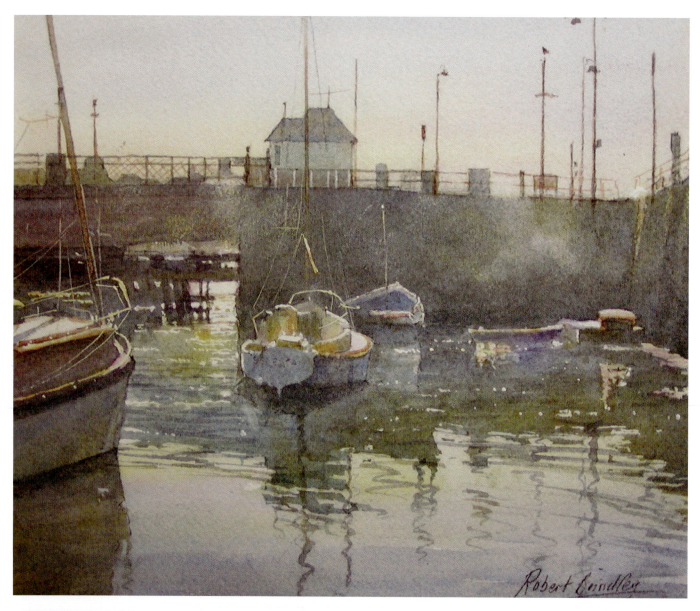

ABOVE: *Hazy Light/Whitby Harbour*, 30 × 25cm (12 × 10in).

LEFT: *The Swing Bridge/Whitby*, 30 × 25cm (12 × 10in).

BOATS

Sunset/Stavoren/Holland was painted on a painting trip with a group of friends. The barges create a wonderful silhouette against the setting sun. The harbour, with its variety of different crafts, masts and rigging provided everyone with a vast number of possible subjects. Boats will give an added dimension to any coastal landscape or harbour scene. The variety and choice for the painter is enormous, from small fishing boats and leisure craft through to larger ships and naval vessels.

It is always advantageous to have a little knowledge regarding any subject that you paint. Before you begin to include a fairly large boat in your paintings, familiarize yourself with its

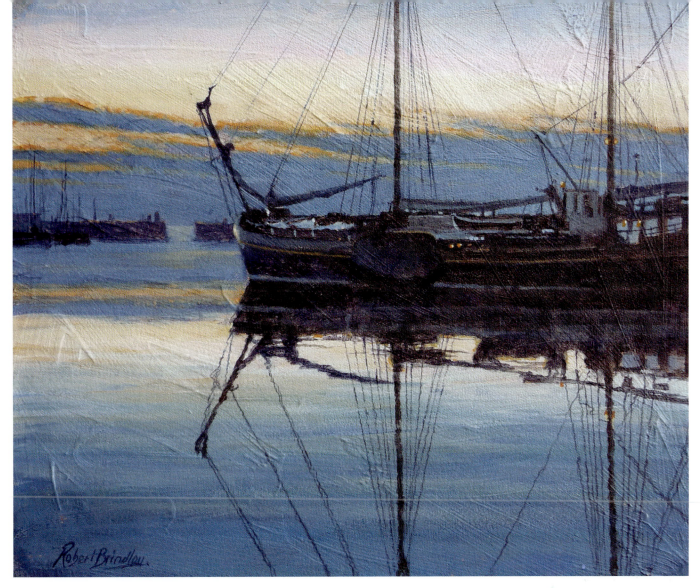

Sunset/Stavoren/Holland, 30 × 25cm (12 × 10in).

basic shape, how it was made and its purpose. It may also help to recognize the essential parts of the boat so that you are able to decide how you could simplify detail without compromising integrity. *Quiet Moorings/Workum/Holland* was painted from sketches undertaken on the painting trip to Holland.

As a painter, your aim should be to capture the essence and character of the craft. Many basic drawing and painting books encourage the beginner to draw and paint simplified boat shapes, often using a figure of eight as a springboard. This can be extremely useful for practising your boat-drawing skills. However, you should be aware that these 'stock' boats exist only in your imagination. It is therefore important not to include stock boats in your paintings, as these formulaic renderings will never satisfy the criteria necessary for capturing any of the craft you will encounter on your painting trips. Over a period of time, try to observe and paint a variety of boats on location to develop the skills needed to capture their essential character.

Finally, bear in mind the times of the tides when painting coastal or harbour scenes, as a rapidly changing tide can be disastrous for the *plein air* painter: always do a little research

before venturing out. Never start a large piece of work unless you have fairly constant tide conditions under which to work. It is extremely frustrating when boats are afloat one minute and high and dry a short time later.

Sparkling Light/Staithes Beck shows two Whitby cobles moored at low tide. It was undertaken around midday from an elevated location, with bright sun glancing off the wet mud in the beck. It was a joy to paint. The elevated viewpoint and dazzling light ensured that the subject had both excitement and impact.

The Moorings/Staithes again shows a Whitby coble moored at low tide, although this time the study was undertaken from a slightly lower elevation and with strong side lighting. Notice how lively brushwork has been used in the foreground to give the impression of a rough, stony stream bed without including too much detail. The only detail used was on the coble itself, which hopefully ensures that the viewer's eye is drawn straight to the focal point.

Wreck/King's Lynn Harbour features two derelict boats in the landscape. The textures and shapes of the two vessels made this subject immediately attractive.

Quiet Moorings/Workum/Holland, 30 × 40cm (12 × 16in).

ABOVE:
Sparkling Light/Staithes Beck, 25 × 30cm (10 × 12in).

TOP RIGHT:
The Moorings/Staithes, 20 × 25cm (8 × 10in).

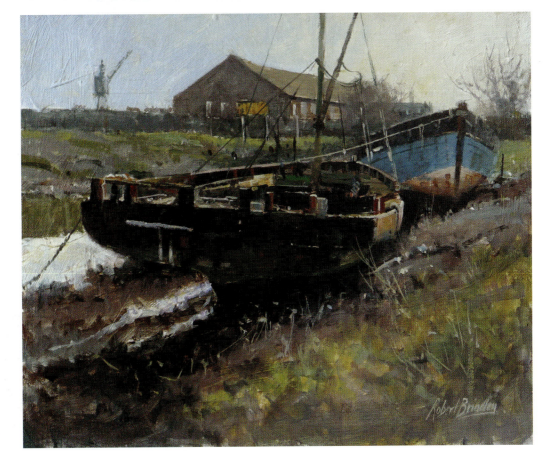

RIGHT:
Wreck/King's Lynn Harbour, 30 × 25cm (12 × 10in).

IN THE SPOTLIGHT

Towards Whitby 2, 25 × 20cm (10 × 8in).

The small *plein air* sketch *Towards Whitby 2* was painted from a favourite elevated location on a fine mid-summer's day. There was a brisk breeze that whipped up the sunlit breaking waves into a white foam. A heavily textured board, under-painted with a cool 'turpsy' wash of Ultramarine Blue and Permanent Bright Red was used.

Evaluation

This sketch was slightly disappointing compared to some of the past works carried out from exactly the same spot. It is always difficult to analyze exactly why one painting disappoints when

compared with another. However, for the purposes of this review a comparison will be made using a much earlier piece of work (see *Towards Whitby 1*). This earlier work was painted on a warm ground of Burnt Sienna.

Composition

When painting from this location, the success or otherwise of the composition depends largely on the state of the tide in conjunction with the prevailing light. At high tide, when the strip of beach is not visible, there is always a danger that the painting will be split into two distinct halves: the distant view towards

RIGHT:
Towards Whitby 1,
25 × 20cm (10 × 8in).

Whitby and the foreground field. This is certainly true in the more recent painting where the extremely white mass of breaking waves exacerbate the problem.

In the much earlier painting the strip of beach in conjunction with just a few breaking waves seem to act as a 'stopper', preventing the eye from leaving the painting and at the same time redirecting it into the distant landscape.

The earlier piece of work was probably painted in a sharper light, which resulted in the use of one or two more accent darks (under the group of trees in the centre, along the distant cliff and beach and in the abbey itself). These darks were not planned at the time, but they do assist the composition by drawing the eye to the focal point. The introduction of a broken fence, in conjunction with looser and more expressive foreground brushwork, also creates greater depth in the painting.

Tone and Colour

On balance, the use of tone and colour in both paintings works well; of course, the earlier work carries far more excitement due to the richness of colour and more expressive brushwork. It must be remembered, however, that the two paintings were painted on very different days in different light conditions. The more recent painting, painted in a cooler, more atmospheric light, has narrower tones and less colour, whilst the earlier work, painted in sharper and warmer light, has a wider tonal and colour range.

Conclusions

Without doubt, the earlier painting works better with regard to composition and has more immediate impact due to the use of more expressive brushwork and stronger colour. However, it would be wrong to get too carried away with regard to the immediate impact of any particular painting. Always look for other qualities in every painting you complete; it may be that, due to lighting or weather conditions, a painting with less visual impact will have other equally important attributes concerning the use of tone, colour or texture.

The important things to glean from any evaluation are to identify possible weaknesses in the composition and to be aware of the temperature of the light. In this instance, one painting was painted in warm light on a warm ground and the other in a cooler light on a cool ground.

Finally, paint what you see in front of you, and never be led by an earlier painting that may have had more impact or was popular with your buyers. An artist should always respond to the subject in front of them and not to the possibility of pleasing the masses.

Summer/Lealholm, 25 × 30cm (10 × 12in).

RURAL LANDSCAPES

Summer/Lealholm was undertaken in the early summer, on a warm afternoon. This typically English cameo scene has all the essential elements of a successful landscape painting: a wide variety of greens in the foliage; warm, subtle reflections in the water; and figures enjoying the tranquil location.

THE SEASONS

The seasons provide the landscape painter with the stimulus of a vast array of ever-changing subject matter. Many artists would soon become bored, losing enthusiasm and inspiration, if they were faced with subject matter that only ever changed due to light changes and weather conditions. Fortunately the weather, in conjunction with the changing seasons, ensures that landscape painters are supplied with an endless source of inspirational subject matter.

As a painter you will be able to benefit from seasonal changes in numerous ways. These days many artists venture far and wide in search of new subject matter, both in this country and abroad. Others, however, may prefer to paint only from their immediate area, relying on a wealth of local knowledge and familiar views. Whether your source material is gathered locally or from further afield it is probably true to say that, over a period of time, you are drawn constantly to a small selection of favourite subjects and locations. You may have painted one of these particular favourites on many occasions, using composition, viewpoint, colour, lighting and the weather to pro-

duce a variety of engaging and creative paintings from what is basically the same material. By painting this subject matter throughout the seasonal changes, the possibilities become almost infinite.

Winter

Snowy Track/Sleights was undertaken as a demonstration on how to paint snow. It was painted on a heavily textured board that was treated with a purple-tinted ground mixed from Ultramarine Blue and Permanent Bright Red. The coloured ground and textured board assisted a rapid execution of the painting; time was not taken up by having to cover all of a stark white background and artificial brush marks were provided by the texture-pasted board. The coloured ground shows through in many places, having a unifying effect on the painting.

Snowy Track/Sleights, 40 × 30cm (16 × 12in).

I prefer winter and fall, when you feel the bone structure of the landscape – the loneliness of it, the dead feeling of winter. Something waits beneath it, the whole story doesn't show.

Andrew Wyeth

The Hermitage near Ugthorpe, 35 × 25cm (14 × 10in).

Evening Light/Egton, 30 × 25cm (12 × 10in).

It has been said that it is almost impossible for an artist to paint a convincing winter scene without having his feet in the snow. There is a certain amount of truth in this statement and there is no doubt that all landscape painters would reap the benefits from the experience of painting outdoors during the winter months. However, many artists, for a variety of reasons, never paint outdoors at this time of year. Time is a major factor these days, being a precious commodity. For others, the thought of painting in temperatures below zero and strong winds is just not a consideration. If you do not have sufficient time, or are unable to work in harsh conditions, the sketchbook and camera are an invaluable source of reference for painting the winter landscape. Being on site, even for just a short period of time, to experience the cold, wind and prevailing conditions will be of enormous benefit when painting the scene at a later date.

Winter gives the artist the opportunity to observe the landscape in its most basic and often most dramatic form. The covering of foliage falls from trees and hedgerows and the long, lush grass and crops disappear from the fields, revealing the bare bones of the landscape. Artists who paint the human figure or animals often study anatomy in an attempt to understand the structure that underlies the observed form. The landscape painter can learn just as much from observing and painting winter scenes. Trees are the perfect example, as each species has its own character and much will be learnt by taking time to observe, draw, sketch or paint winter trees.

Winter also reveals its own range of quiet, subtle colour. The purer, more strident colours of summer, followed by autumn, become a thing of the past and soft grey-purples, grey-blues and grey-browns dominate the scene. It is at this time of year when the use of a limited palette with its pre-mixed greys comes into its own.

Each day has its own individuality of colour.

Charles Hawthorne

The Hermitage near Ugthorpe was created on a fine, cold November afternoon. This particular subject has become a firm favourite and has been painted on regular occasions from slightly different viewpoints and throughout the different seasons. The composition is excellent, having a strong focal point centring on the farm house and the cluster of trees. A subtle lead-in is provided by the diagonals from the bottom corners. On this occasion the added attraction was the wonderful winter light in conjunction with the wide range of subtle greys present throughout the subject. A board tinted with a warm ground of Raw Sienna and Burnt Sienna was used.

The presence of snow in the winter landscape offers the painter an additional dimension. A blanket of snow simplifies a scene even further by reducing many of the details, often revealing features such as trees, walls, hedges, fence lines, buildings and so on more dramatically.

The small *plein air* oil *Snowy Evening/Egton* illustrates perfectly how the basic structure of walls, fence lines, trees and buildings stand out with a greater impact in a snow scene. Once again, subtle warm greys were observed throughout the entire painting, creating overall harmony. Painting snow scenes will be discussed in greater depth later in this chapter.

Spring

Spring/Stokesley is typical of this season of renewal and the promise of the warmer days to come. Buds begin to burst on the lower branches of the trees, daffodils flower almost everywhere and the tired, winter grass is replaced by brighter, fresher greens.

The gradual approach of spring is first noticed by the lengthening days and the appearance of flowers in gardens and hedgerows. As the days begin to warm up the warm greys of the trees and hedgerows are gradually replaced by a delicate haze of soft yellows and greens. By the middle of May these greens become stronger, presenting many problems for the inexperienced painter. Greens, and in particular how to paint them, will be covered in the following section.

During the last twenty or thirty years oil seed rape has become a familiar sight in the English countryside. In some instances where it has been sown in huge fields, its presence can be overwhelming. Where it is found in smaller fields, however, or glimpsed through gateways or the gaps between trees, it can provide striking subject matter. The small *plein air* painting *Oil Seed Rape/Cross Butts Farm* illustrates how such a field can be incorporated into a successful piece of work.

For the landscape painter spring can be the most exciting and inspiring season of all. However, there are a few words of caution needed for the less experienced painter. Dramatic changes are witnessed in the spring; the saturation of new colour and rapid growth of everything in sight can be overwhelming and it is vitally important to take a step back and consider adopting a few new tactics to deal with these changes. It is extremely easy to become blinded by the sheer abundance of subject matter at this time of the year, so it pays to be a little more critical and selective regarding your selection. Be patient and give more time and consideration to everything in front of you.

When you do eventually decide on exactly what you want to paint, remain focussed on your original theme and do not let strong colour and activity distract you, especially when rendering the outer edges of your painting. A viewfinder is an extremely useful tool to help you isolate focal points in your paintings. Keep using the viewfinder throughout the entire execution of the painting to refresh your mind regarding the focal point and to assist you in isolating areas of distraction.

When you are trying to capture the fresh colours of spring you will find that your reliance on the pre-mixed greys, that proved so useful during the winter months, is no longer so helpful.

The panoramic painting *Spring/Green End* was undertaken from sketches and photographic reference and illustrates the fresh, delicate green foliage of mid-spring. Note the foreground, moorland grass that retains its straw-like winter colour – a sure sign that the days have not yet been quite warm enough to stimulate the new growth to come.

Spring/Stokesley, 40 × 30cm (16 × 12in).

Oil Seed Rape/Cross Butts Farm, 20 × 25cm (8 × 10in).

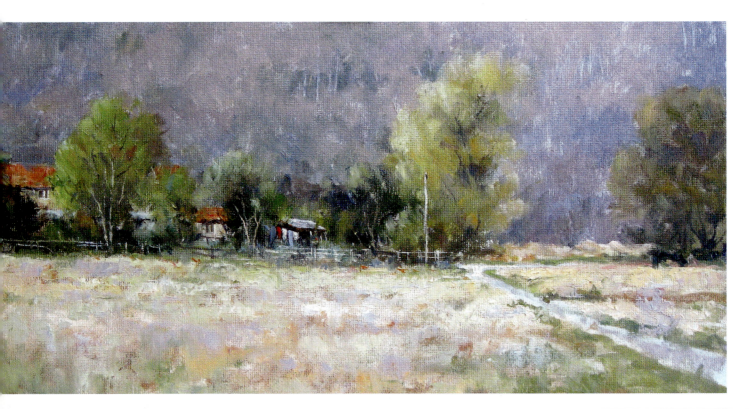

Spring/Green End, 40 × 20cm (16 × 8in).

Summer

The *plein air* oil study *The Bee Hive* was painted in the garden on a glorious mid-summer's afternoon. Notice how the deep foreground grass has turned to a rich straw colour caused by several weeks without rain. The Lavatera bush in the foreground provides a wonderful splash of colour.

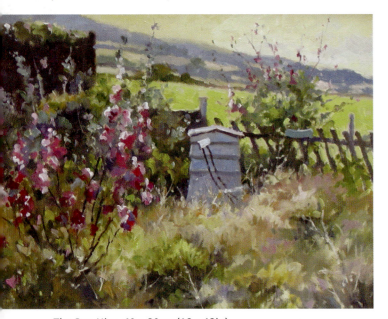

The Bee Hive, 40 × 30cm (16 × 12in).

Summer is a paradise for any landscape painter, with an abundance of colour wherever you look. The summer months offer the keen *plein air* painter plenty of opportunity to exercise their skills. Even far less adventurous painters can be found beavering away on the best days the summer has to offer. There is surely no better way of spending time than to sit painting on the edge of a wood or cornfield where you are at one with nature. This scene sounds wonderful, and of course it is, although for the beginner and less experienced painter the word 'summer' immediately conjures up the dreaded word *green*.

DEALING WITH GREENS

Summer landscapes, especially in the UK, contain a plethora of greens, the identification and mixing of which have always presented problems for painters, especially for beginners and those with little experience.

For any landscape painter prepared to look carefully at the scene in front of them, there will always be countless different greens present. By learning to take your time to look closely at the subject you will notice areas that, whilst appearing initially to be entirely green, will actually contain many other colours. Consider a hedgerow, for example: the age and relative position of the leaves combined with the prevailing light conditions produce a variety of different colours. The success of any landscape painting relies on the artist's ability to identify, isolate and render

this variety of colour in the subject. It is equally important for you to develop a discipline that avoids the use of stereotypical colour – green for grass or blue for sky, for instance. One of the fundamental problems encountered by the artist when painting greens is that what we see in nature is light reflected off a surface. It shares a relationship not only with its surroundings but also with the bias of the light source.

If you have a problem with mixing and using greens it may be helpful to begin with the colour wheel. By studying the relationships of individual colours and how they interact with each other you will develop a better understanding of why certain colours work when placed together. This is a powerful tool in choosing what to place in a painting. As previously discussed, colour is made up of three primaries (red, yellow and blue) from which all the other colours are derived. They share no relationship until mixed. When mixed they create secondary colours: orange, violet and green. Any combination of these secondary colours can be used to create a natural harmony.

Certain colours work better in relationship to others, so everything is affected conversely, according to what is next to it. For example, an object may appear lighter when placed against a dark background and warmer when placed against a cool background (*see* Chapter 2). This is very useful when using greens and goes some way to explaining why one green pigment can never be perfect for all situations. An understanding of these colour relationships is invaluable when planning your paintings.

It may be useful to try this exercise: using a limited palette of three primaries (Cadmium Red Light, Cadmium Yellow Lemon and Ultramarine Blue can be used although there are numerous alternatives), mix a selection of greens, oranges and violets. Using these mixes make a number of random marks on a prepared oil board. As the surface becomes covered, it will become apparent where the green choices seem to be working and where they are not. You will notice that some of the colours used work better than others. By studying these relationships you will begin to appreciate the importance of using different oranges and/or violets against certain greens.

In addition to gaining an understanding of colour relationships you will need to pay particular attention and be more sensitive to the variety of subtle colour temperatures within different green mixes. The two components of a series of basic greens are blue and yellow, which have a cool-versus-warm relationship. By considering the use of red, a further series of options will become apparent. Remember that warm sunlit areas tend to be warmer than the passages of shadow within the same scene.

One final, essential observation with regard to the success or failure of greens in landscape painting is the importance of interpreting the correct relationship of tone to colour. As emphasized on many occasions within the pages of this book, 'tone is king'

and its relationship with colour must always be rendered accurately. Remember that if a particular colour does not seem to work the solution may lie in its value, not its hue.

It may be beneficial to paint a green picture, putting everything you have learned into practice. Experiment with a number of green, orange and violet mixes, looking for the most successful combinations.

The Bridge/Madison County was painted from photographic reference. When this subject was first considered there appeared to be an overwhelming number of very similar greens. However, by taking a little time to look more carefully it became clear that there were in fact many subtle varieties of green, both cool and warm and light and dark. Even more noticeable was the presence of yellows, oranges and violets. Notice how the foliage has been painted very simply. Subtle colour and tonal shifts, with no hard edges at all, have been used for the majority of the area. Form has been accentuated here and there with a combination of lighter tonal masses and the occasional more defined edge, giving the impression of individually lit leaves.

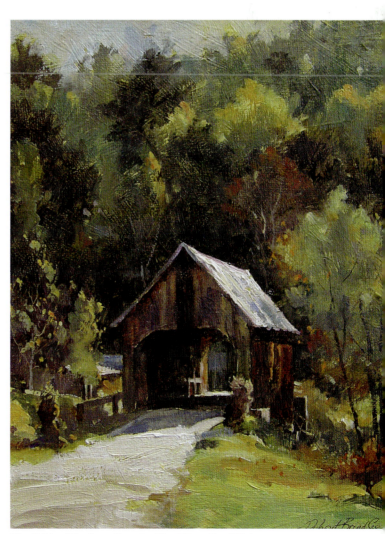

The Bridge/Madison County, 20 × 25cm (8 × 10in).

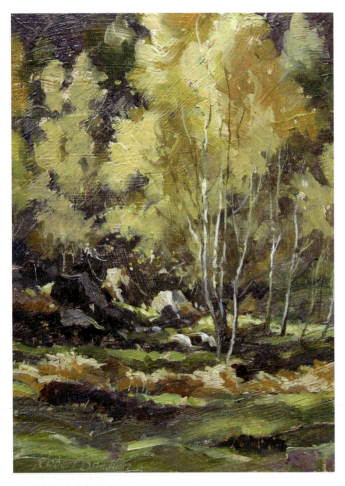

Autumn/Mulgrave Woods, 15 × 20cm (6 × 8in).

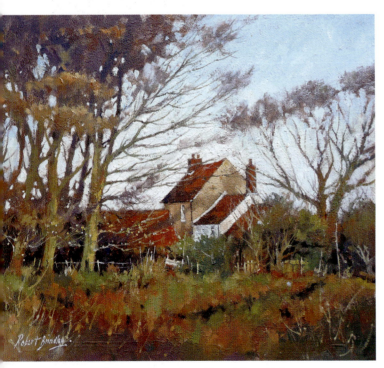

Autumn/The Hermitage, 33 × 30cm (13 × 12in).

Autumn

The small *plein air* painting *Autumn/Mulgrave Woods* was undertake on a fine autumn afternoon. The small scale and simplicity of the subject matter made it possible to use rapidly applied, loose brush marks to capture the scene in just under an hour.

Every season has its appeal: winter is calm and introspective; spring promises renewal and summer bursts with energy. Autumn is known not only for its colour but also the wonderful, misty, atmospheric mornings and evenings that never fail to inspire the landscape painter.

The gradual transition from greens to warm yellows, oranges and reds, never seems to disappoint. The juxtaposition of cool and warm colour present in many autumn scenes can occasionally give them an artificial look, however, especially when the colours border on garish. Many landscape painters, who may have no difficulty in painting winter, spring and summer scenes, often struggle to make a vibrant autumn scene look realistic. If you have a problem with painting convincing autumn scenes try choosing a dominant colour temperature for your painting. A painting, in general terms, should avoid the use of opposing colour groups, so the colours you choose should be biased towards a dominant colour temperature as a means of unifying the whole.

You might, for example, choose a warm colour temperature and then tone down the intensity of any blue sky, green grasses and so on to ensure a better unity with any bright, intense warm tones that dominate the painting. The action of toning down or greying the cooler tones makes them naturally warmer, thereby allowing the warm passages to dominate your painting. *Autumn/The Hermitage* illustrates this point perfectly. A cooler colour temperature would have affected the intensity of the autumn foliage, making it slightly greyed and better unified against the intense, cool sky and grasses. By choosing one dominant colour temperature, of the highest chromatic intensity, a painting that has even the most exciting colour variations (such as yellow, red and orange adjacent to blue and green) will harmonize.

DEMONSTRATION: *Autumn Frost*

This painting was undertaken from photographic reference of a hazy autumn day with an early frost. Notice how the colours are far more muted in the hazy distance and also where the frost still lies. In the immediate foreground and sunlit patches the autumn colours are very vibrant.

Step 1.

Step 1: Drawing Out and Commencing the Block-In

Use a 2B pencil to draw a simple outline of the subject. Under-paint a simple version of the subject using 'turpsy' washes of Ultramarine Blue, Permanent Bright Red and Cadmium Yellow Lemon.

MATERIALS

Support
A 40 × 30cm (16 × 12in) MDF board treated with one coat of texture paste and one coat of white acrylic primer.

Brushes
- Nos. 4, 6 and 8 Eclipse, Filbert brushes by Rosemary and Co.
- A no. 3 round sable or synthetic Rigger.

Colours
Once again a limited palette of six colours (a warm and a cool version of each primary) and alkyd white were used: Permanent Bright Red, Alizarin, Cadmium Yellow Lemon, Winsor Lemon, Ultramarine Blue, Cerulean and 'Griffin' alkyd Titanium White, which helps to speed up the drying time. Three greys were also mixed from the above primaries and white:
- Grey 1: A warm, light-toned grey.
- Grey 2: A cooler, light-toned grey.
- Grey 3: A mid-toned grey-green.

Additional Items
- Turpentine, or a low odour solvent or white spirit (for cleaning the brushes only).
- A 2B pencil.
- A palette knife.
- A copious supply of kitchen towel.

Step 2.

Step 2: Continuing the Block-In

Using the pre-mixed warm and cool greys, begin to block-in some of the distant tree and field masses. To ensure recession, take particular care to keep these distant colours cooler and greyer than the colours you intend to use further forward (*see* Detail 1).

DEMONSTRATION: *Autumn Frost* (continued)

Step 3.

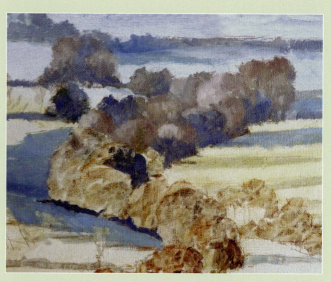

Detail 1: showing cool, grey colours.

Step 3: Developing the Block-In

Continue blocking in the trees in the middle-distance using slightly warmer and darker colours. The mixes used in Step 2 can be darkened by using the dark pre-mixed grey and may be intensified if necessary by adding the primary colours. At this distance, the colours used should still be slightly muted; reserve the strongest, purest colours for the immediate foreground.

Look carefully at the cast shadows to pick up the many subtle colour changes. You will be able to see several grey-greens, blue-greens and purple-greens. These colour changes, although subtle, will add variety. At this stage it is important not to be too concerned with detail. It is however, essential that your tonal relationships are accurate.

As usual, experiment with your mixes as there are numerous ways to achieve the required colours from a limited palette. Always be aware that by adding too much white to your colours you run the risk of cooling the mix too much, or of making the mix appear chalky.

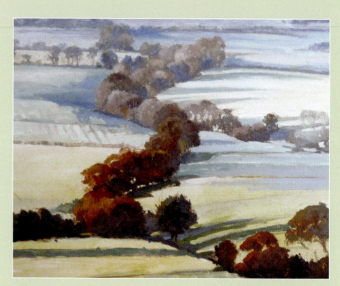

Step 4.

Step 4: Block-In the Foreground Trees and Hedgerows

At this stage, concentrate on painting the foreground trees. The mixes from the previous steps can be adjusted by using the primary colours. Be careful not to use too much red in the nearest autumn foliage; you will be able to neutralize red fairly easily by adding a touch of the pre-mixed grey-green, or small amounts of the blue and yellow primary colours.

Step 5: Complete the Block-In, Foreground and Details

Bring the painting to its conclusion by painting the sunlit fields. Once again, look for differences in tone and colour by comparing the distant fields with the foreground ones. Convincing sunlit greens can be achieved by experimenting with yellows, blues and white. To warm any of these mixes slightly add a touch of Permanent Bright Red. The cool cast shadows can be achieved in numerous ways. Experiment by mixing them from the primary colours and also from the pre-mixed greys.

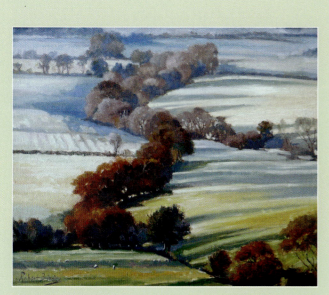

Step 5.

Notice how warm and cool colour combinations have been used throughout the painting. In order to create more recession, bold, confident brush marks in conjunction with thicker paint should be used in the foreground.

Detail can now be added to the trees, bushes, fence posts and so on. Take care not to distract any future viewer by over-detailing near the edges of the painting.

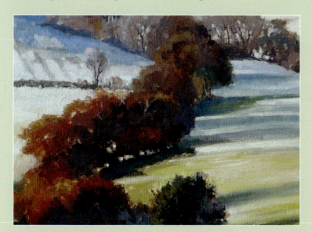

Detail 2: showing thickly applied impasto paint.

You can now paint the final highlights on the fields and the smaller ones that punctuate the trees forming 'sky holes' and gaps between the tree trunks (see Detail 2). These smaller highlights can be applied with the Rigger using impasto paint to enhance the light effect.

As usual, before cleaning your palette, take a little time for assessment and make any necessary changes.

PAINTING SNOW SCENES

The small painting *Snow/Mulgrave Woods* uses warm and cool colour combinations to produce a harmonious snow scene. Notice how the foreground snow has been handled by the use of confident impasto brush marks.

Snow covers the landscape in a variety of different ways. A light snowfall or a thaw results in very patchy covering. A steady snowfall that blankets all may seem to give an even covering, or a snowfall that is accompanied with wind will result in a landscape that is bare and exposed in places but with deep drifts elsewhere.

Snow/Lastingham shows patchy areas of snow after a slow thaw. The snow remains only in low-lying areas and along the hedgerows. *Snow on the Moors* was painted after a heavy fall accompanied by strong winds, resulting in a combination of bare patches and deep drifts. The snow plough had been busy leaving snow six to eight feet deep in places at the sides of the road.

The presence of snow gives an otherwise familiar landscape a completely different appearance, offering the landscape painter the opportunity to design their painting, contrasting light areas creatively against the structural elements in the composition such as trees, telegraph poles, buildings, walls and hedgerows. Certain more prominent landmarks and features such as these can occasionally be completely obliterated, whilst other previously unnoticed secondary features, such as field boundary fences and walls or certain trees and buildings, can be revealed, often standing out in stark contrast to the snowfield.

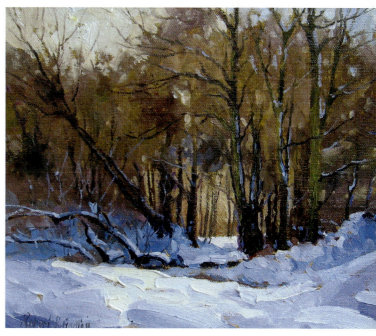

Snow/Mulgrave Woods, 25 x 20cm (10 x 8in).

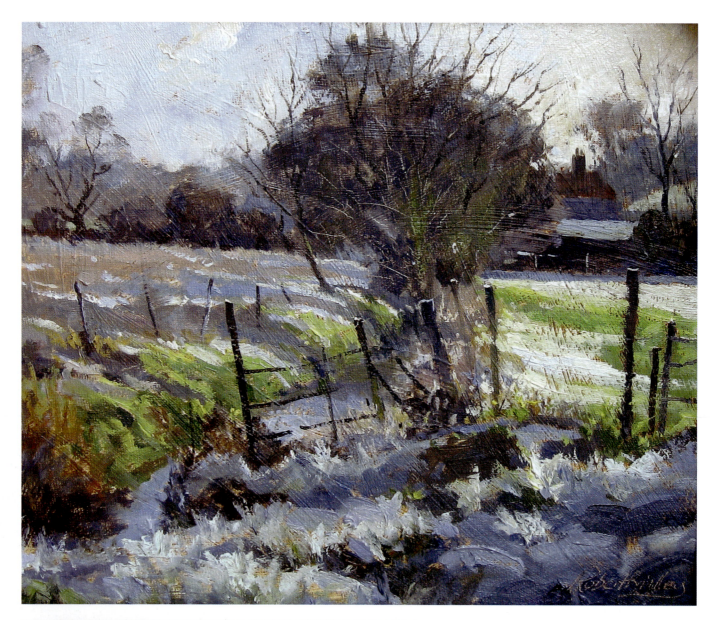

ABOVE: *Snow/Lastingham*, 30 × 25cm (12 × 10in).

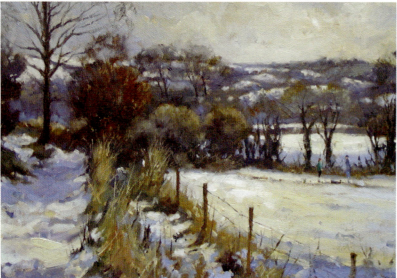

LEFT: *Snow/Sleights Bottoms,* 40 × 30cm (16 × 12in).

Snow/Sleights Bottoms illustrates the above points extremely well. Notice how the fence line and winter trees stand out in stark contrast to the areas of snow. The snow blanket simplifies the contours and details that would have been observed in the fields and the track on the left.

Generally, a covering of snow simplifies many of the features in a landscape; grasses, bushes, tracks, roads and other low-lying features often disappear altogether, giving the painter the opportunity to observe and capture the beauty of simple form. This can also be extremely beneficial to the artist by smoothing out awkward undulations and features that, in normal conditions, may have made a particular scene almost impossible to paint.

The Colour of Snow

Never paint the greatest mass of the snow field too light, as it will never be pure white. The colour and tone of the snow will always be determined by the light cast and reflected on it from the prevailing light and weather conditions. See *January Snow/Whitby* where the warm and cool greys evident in the sky are echoed in the foreground snow.

A warm evening or early morning sky will be echoed in the colour of the snow, where the presence of yellows and soft pinks will be in evidence. The studio painting *Snow/North Yorkshire Moors* was painted from the *plein air* sketch illustrated in Chapter 9 and shows how the warm greys and yellows present in the sky have also been used in the sunlit snow of the foreground.

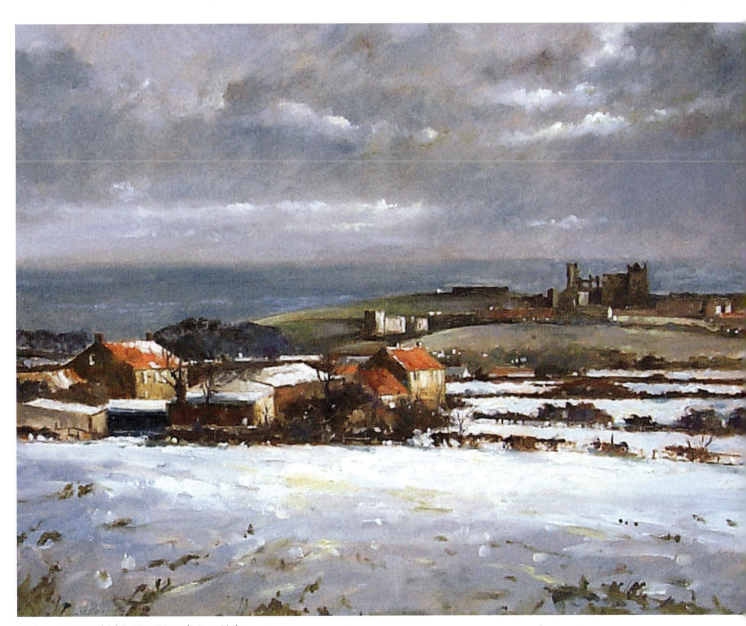

January Snow/Whitby, 40 × 30cm (16 × 12in).

DEMONSTRATION: *Sheep In The Snow/Sleights*

MATERIALS

Support

A 30 × 25cm (12 × 10in) canvas, proprietary canvas-covered board or an MDF board treated as follows:

- Cut a piece of MDF and sand down both faces and all edges using fine sandpaper.
- Apply one coat of texture paste with a 25mm hog brush.
- Apply one coat of white acrylic primer to each side of the board to prevent warping.
- Apply a second coat to the chosen working surface.
- Apply a 'turpsy' wash of predominantly Ultramarine Blue and Permanent Bright Red to the board.

Brushes

- Nos. 4, 6 and 8 Eclipse, Filbert brushes by Rosemary and Co.
- A no. 3 round sable Rigger.

Colours

For this, a limited palette of six colours (a warm and a cool version of each primary) and alkyd white were used: Permanent Bright Red, Alizarin, Cadmium Yellow Lemon, Winsor Lemon, Ultramarine Blue, Cerulean and Griffin alkyd Titanium White (to speed up drying time). Three greys were mixed from the primaries and white:

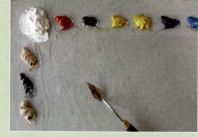

A palette of colours.

- Grey 1: A warm, light-toned grey.
- Grey 2: A cooler, light-toned grey.
- Grey 3: A dark neutral grey.

Additional Items

- Turpentine, or a low odour solvent or white spirit (for cleaning the brushes only).
- A 2B pencil.
- A palette knife.
- A copious supply of kitchen towel.

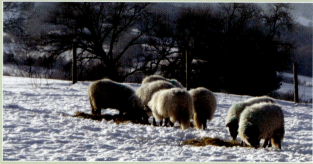

Photographic reference for the painting *Sheep in the Snow/Sleights*.

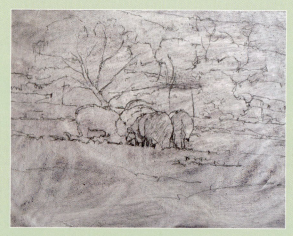

Step 1.

This photograph was taken in early December in the middle of extreme winter weather. Snow had been lying on the ground for nearly three weeks, accompanied by harsh below-zero temperatures. Long blue-grey shadows cut across the snowfields and the top edges and sides of the sheep were lit dramatically. The painting was undertaken in the studio from photographic reference the next day, when everything was still recalled easily. The warm and cool colours were enhanced slightly to increase the colour contrast. At the same time, the lit and shadowy areas of snow were orchestrated to place the sheep 'in the spotlight'.

Step 1: Drawing Out

Use a 2B pencil to draw a simple outline of the subject, paying particular attention to the sheep.

Step 2: Commencing the Block-In

Using the pre-mixed greys begin to block-in some of the main dark and mid-toned darkish masses in the distance. At the same time the trees in the middle-distance can be painted, again using

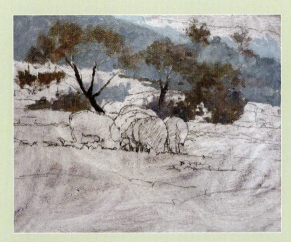

Step 2.

Always remember the fact that a dark object that is brightly illuminated is often lighter than a white object in shadow. At this stage an accurate rendering of colour and detail is not necessary, but is essential that all the tonal relationships are accurate.

Actively experiment with mixes, as there are numerous ways to achieve the required colours from this limited palette. Be aware that by adding too much white to your colours you run the risk of cooling it down too much, or making the mix appear chalky.

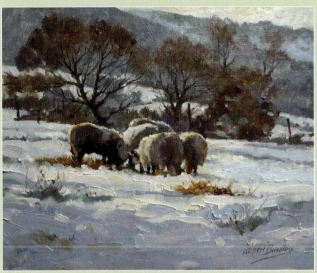

Step 4.

the three pre-mixed greys. You will find it easy to adjust these greys by using the primary colours and white.

A really good, strong dark can be mixed by using a combination of either Ultramarine Blue with a little Permanent Bright Red or Ultramarine Blue with Alizarin Crimson. You will be able to grey the colour slightly by adding a small amount of yellow or warm grey to the mix. A measured amount of white will lighten the mix slightly, but be very careful not to add too much.

If you have any difficulty identifying the major shapes and masses, squint your eyes. This will help you to eliminate detail and simplify the tonal range.

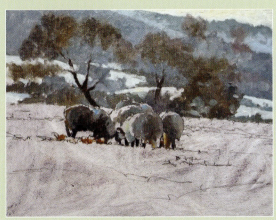

Step 3.

Step 3: Developing the Block-In and Painting the Sheep

Continue blocking in the distance as for Step 2, but at the same time turn your attention to the sheep. Notice how the same range of warm and cool greys have been used for the shadow sides of the sheep. Never assume that sheep are white. Even when brightly lit they will be at best only a very light warm tone; at this time, however, leave these highlights until later.

Step 4: Completing the Block-In and Adding Highlights and Details

Using your largest brush, block in the foreground shadow areas using bold, confident strokes. Notice how once again warm and cool colour combinations have been used; now, however, these mixes are slightly cleaner and lighter. You will be able to achieve cleaner colour by starting out with two primaries, say a blue and a red. By adding a very small amount of the third primary, in this case yellow, you should be able find the exact colour you need. Should you add too much yellow it will become immediately apparent that the mix is turning too grey.

At this stage turn your attention to the sunlit areas of snow. Try to employ the same bold, confident brush marks, but now use far lighter, warmer impasto paint.

The details on the trees, bushes, fence posts and foreground grasses can now be painted using a combination of slightly different tones to give variety. Many beginners struggle to achieve convincing results when painting tree trunks, branches and twigs. By looking carefully at the photographic reference and Step 4 of the demonstration you will notice how the trunks, branches and twigs have a continual taper. Also notice how these branches and twigs seem to have a mind of their

DEMONSTRATION: *Sheep In The Snow/Sleights* (continued)

own with regard to the angles and direction in which they grow. The Rigger brush is perfect for painting these features. By varying the pressure applied and constantly changing the direction of the brush you will soon master the skill of painting convincing trees. A fairly light touch with the brush is necessary for all the finer branches and twigs. A flick of the wrist at the end of each stroke will result in extremely fine, tapering marks. You should aim to execute these marks as quickly and confidently as possible to achieve convincing results.

A word of warning: be extremely careful not to get too carried away by detail. Keep everything simple. It is all a matter of becoming familiar with your tools and, as always, practise, practice and more practice!

You can now paint the highlights on the sheep. Using lots of white, with traces of yellow, red or blue, mix a variety of extremely light warm and cool colours. Once again use the Rigger to apply the colour. Load the brush with plenty of paint, which should be applied as impasto to enhance the light effect.

Look carefully at the detail shown here, which illustrates how thickly applied impasto paint has been used to enhance the light effect on the lit snow in the foreground and also on the lit edges of the sheep.

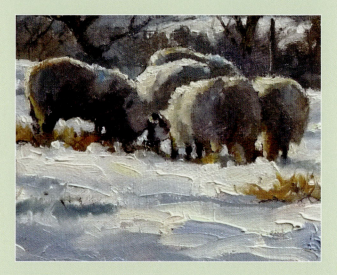

Detail showing thickly applied impasto paint.

As usual, before scraping down your palette and packing up, take a little time for assessment. Never settle for even the smallest of errors; if you feel something is not right, find the solution and make the necessary changes.

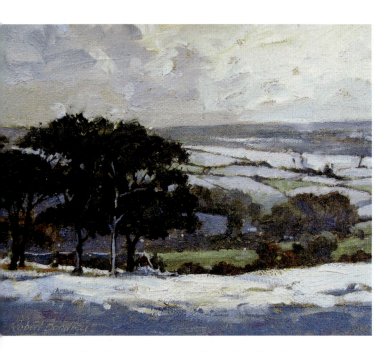

Snow/North Yorkshire Moors, 30 × 23cm (12 × 9in).

Conversely, a cool blue sky will be reflected in the cast shadows where the light cannot reach. You will be able to use this play of warm against cool colour creatively in your paintings to intensify both contrast and colour harmony.

The use of a limited palette can be extremely beneficial when painting snow scenes. By restricting choice and making use of your pre-mixed warm and cool greys you will be able to reproduce quickly all the subtle greys revealed by nature in the winter landscape.

As usual, before starting to paint take a little time to plan your painting with regard to the use of shadows, colour and tonal balance. A far more successful balance will be achieved by letting either the light tones or the darker tones dominate. Never allow these tonal areas to carry equal importance.

Snow/Roseberry Topping illustrates how well-placed, relatively small areas of light surrounded by mid-tones and darks can be used creatively to produce a well-balanced tonal effect. Careful consideration was given to the placing of these lights as, on the day, the light was distributed far more widely across the picture plane. Once again a limited palette of three primaries and white were used; this painting shows how a wide range of warm and cool greys can be mixed from a small number of colours.

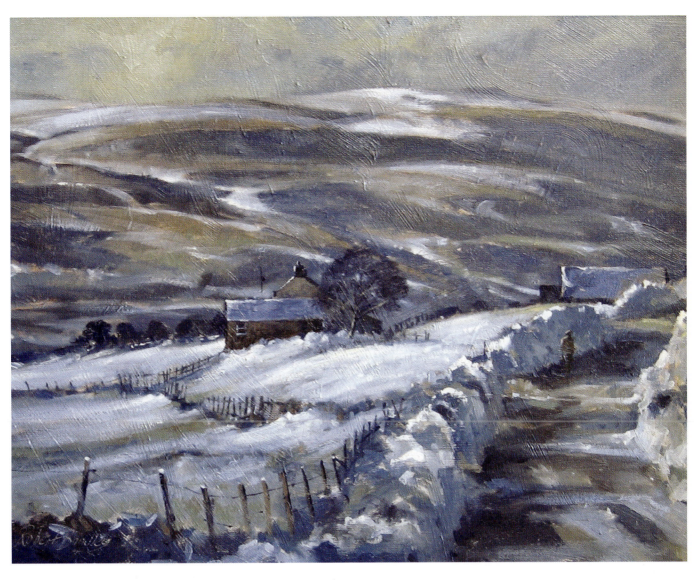

Snow on the Moors, 40 × 30cm (16 × 12in).

Although you will probably be more excited by dramatic sunlight falling upon snow, you will probably benefit greatly from painting on a cloudy day. Dark, threatening, blue-grey banks of cloud are very often extremely effective for providing a dramatic backdrop to snow-covered landscapes.

Nature won't be summoned to order and won't be kept waiting. It must be caught, well caught.

Claude Monet

RIGHT: *Snow/Roseberry Topping*, 30 × 28cm (12 × 11in).

Early Autumn/Peak District, 20 × 20cm (10 × 8in).

TREES

The small *plein air* painting *Early Autumn/Peak District* was under-taken on a warm, sunny, early autumn day with the leaves just 'on the turn'. The main tree has been positioned just off-centre, acting as a device to lead the viewer's eye through the gap in the tumbledown wall and into the picture.

Trees are the largest living things on earth and probably feature in landscape paintings more than any other element. Their structure and beauty enhance many pictures, often providing a compositional device such as a vertical or large mass to give much needed balance and harmony. The inclusion of a single tree or group of trees can be all that is needed to complete even the simplest of subjects.

To draw and paint trees convincingly it is essential to have some knowledge of their nature and structure. As mentioned previously, painters of the human figure reap benefits from their knowledge of the anatomy of the skeleton; in the same way, the landscape painter can learn much from studying and making drawings or small colour sketches of trees. Probably the best time to learn about the nature of trees is during the winter months when the leaves have fallen to expose their skeletal form.

Winter Light/Wheeldale Gill was painted on a crisp, bright Febru-ary afternoon. Subject matter such as this would be perfect for making several studies of winter trees, either in pencil or paint. Notice how the branches and twigs have a natural taper as they grow further away from the trunk and also how they criss-cross each other in a random manner. Many beginners fail to achieve

RIGHT:
Winter Light/Wheeldale Gill,
30 × 25cm (12 × 10in).

depth and a feeling of volume in their tree studies, so remember that branches grow out of the tree trunk at all angles: towards you, away from you and never from just the two sides observed from your location. Look carefully at this painting and see the variety of colour present in the trunks and branches. You will see that a wide range of subtle blue-greys and blue-greens has been observed.

For any inexperienced painter it may be helpful to start by making studies in pencil or charcoal. Look carefully at the basic structure of the particular tree under observation. There are numerous species to study and each has very different characteristics, some being tall and slender and others more compact with a tendency to spread. Note how in some species, such as the oak, branches grow out of the trunk in a horizontal direction, whilst for others, such as the poplar, branches leave the trunk at an acute angle and rise vertically, as if competing with the trunk itself.

Hillside/Tuscany, 20 × 15cm (8 × 6in).

Woodland Cottage/Sleights: detail showing brushmarks.

Woodland Cottage/Sleights, 30 × 25cm (12 × 10in).

Château at Savigny-lès-Beaurne, 20 × 25cm (8 × 10in).

When you have undertaken a series of pencil/monochrome studies you will be ready to carry out further studies, but now using colour. It is extremely important to make careful observations of the colour and texture of each species of tree, paying particular attention to the foliage, trunks and branches. If possible, carry out a series of studies of the same tree in different seasons to identify the changes. The study *Hillside/Tuscany* was painted to capture the attitude, texture and colour of this small tree clinging desperately to a rocky hillside.

Painting trees with a mass of summer foliage can be a daunting prospect for many inexperienced painters; indeed, it often presents a challenge to those with greater experience. There are several reasons for this. It may be that the trunks and branches, which provide the structure to any tree, are not visible and subsequently the mass of foliage has no form and may lack sufficient definition. This is often compounded by the tree or mass of trees being poorly illuminated, resulting in uniform tonal masses.

The small *plein air* study *Woodland Cottage/Sleights* illustrates the above conditions perfectly. The mass of foliage revealed very few branches and was lit only by weak-filtered light, resulting in little tonal variety. To compensate, artistic licence was used by introducing a few trunks and branches, together with more light and warm and cool colour changes, into the painting. Try squinting your eyes to isolate and identify very close mid-tone and dark tonal changes in masses of foliage; when you have done that, imagine that the mid-tones were picking up a fraction more light and also that the darks were a fraction darker. At the same time, use a variety of warm and cool greens. By doing this you will be able to create slightly more contrast, variety and light in your painting. The introduction of a few carefully placed trunks and branches will add structure to the tree mass. Lively, confident brushwork is an important factor, which can also be used to break up large masses of foliage (see the detail illustrated).

Bearing the above in mind, if you have little experience it may help you to carry out your first colour studies in good sunlight, where the trees will preferably be illuminated from one side or the other. In these conditions, by squinting your eyes to eliminate the confusing half-tones, it should be fairly straightforward for you to identify the main light and dark planes and masses. Once these masses and their approximate colour and tone have been identified, you should be able to block in these shapes quickly. Keep this block-in simple, giving no consideration to individual leaves or small areas of varying tone within the broader mass.

The small *plein air* painting *Château at Savigny-lès-Beaurne* illustrates how, by squinting the eyes, many details and confusing half-tones can be eliminated, resulting in much-simplified shapes and masses. Trees in hazy early morning or evening light are often reduced to simple shapes and tones, making them ideal for both the novice and slightly more experienced painter to execute rapid studies. *Sunrise, Late Autumn* was painted as a demonstration of how to paint an atmospheric subject of trees.

Sunrise, Late Autumn, 30 × 25cm (12 × 10in).

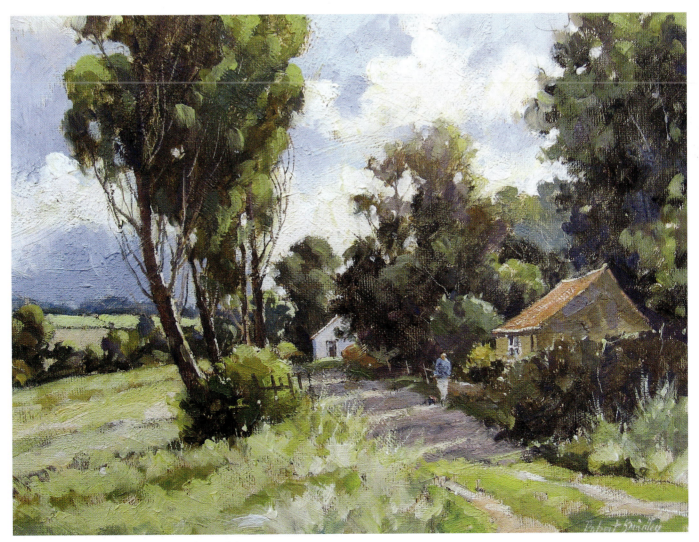

The Track Near Ruswarp, 30 × 23cm (12 × 9in).

Hazy Morning/North Yorkshire Moors, 40 × 30cm (16 × 12in).

Painting the Light Coming Through Trees

A mass of upright trees set against the light make a wonderful subject, but they often present major problems for many beginners. Light bursting through gaps in the foliage must be one of the most exciting features to paint of any landscape. The decision of how many of these gaps to paint depends on the density of the foliage and the characteristics of the trees being painted. In some instances the decision regarding the number of gaps to paint is relatively easy. This was the case in *The Track near Ruswarp*, where the trees were painted fairly literally, resulting in a convincing balance of gaps to foliage. In other instances, far more consideration is needed before the trees are painted. In the painting *Hazy Morning/North Yorkshire Moors*, for example, there were numerous gaps in evidence. In order to simplify the painting the number of gaps was reduced drastically. Whenever you carry out this sort of simplification, remember that it is essential that you retain the identity and characteristics of the trees.

The other important consideration concerning painting gaps in foliage is whether or not the general value and colour used for the sky should be used for the gaps themselves. When they are painted with the same value the holes often appear far too light, standing out too prominently. To counter this you will need to hone your powers of observation and also understand what happens to light passing through small holes in masses of foliage. As the light travels through the gaps in foliage it becomes scattered and diffused, becoming less intense. In addition to this, the tonal relationship of the light with the darkness of the tree often makes it appear lighter than it really is. Therefore, the value and colours chosen to portray these gaps should be slightly darker than the rest of the sky. It is important to remember though that the larger the gap, the lighter the centre can be.

Finally, when painting these gaps pay particular attention to the edges created. Too many sharp edges look unrealistic so bear in mind that you will need to carry out a little blending and softening to achieve a convincing effect.

Detail of the 'sky holes' in *Hazy Morning/North Yorkshire Moors*.

DEMONSTRATION: *The Moor Near Castleton*

This late summer moorland scene features a variety of trees and was painted using a limited palette of three primary colours and white, from on-site sketches and photographic reference.

MATERIALS

Support
Treat a 25 × 20cm (10 × 8in) proprietary canvas-covered board as follows:
- Apply one coat of texture paste with a 25mm hog brush.
- Apply one coat of white acrylic primer to each side of the board to prevent warping.
- Apply a second coat to the chosen working surface.
- Apply a 'turpsy' wash of Raw Sienna plus Burnt Sienna to provide a coloured ground.

Brushes
- Nos. 4, 6 and 8 Eclipse, Filbert brushes by Rosemary and Co.
- A no. 3 round Rigger.

Colours
For this demonstration a limited palette of four Rowney artists' quality, primary colours and white were used: Cadmium Red Light, Cadmium Yellow Medium (warm), Cadmium Lemon Yellow (cool) and Ultramarine Blue. A Griffin alkyd white was used to speed up the drying time. The following three greys were mixed from the above primaries and white:
- Grey 1: A warm, light-toned grey.
- Grey 2: A cool, light-toned grey.
- Grey 3: A dark neutral grey.

Additional Items
- Turpentine, or a low odour solvent or white spirit (for cleaning the brushes only).
- A 2B pencil.
- A palette knife.
- A copious supply of kitchen towel.

Step 1.

Step 1: Drawing Out and Commencing the Block-In
Use a 2B pencil to draw a simple outline of the subject. Begin to block-in some of the distant mid-tones. The three pre-mixed greys can be used here and the colour adjusted by using the four primaries.

Step 2.

Step 2: Continuing the Block-In
Look carefully at the subject and squint your eyes to isolate the major shapes. At this time concentrate only on the darks and mid-tones. Remember that tone is all important and is the key to all successful paintings so keep colour and detail simple in these early stages.

DEMONSTRATION: *The Moor Near Castleton* (continued)

Continue to make full use of your warm and cool grey mixes, adapting them where necessary. Never be afraid to experiment with your colour mixing when trying to assess a certain passage; this is how you learn and become familiar with your palette. Be aware of the sometimes unexpected results of using white; you will not always get what you expect as the mix may appear chalky or cooler than anticipated. A good, strong dark can be mixed by using a combination of the three primaries. Use Ultramarine Blue with a little Permanent Bright Red and a touch of yellow and white to adjust the mix.

To begin with it would be beneficial to experiment by using the the four primaries to mix the subtle greens present. It may help to start with Ultramarine Blue and one of the yellows, which will give you a base green. This base can be adjusted to the correct colour and value by adding a small amount of red and white. Remember that a cool green will have more blue in the mix and a warm green will have more red. The alternative is to use one of the greys, adjusting the colour and value by adding the primary colours and white.

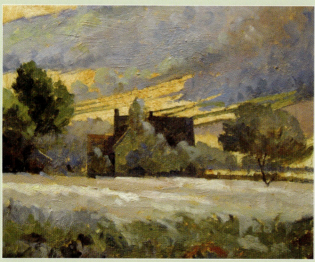

Step 3.

Step 3: Developing the Block-In and Painting the Foreground

Continue to develop the overall block-in by turning your attention to the foreground. To portray the foreground convincingly, pay particular attention to the brush marks used; they should be expressive, directional, immediate and placed with confidence.

A greater variety of colour and tone should also be used in the foreground; however, never over-detail a foreground otherwise the focus of your painting will be diminished.

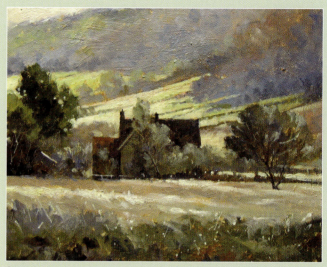

Step 4.

Step 4: Complete the Block-In by Painting the Lighter Passages

At this stage the painting should really begin to come together. By blocking in all the lighter passages for the distant light-struck fields the full range of tones, with the exception of highlights and dark accents, should now be present.

These light, more colourful greens are very different from the ones mixed so far and can be achieved by using the primary colours and white, without the use of pre-mixed greys. The greens contain less blue and far more yellow. The following suggestions may prove useful:

- Cadmium Yellow Medium, Ultramarine Blue plus a touch of Cadmium Red Light will result in a warm green that can be lightened with white. If the mix appears either chalky or too cool, add a touch more yellow and possibly red.
- Cadmium Lemon Yellow and a little less Ultramarine Blue plus Cadmium Red Light will result in a slightly cooler green. Once again, add white to lighten the mix and yellow and red to adjust the balance if necessary.

At this stage a few details such as fences, foreground grasses, tree trunks and branches can be introduced. The tree trunks and branches in the darker mass of trees on the left-hand side of the painting were scratched out with the wooden tip of the brush handle. This technique produces very fine lines, resulting in a more convincing rendering of features such as these, but it can only be done when the paint is still wet.

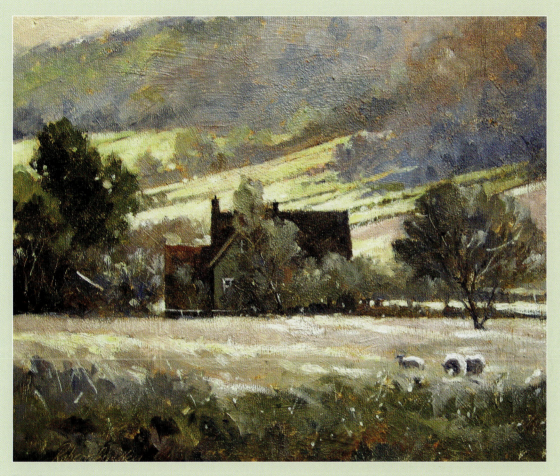

Step 5.

Step 5: Add Highlights and Final Details and Work on Edges

You can now begin to work on what can be the most satisfying part of the painting: the highlights and final details. These highlights should be applied with impasto. When light strikes this thickly applied paint the light effect in the painting becomes far more convincing.

Try to avoid the use of pure white when applying these effects. There is no pure white in nature and it seldom looks convincing when used in a painting. Add very small amounts of yellow, red, orange or blue to the white and you will achieve more realistic effects. You will need to experiment with these mixes and their application to achieve success.

The sheep can be added using your grey mixes and other areas of suitable colour that should now be available on your palette. It is worth remembering that sheep are not white.

Their fleeces will be quite dirty and consequently their shadow sides should be rendered with both warm and cool mixes of grey. You should also look carefully to observe any reflected light that may come from the immediate surroundings. The rim lighting around the top edges of the sheep should be applied with heavy impasto, using a mix of predominantly white with small touches of yellow and/or red.

Now that you have covered the entire painting surface, step back from your work to assess and evaluate. Consider all of the edges: do any of them need enhancing or softening? Generally speaking, reserve most of your sharper, cleaner edges for the lead-in and focal point and soften overly insistent edges around the extremities of the painting. The farmhouse and left-hand trees should have the sharpest edges as they are set against the middle-distance sunlit fields, thus creating the clearest contrast.

ANIMALS

You will be surrounded by all kinds of animal and bird life when painting out and about, ranging from farm animals such as cows, horses and sheep, to wild animals such as foxes, deer and so on. By including animals in your landscape paintings you will be able to add interest, life, movement, colour and scale. Single animals and carefully composed groups can be used effectively to transform an otherwise ordinary subject. Their correct placement is critical to their success, however, as composition and balance can be affected drastically by poor placement. It is probably wise not to use animals just for the sake of it, as they should be an integral part of the painting and can be an unnecessary distraction if they are not needed.

The small study *The Pony* was painted from photographic reference and sketches; it shows how an animal can be used as the primary subject. Notice how loose, expressive brushwork has

The Pony, 20 × 13cm (8 × 5in).

Henhouses, The Lund, 30 × 23cm (12 × 9in).

been adopted for the field and hay, ensuring that the viewer's attention is drawn immediately to the pony where the greatest detail has been used. It may prove useful to consider the following factors when including animals in any of your paintings.

- Animals can be useful for scale comparison in your work. You will automatically recognize the height and size of familiar animals such as cows and sheep and therefore be able to relate this known element to create distance and perspective in your work.

- Where possible, it is advantageous to give sufficient thought to the placing of larger animals or groups very early on, or perhaps before the painting is commenced. Smaller, incidental animals can often be placed fairly late in the process, or even after the painting has been completed if necessary. The hens in *Henhouses, The Lund* were added as the final touches to this painting. It was decided to position them in the patch of sunlit grass, just off-centre, as a means of strengthening the focal point.

- Consider why you are using the animals. If you are concerned only with adding a little life to your painting by including one or two distant cows or sheep then, provided they are used reservedly, not too many things can go wrong. However, you must take care to ensure that they contribute to the painting without taking anything away from what would have been a successful piece of work. Take particular care over scale, tone and colour, as any errors will ruin an otherwise successful piece of work. Consider including a well-positioned animal to establish or reinforce the focal point, but when doing this never be tempted to use overly bright colours that may appear too intrusive.

- When painting a number of animals as an integral part of your composition make sure that you give priority to either one particular animal or group of animals only, thus ensuring a hierarchy within your painting. By littering the painting with too many individual animals of equal importance, scale or size your viewer will be overwhelmed and their eyes unable to travel through your painting. This will result in loss of impact and, more often than not, a weakened focal point. When drawing or painting foreground animals take a little more time for careful observation. By doing so you will be far more able to include a little more information and detail, vital to producing a convincing rendering. Be wary of over-detailing.

- Occasionally you may come across just one or two animals that you feel would make a wonderful subject on their own. It could be a simple study of a cow or pony grazing (see *The Pony*). Another good example of this type or subject matter is shown in the small study *Spring/Snow and Sheep*.

- Consider using animals as a compositional device to lead the viewer into and through your painting.

- Always be aware that odd numbers work better than even, so try to use three, five, seven, and so on. Overlapping shapes also work better, as an abundance of evenly spaced individual animals are never as convincing or aesthetically pleasing as well-composed groups.

When painting *plein air* it is often difficult, even for the more experienced painter, to capture moving animals. Even if you feel confident enough to render quick and accurate animals in your *plein air* paintings it may still be advisable to be patient and wait for a suitable opportunity, when they settle down for a while.

It is good practice to keep a sketchbook handy at all times, which can be used to make quick studies. You could also find it useful to travel with a small digital camera, which will enable you to build a library of photographic references. This varied reference material will be invaluable for use in future paintings.

Spring/Snow and Sheep, 25 × 20cm (10 × 8in).

IN THE SPOTLIGHT

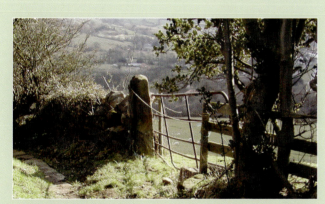

Reference photograph for *The Gate/Featherbed Lane.*

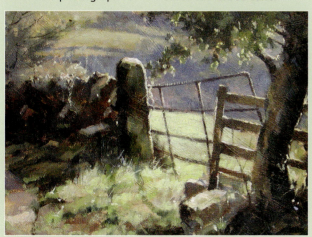

The Gate/Featherbed Lane, 25 × 20cm (10 × 8in).

The Gate/Featherbed Lane was painted from photographic reference and illustrates how even the simplest of subject matter can be developed into a successful painting provided the light is right. A heavily textured board, under-painted with a 'turpsy' wash of Burnt Sienna was used.

Evaluation

The inspiration for this painting came from the back-lit leaves and also the light streaming through the gate, casting long, soft shadows across the broken foreground.

Composition

The composition works extremely well, even considering the fact that the gate cuts straight through the centre of the painting. To prevent the gate becoming too much of a barrier, the rails were painted in a 'hit and miss' diffused manner, which allows the eye to pass into the field beyond.

Tone and Colour

To achieve a softer, more diffused light the tonal range was narrowed and 'lost and found' edges were used throughout. The colour temperature is also much warmer in the painting, which is mainly due to the Burnt Sienna ground used on the prepared board (compare the painting with the reference photograph).

Robert Brindley

VILLAGES AND RURAL BUILDINGS

A Quiet Corner/Châteauneuf was painted on textured board from on-site pencil sketches.

Villages, farms and other rural buildings offer the landscape painter the opportunity to add variety to their work. Although drawing and painting buildings may appear to be quite a daunting prospect to many beginners, there is no need to be over ambitious. Even the simplest barn or cottage will add another dimension to what might have otherwise been a fairly ordinary subject. However, it is essential that careful consideration be given not only to the placing of the building within the composition but also to the drawing. To achieve a successful rendering of any building or structure within the landscape it is essential that sufficient time is taken to ensure that the rules of perspective are adhered to and also that proportions, in terms of height in relation to width and so on, are observed correctly.

It may help to begin by selecting extremely simple buildings or their silhouettes as your subject matter, where you can reduce detail and concentrate on basic shape. The two small *plein air* studies *Sharp Light/Green End* and *Morning Light/West Cliff/Whitby* both illustrate how simple silhouettes can be used.

When more complicated buildings or groups of buildings are to be painted consideration should be given to other factors, including the importance of the light illuminating them. The following observations may prove useful.

- For the *plein air* painter it is essential that consideration is given to the movement of the sun, as this will obviously have an effect on how the buildings are illuminated. Unless you have a reliable memory, it may help to place the shadows early on so that they are fixed.

OPPOSITE PAGE:
A Quiet Corner/Châteauneuf,
15 × 20cm (6 × 8in).

RIGHT:
Sharp Light/Green End,
25 × 20cm (10 × 8in).

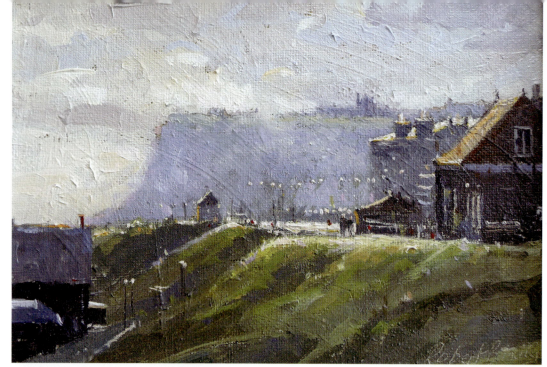

Morning Light/West Cliff/Whitby, 20 × 15cm (8 × 6in).

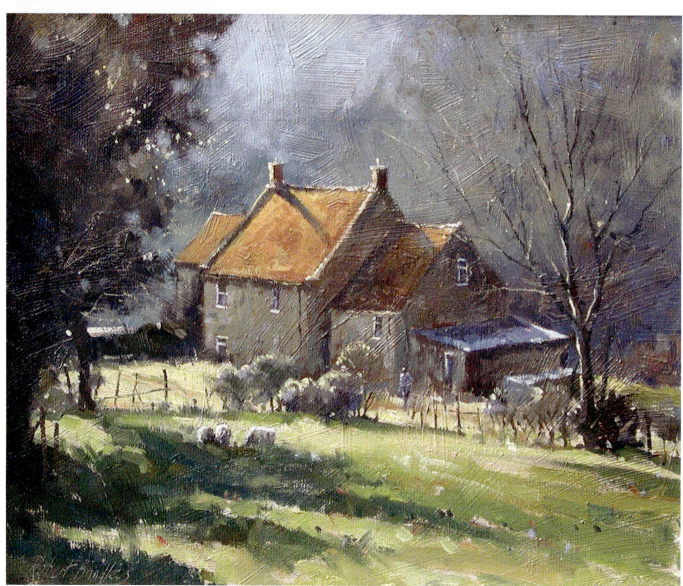

Spring Light/Littlebeck, 30 × 25cm (12 × 10in).

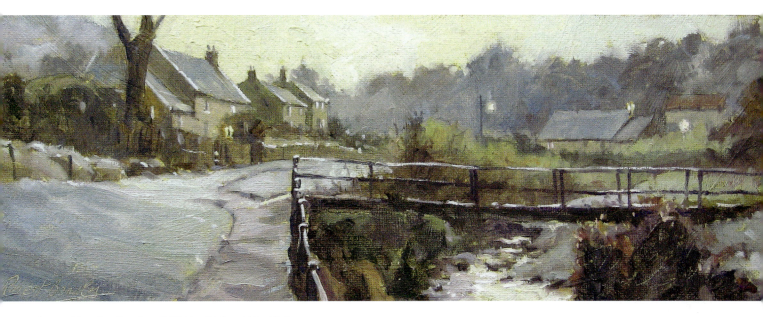

Frosty Morning/Sandsend, 35.5 × 12.5cm (14 × 5in).

- When painting shadows on the side of buildings look for the presence of any reflected light that may be picked up from surrounding features. Notice how subtle, olive green reflected light has been used on the front face of the cottage in *Spring Light/Littlebeck*.
- A good composition is essential for the success of any painting, which should have a strong focal point, a convincing lead-in and a balance of both tone and colour. Buildings can be a useful compositional element in many ways; they can be used either as the main centre of interest, as a supporting feature, or to provide a lead-in to the painting. Depending on the prevailing lighting conditions the light, mid-tone or dark masses within the buildings can be used to provide a satisfactory tonal balance. The cottages in *Frosty Morning/Sandsend* are the focal point; however, they also support the lead-in provided by the foreground fence and path.
- Refer again to the painting *Spring Light/Littlebeck*, where all the above criteria have been used to good effect. The cottage provides the main subject matter, which, in conjunction with the fence line, acts as a subtle lead-in to the painting. The brightly lit orange roof and sunlit patch of grass reinforce the focal point. Additionally, the gable walls in shadow help to enclose the sunlit walls of the cottage, providing balance.
- *Barns near Dalehouse* provides another good example of how a group of buildings has been used as the main subject matter and at the same time as a lead-in device. Notice how the orange roof and sunlit wall help to draw the eye into the painting and towards the focal point.
- *The Red Barn* posed a few more problems compositionally. The barn itself is a wonderful subject; however, the prevailing

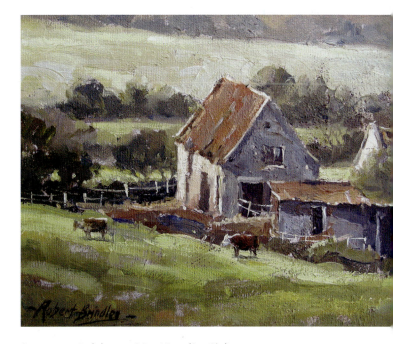

Barns near Dalehouse, 20 × 15cm (8 × 6in).

light, which illuminated the tin roof in conjunction with the bright red walls, drew the eye too deeply into the painting, to where there was no interest at all. To counteract this problem a fence line, together with indications of a track, were introduced to the foreground. This subtle lead-in takes the eye to the top edge of the sunlit field, where the eye then travels along to the pony, which was introduced to create a focal point under the shadowy gable end. The vertical tree also helps to reinforce the centre of interest.

135

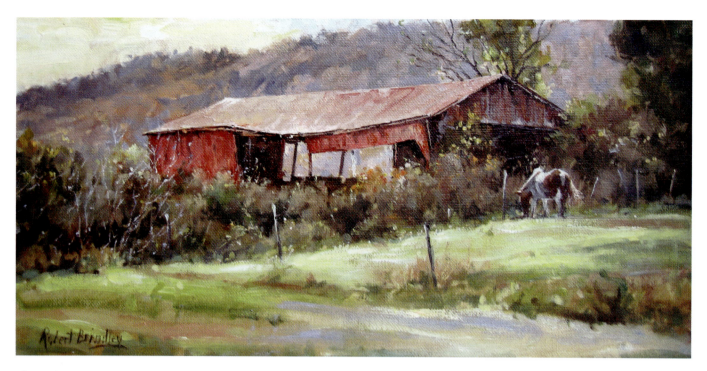

The Red Barn, 40 × 20cm (16 × 8in).

Generally speaking, buildings or groups of buildings that are viewed square-on are not as visually stimulating or successful as those viewed from an angle where perspective lines can be used to direct the eye into the painting. Nevertheless, the painting *Highgate Howe Farm* illustrates how buildings such as these can be used successfully. A small panoramic board was selected for this painting, which emphasizes the shape of the building with its interesting stepped roof and chimneys. Detail has been kept to a minimum by eliminating unnecessary clutter. The elongated shape of the farm building is punctuated by a number of trees and bushes, which add a little more interest. A convincing lead-in is provided by the foreground fence line. *The Windmill/Cley Next the Sea* also features buildings that have been painted square-on.

Highgate Howe Farm, 20 × 10cm (8 × 4in).

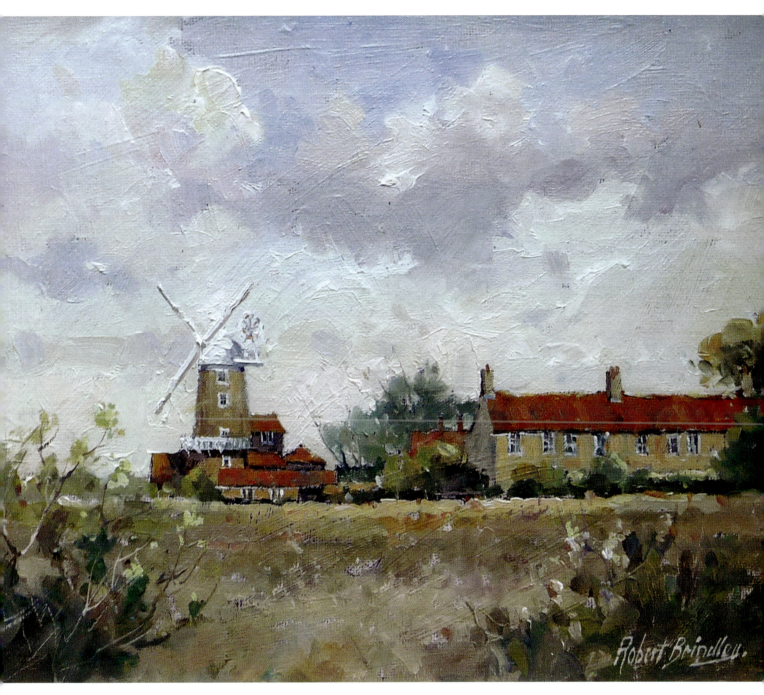

The Windmill/Cley Next the Sea, 30 × 25cm (12 × 10in).

DEMONSTRATION: *Winter Sunset*

MATERIALS

Support

A 20 × 15cm (8 × 6in) canvas or proprietary canvas-covered board, or MDF board treated as follows:

- Cut a piece of MDF and sand down both faces and all edges using fine sandpaper.
- Apply one coat of texture paste with a 25mm hog brush.
- Apply one coat of white acrylic primer to each side of the board to prevent warping.
- Apply a second coat to the chosen working surface.
- Apply a 'turpsy' wash of Ultramarine Blue and Permanent Bright Red to the board.

Brushes

- Nos. 4, 6 and 8 Eclipse, Filbert brushes by Rosemary and Co.
- A no. 3 round sable or synthetic Rigger.

Colours

For this demonstration a limited palette of six colours (a warm and a cool version of each primary) and alkyd white were used: Permanent Bright Red, Alizarin, Cadmium Yellow Lemon, Winsor Lemon, Ultramarine Blue, Cerulean and Winsor and Newton Griffin alkyd Titanium White, which helps to speed up drying time. As usual, three greys were mixed from the above primaries and white:

- Grey 1: A warm, light-toned grey.
- Grey 2: A cooler, light-toned grey.
- Grey 3: A dark neutral grey.

Additional Items

- Turpentine, or a low odour solvent or white spirit (for cleaning the brushes only).
- A 2B pencil.
- A palette knife.
- A copious supply of kitchen towel.

This atmospheric scene was observed late on a January afternoon after a light snowfall. The sun was setting rapidly and there was insufficient time to complete an on-site study. The painting was undertaken in the studio the next day when everything was still recalled easily.

Lighting conditions such as this are fairly common during the winter and this step-by-step demonstration using a limited palette of colours should show how to paint buildings in a small winter scene with a fairly low level of light.

Step 1.

Step 1: Drawing Out

Use a 2B pencil to draw a simple outline of the subject.

Step 2.

Step 2: Commencing the Block-In

Begin to block-in some of the main dark and darker mid-toned masses using the three pre-mixed greys. These greys can be adjusted using any one of the six primary colours.

A really good, strong dark can be mixed by using a combination of Ultramarine Blue with a little Permanent Bright Red. You may want to experiment by adding a little yellow or white, or a combination of both to fine-tune the tone and colour.

If you have any difficulty identifying the major shapes and masses, squint your eyes. This will help to eliminate detail and simplify the tonal range.

Step 3.

Step 3: Developing the Block-In and Painting the Sky

Continue to develop the block-in by turning your attention to the sky. In this particular painting the sky is very simple and consists of subtle changes of warm colour. These colours can be mixed using any combination of the six primary colours and white. However, the amount of blue in the mixes will only be very small. It is recommended that you experiment with your own mixing, but it may help you to consider some of the following suggestions.

- *The bottom of the sky along the horizon:* Try Ultramarine Blue with a touch of Alizarin Crimson and a smaller amount of Cadmium Yellow Lemon plus white.
- *The centre section:* To give this area variety, try slightly different combinations of either Cadmium Yellow Lemon, Permanent Bright Red and Ultramarine Blue plus white, or Winsor Lemon, Alizarin Crimson and Ultramarine Blue plus white. Only the slightest adjustment to any of these mixes will give you the subtle tonal and temperature changes you may be looking for.

- *The top of the sky (main mass):* Try white, Cadmium Yellow Lemon and a touch of Permanent Bright Red.
- *The top of the sky (top left-hand corner):* Try Ultramarine Blue, Permanent Bright Red and a touch of Cadmium Yellow Lemon plus white.

Further adjustments to these mixes can be made using the two lighter pre-mixed greys if necessary. At this stage an accurate rendering of colour and detail is not necessary, but the painting must be fairly accurate with regard to tone.

Note: Experiment with your mixes, as there are numerous ways to achieve the required colours from this limited palette. Always be aware that by adding too much white to your colours you run the risk of cooling the mix too much or of making it appear chalky.

Step 4.

Step 4: Working on the Trees and the Setting Sun

The trees can now be developed further. First, the masses of smaller branches and twigs can be rendered by using the two pre-mixed, light-toned greys, adjusting them as required with the primary colours. A fairly light touch with the brush is necessary here, as you will be painting into the wet sky colour. You should aim to execute these marks as quickly and as positively as you can to achieve a fresh application of colour with good definition.

The larger branches and telegraph poles can be painted now, using a combination of the mixes available to you on the palette. Be extremely careful not to get too carried away by detail. Keep everything simple.

The sun can now be painted using a combination of both reds and yellows plus white. It is essential to keep these colours clean and fresh. The impact and effect of the light given out by the sun will be enhanced by the use of impasto paint.

DEMONSTRATION: *Winter Sunset* (continued)

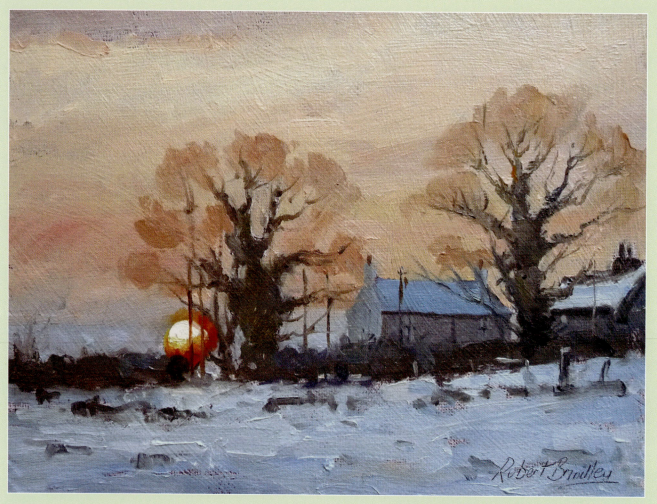

Step 5.

Step 5: Painting the Foreground and Completing the Painting

The foreground can now be painted by using either the cool mid-toned grey and adjusting the colour with the addition of one or two of the primary colours, by adjusting some of the many colour mixes now available to you on the palette, or by mixing fresh colour from the primaries plus white. When you are happy with your mixes apply the colour with quick, confident strokes. Once again the use of impasto paint will create a lively, textural quality to the foreground.

You can now add all the final details and highlights. Pay particular attention to the treatment of edges. You should have a pleasing combination of 'lost-and-found' edges throughout the painting. Use your finger or a clean brush to soften any edges that are too stark.

Colour mixes on the palette.

As usual, before scraping down your palette and packing up, take a little time for assessment. Never settle for even the smallest of errors; if you feel something is not right, find the solution and make the necessary changes.

WORKING ON COLOURED GROUNDS

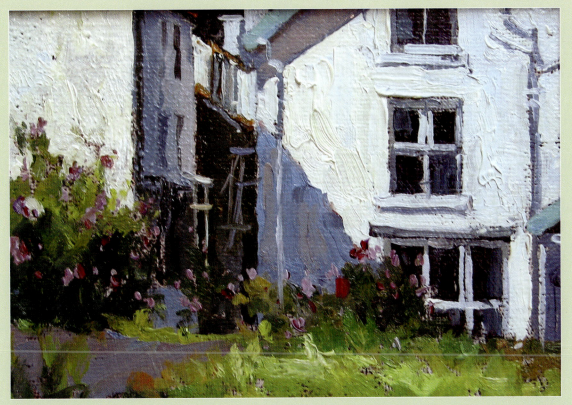

Sunlight and Shadows/Runswick Bay, 18 × 13cm (7 × 5in).

Sunlight and Shadows/Runswick Bay was painted from photographic reference and illustrates how good lighting in conjunction with just a small section of a building can be used to produce a successful painting. A heavily textured board under-painted with a cool, 'turpsy' wash of Ultramarine Blue and Permanent Bright Red was used. The image was cropped to concentrate attention onto the flowers and sunlit textured walls.

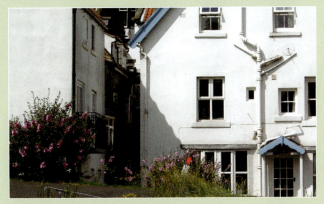

Reference photograph for
Sunlight and Shadows/Runswick Bay.

Evaluation

The inspiration for this painting came from the flowers and shrubs set against the brilliantly lit textured walls. The strong shadows also play an important part as they reveal the intensity of the light.

Composition

The composition works extremely well, having a good balance of tone and a subtle lead-in provided by the path in the bottom left-hand corner.

Tone, Colour and Texture

To achieve greater all-round impact impasto paint was applied to many areas, especially on the white walls, window frames and foreground grass. To help achieve the sharp contrast between light and shade there are several areas where some of the darkest darks have been used alongside the lightest lights. Colour also plays an important part in capturing the hot summer day.

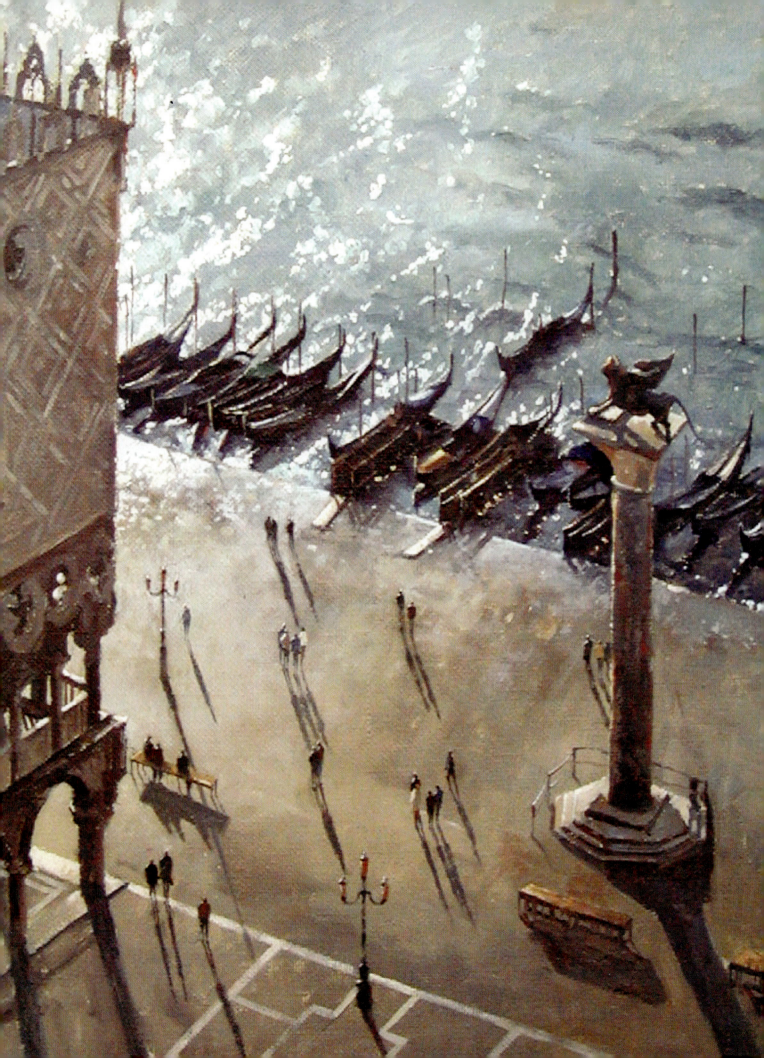

URBAN LANDSCAPES AND TRAVEL

View from the Campanile Tower/Venice illustrates how an unusual subject matter such as this takes full advantage of viewpoint to add design and drama to the finished piece of work. The composition has been well conceived; the line formed by the water's edge leads directly to the focal point, which has been emphasized by using the darkest darks for the gondolas positioned on the upper golden section, surrounded by the lightest lights for the sparkling water of the Grand Canal. The positioning of the column balances the strong, vertical mass of the Doge's Palace on the extreme left.

Even genius itself is but fine observation strengthened by fixity of purpose. Every man who observes vigilantly and resolves steadfastly grows unconsciously into genius.

Edward G. Bulwer-Lytton

Should you decide to venture out and paint in a city or town, you will find a wealth of fascinating subject matter and an interesting variety of shapes, tones and colours with which to work. When setting up to paint or searching for a suitable subject, try not to be too overwhelmed by everything you see before you. A street full of solid, man-made shapes in the form of buildings and cars can be a daunting prospect, but there are many ways of overcoming your doubts and fears. The following suggestions may help you with subject selection.

- When you are visiting any major town or city, take along a sketchbook and camera for recording possible subject matter.
- Consider a wide range of subjects, such as buildings which may have a strong architectural slant, houses, shops and so on. It may be that some of these subjects still have original architectural features such as iron railings and trees in front of them, all of which add variety and interest. *Morning Light/*

URBAN LANDSCAPES

Autumn Light/Edinburgh is once again a subject viewed from an elevated vantage point, giving additional drama to what was an already mouth-watering subject. Bright light had just begun to break through a veil of mist, illuminating the randomly scattered rooftops below. Although the majority of landscape painters may prefer to paint the rural or coastal scene, city and urban landscape subjects offer a refreshing opportunity to paint in a completely different environment whilst adding variety to your work.

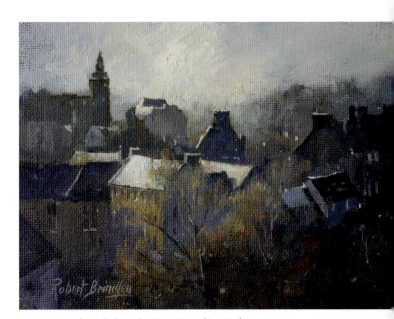

OPPOSITE PAGE:
View from the Campanile Tower/Venice, 40 × 50cm (16 × 20in).

Autumn Light/Edinburgh, 18 × 13cm (7 × 5in).

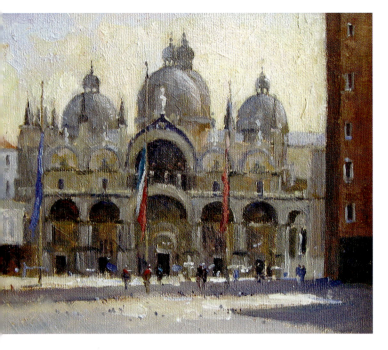

Morning Light/St Mark's Square/Venice, 20 × 25cm (8 × 10in).

Kensington Villas/London, 30 × 25cm (12 × 10in).

St Mark's Square/Venice contains wonderful architectural features creating a variety of interesting shapes, colours and textures. The flags, figures, long cast shadows and bright sunlight made this *plein air* study a joy to paint.

- Cameo scenes or narrow passages make excellent compositions. They will allow you hone in to a particular subject by editing out unnecessary buildings, details and clutter. *Kensington Villas/London* illustrates just such a scene, painted from cropped photographic reference.

- Figures, cars, taxis and so on provide movement and interest within a painting. *The Umbrella/Accademia/Venice* uses dramatic light, figures and trees to create a cameo scene in the centre of one of the world's busiest cities. Notice how the main elements of the painting – the figures, chairs, stands, umbrella and cast shadows – have been arranged with care to give pleasing, overlapping shapes whilst at the same time allowing the viewer to meander through the painting. *The Red Bus/Whitehall* provides another example. It uses a red bus, taxis, cars, trees and figures to add interest to this busy London scene. Notice how trees can be used to soften and punctuate the solid, angular shapes of the buildings.

- Even the most overwhelming of city subject matter can be transformed dramatically by transient light effects and the weather. Hazy light will have the effect of unifying an

The Umbrella/Accademia/Venice, 20 × 25cm (8 × 10in).

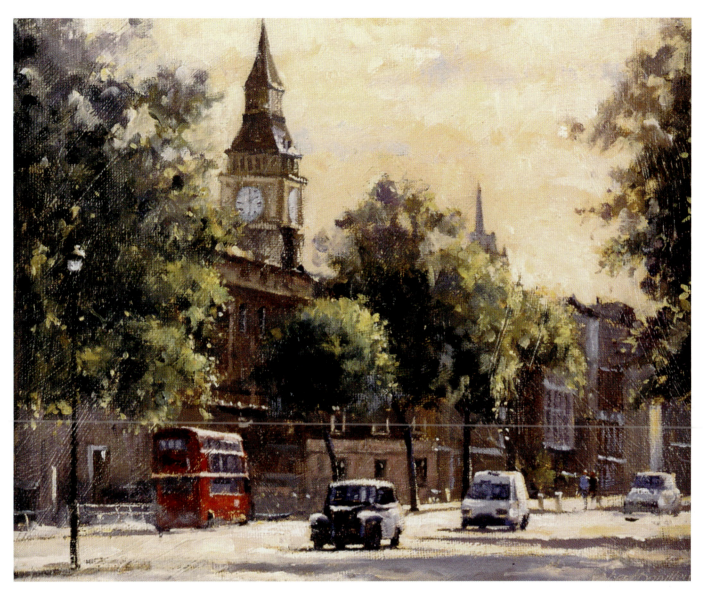

The Red Bus/Whitehall, 30 × 25cm (12 × 10in).

otherwise over-complicated scene, softening edges and merging shapes. Trees, as discussed earlier, can have a similar effect; their form tends to soften and break up the rigid form of buildings. The soft, hazy light and autumn trees in *Hazy Light/The Mall/London* illustrate these points extremely well. Notice how the distant trees merge seamlessly with the nearer ones, and into the low building on the extreme right. This diffusion of colour and form enabled the nearer trees, taxi and figures to have more impact, thereby strengthening the centre of interest.

- Heavy rain causes real problems for the *plein air* painter. However, by painting between showers or immediately after heavy rain, the results can be stunning. Wet streets and pavements are transformed dramatically, changing mood and atmosphere and often introducing vitality to a painting,

Hazy Light/The Mall/London, 30 × 25cm (12 × 10in).

DEMONSTRATION: *High Aspect/River Thames*

This painting was commissioned and undertaken from photographic reference overlooking the River Thames near Tower Bridge. It was painted using a limited palette of three colours and white.

MATERIALS

Support
A 36 × 92cm (14 × 36in) canvas-coated board treated with one coat of texture paste, one coat of white acrylic primer and a dark, 'turpsy' wash of Ultramarine Blue and Permanent Bright Red.

Brushes
- Nos. 4, 6 and 8 Eclipse, Filbert brushes by Rosemary and Co.
- A no. 3 round sable or synthetic Rigger.

Colours
A limited palette of three primary colours and alkyd white were used: Permanent Bright Red, Cadmium Yellow Lemon, Ultramarine Blue and Griffin alkyd Titanium White, which helps to speed up drying time. Four greys were also mixed from the above primaries and white:
- Grey 1: A warm, light-toned grey.
- Grey 2: A cooler, light-toned grey.
- Grey 3: A mid-toned grey.
- Grey 4: A dark-toned grey.

Additional Items
- Turpentine, or a low odour solvent or white spirit (for cleaning the brushes only).
- A light-coloured pencil.
- A palette knife.
- A copious supply of kitchen towel.

Step 1.

Step 1: Drawing Out
Use a light-coloured pencil or a 'turpsy' mix of Titanium White to draw a simple outline of the subject.

Step 2.

Step 2: Commencing the Block-In
Using the pre-mixed greys, begin to block in some of the darkest darks around Tower Bridge and also some of the more distant features around St Paul's Cathedral. To assist the feeling of recession, take particular care to keep these distant colours cooler and lighter than the colours used further forward. At this stage keep detail to an absolute minimum.

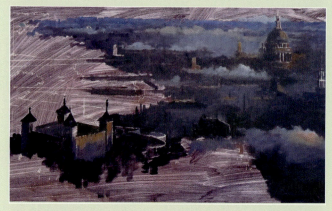

Close-up: step 2.

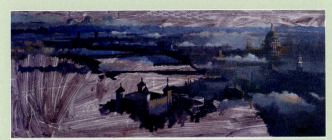

Step 3.

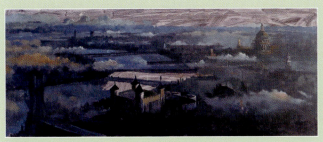

Step 4.

Step 3: Developing the Block-In

Continue blocking in the middle and far distance using the same mixes. The far distance mixes can be adjusted using white and more of the cooler grey. At this stage it is essential that your tonal relationships are accurate.

Step 4: Continuing the Block-In and Beginning to Add Detail

Complete the block-in and, at the same time, begin to add a little more detail and colour to the foreground. The foreground colours can be intensified by adding the primary colours.

Step 5: Completing the Block-In and Final Details

Bring the painting to its conclusion by painting the distant warmer sky. Look carefully to identify the tone and colour of the sky by comparing it with the foreground. Notice how subtle warm and cool colour combinations have been used throughout the painting.

In order to create more recession in your painting, bold, confident brush marks and thicker paint should be used in the foreground.

The final details and highlights can now be added. Take care not to create distraction by over-detailing around the edges of the painting, however.

As usual, before cleaning off your palette take a little time for assessment and make any necessary changes.

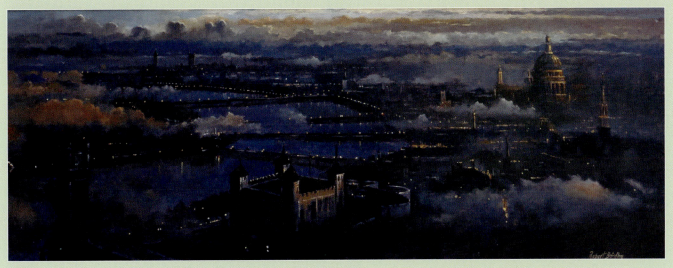

Step 5.

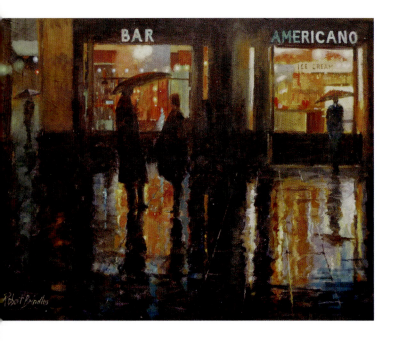

such as colourful, dancing lights reflected in the wet surface. *Reflections/San Marco/Venice* was painted from photographic reference and illustrates shimmering, colourful reflections from a bar seen on an evening walk.

- Night scenes offer a further option. In some respects, the effects observed can be very similar to those seen on rainy days. Lights from windows, street lamps, cars and so on provide movement, contrast and interest in the chosen subject. Another advantage in painting night scenes is the fact that, due to the reduced levels of lighting, many of the bewildering details that would be present in the daylight will have been simplified.

LEFT: *Reflections/San Marco/Venice*, 40 × 30cm (16 × 12in).

BELOW: *Towards Burano from Torcello*, 30 × 20cm (12 × 8in).

TRAVEL

Towards Burano from Torcello was painted from the Campanile on a beautiful sunny morning, looking across the lagoon to the remote, marshy island of Burano. From the Byzantine Basilica, the oldest building in the lagoon, a 360-degree view of the lagoon can be observed and Venice can be clearly seen in the distance. This island, with its varied and spectacular views of the lagoon, is a landscape painter's paradise with numerous quiet waterside locations where you are able to settle down and paint in peace.

The UK offers the landscape painter a vast diversity of constantly changing subject matter. Depending on the prevailing light, weather conditions and the seasons, many familiar views can be painted repeatedly, each version producing something entirely different. However, travel to different parts of the world always stimulates creativity and at the same time helps to broaden and develop an artist's knowledge and skill level. Should you have the chance and desire to paint a variety of more exotic scenery with intense light and colour, you will find this in abundance by visiting other countries. The following destinations may be of interest.

Goa

Goa is a small Indian state that was once ruled by the Portuguese. Consequently it offers the painter a combination of traditional Indian countryside and buildings and a strong European influence. The landscape painter will be overwhelmed by the subject matter to be found, from long sun-drenched beaches to wonderful countryside, towns and villages. Sunlight and extremes of tone, colour and texture are everywhere, and on top of that you will be warmly welcomed with generosity and smiling faces wherever you go.

The studio painting *The Boat/Calangute* provides just one idea from the subject matter to be found on one of Goa's beaches.

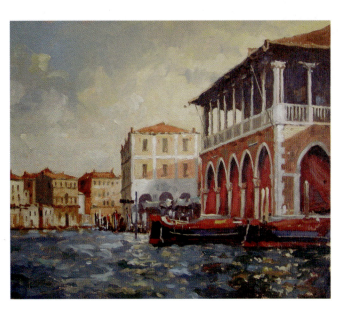

TOP RIGHT:
The Boat/Calangute, 50 × 40cm (20 × 16in).

MIDDLE RIGHT:
A Side Canal/Castello, 30 × 20cm (12 × 8in).

BOTTOM RIGHT:
The Fish Market from the Grand Canal, 30 × 25cm (12 × 10in).

Venice

Venice is described frequently as 'the most beautiful city in the world' and this must surely be true. Over many centuries it has attracted more painters than probably anywhere else in the world and artists return over and over again in search of inspiration.

The small study *A Side Canal/Castello* was painted to capture colour and texture and is typical of the subject matter to be found in abundance anywhere in the city. The artist's wide choice of subject matter is also changing constantly due to either the intensity of the sunlight, the mood and atmosphere created by misty, early mornings, or the influence of the seasons. Spring can be a wonderful time in which to paint the city, with either long sunny days or rising mists from the lagoon so often experienced in the mornings and evenings at that time of the year. Autumn can also be very special, with similar light effects that are then played against rich autumn foliage.

The Fish Market from the Grand Canal was painted from reference photographs and sketches.

For those painters wishing to venture a little further afield the numerous islands of the lagoon should be considered, as they offer slightly different subject matter and are quite often much quieter than Venice itself. The *plein air* sketch *The Washing Line/Burano* was painted in a quiet location, being inspired by the colourful scene.

Corfu

The beautiful island of Corfu lies in the north of the Ionian Sea and, unlike many other Greek islands, is noted for its lush green countryside and stunning coastal scenery. The seas are a crystal clear, deep blue and the north-east coast in particular is extremely paintable, having rugged tree-covered cliffs, wonderful coves, coastal villages and beaches. The villages and towns are numerous, with a blend of traditional Greek and Venetian architecture. Corfu town and its old harbour can be recommended for the diversity and wealth of subject matter. It is recommended that you paint either in the early morning or in the evening to avoid the heat, which can be oppressive. These times will also provide you with the best lighting conditions.

The Blue Boat/Mesongi is a *plein air* study inspired by the colour of the water, the overhanging trees and the small, constantly moving boat.

TOP LEFT:
The Washing Line/Burano, 13 × 18cm (5 × 7in).

BOTTOM LEFT: *The Blue Boat/Mesongi*, 18 × 13cm (7 × 5in).

IN THE SPOTLIGHT

Sparkling Light/Grand Canal/Venice, 20 × 25cm (8 × 10in).

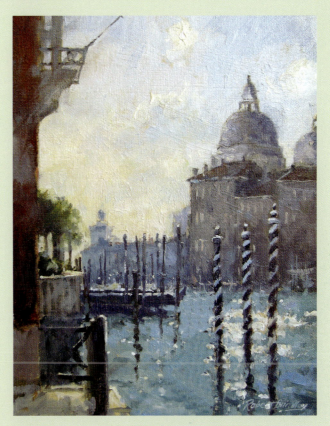

Digital alteration of *Sparkling Light/Grand Canal/Venice*.

The small *plein air* painting *Sparkling Light/Grand Canal/Venice* was painted in a quiet location at around 7am on a warm summer morning. The inspiration for the painting came from the colour and movement of the water, including the interesting reflections of the mooring posts and the distant Salute. A heavily textured board, under-painted with a 'turpsy' wash of Burnt Sienna was used.

Evaluation

This small study, painted from a favourite location, was a joy to work on. Many paintings have been undertaken from this spot over the years as it is possible to paint virtually all day long without being disturbed. From this location the first light of the day can be observed *contre-jour*, lasting for around an hour, before it moves progressively in a clockwise direction for the rest of the day. Consequently, from the same location it is possible to paint four or five different versions of the same view under changing light conditions.

Composition

The composition works fairly well. It could be improved, however, by removing the central large mooring post (see the illustrated digital alteration). To create compositional balance the water line has been positioned on the horizontal golden section and the dome of the Salute on the vertical golden section.

Tone and Colour

The tone and colour work perfectly well and nothing would be changed in any future painting.

OBSERVATIONS AND CONCLUSIONS

The small *plein air* sketch *Mid Day Light/The Arsenale/Venice* was painted on a hot, sunny day. The inspiration came from the warm, soft brick colours playing against the blue sky and the gently undulating reflections in the canal.

Observation and study are necessary to achieve mastery of light and form.

Andrew Loomis

CONFIDENCE AND SELF-ESTEEM

At some time or another, all artists, no matter how experienced they are, suffer from a lack of confidence and self-esteem. To recognize this fact and come to terms with it at an early stage is vital for your development. There are many reasons for lack of confidence. It may be brought on by a run of mediocre paintings, or criticism, which can be very difficult to take, especially if it comes from someone close to you or one of your peers. More often than not, however, a lack of confidence can simply be put down to the ups and downs of life. Successful painting, like everything else in life, fluctuates with how an individual feels on the day; regrettably, the only recourse is to be patient, work even harder through these times and await an upturn.

It helps to have a positive attitude to all your work, good, bad, or indifferent – after all, you will always learn far more from a failed painting than from a successful one that almost painted itself. Be objective and adopt an honest approach to all your work and you will reap the benefits.

One very useful piece of advice is this: if at any time during the painting process you feel unsure about the area of the painting on which you are working then stop working on it immediately.

Take time out for assessment or continue on another area. Many paintings can be ruined during these periods of indecision. This advice becomes more pertinent as you approach completion, so be careful not to over-work the painting at this critical stage.

Be confident in your approach to your work, as a lack of self-confidence or fear will restrict your progress. Try not to be overly critical of your work and never be too concerned about your ability. A natural talent and ability is only present in a relatively small number of artists; the level of talent varies and is often indefinable. All you can hope for is that at some stage a degree of mastery will emerge. To progress you must love to paint, work hard to develop your abilities, listen to advice from experienced artists and paint only what inspires or excites you.

Do not be afraid to keep things simple; sometimes the simplest subjects are the most successful and rewarding of all. The pleasure of sitting in the garden on a warm summer's day painting the small sketch *The Bee Hive/Artist's Garden* helped to kick-start my lost enthusiasm, in what had been a fairly unproductive period of mediocre work.

The Bee Hive/Artist's Garden, 25 × 20cm (10 × 8in).

OPPOSITE PAGE:
Mid Day Light/The Arsenale/Venice, 20 × 25cm (8 × 10in)

Creativity requires introspection, self-examination, and a willingness to take risks. Because of this, artists are perhaps more susceptible to self-doubt and despair than those who do not court the creative muses.

Eric Maisel

SELF-CRITICISM

For any open-minded artist there will always be things to learn and progress to be made. The only difference between a beginner and a more experienced artist is their relative position on the learning ladder. As mentioned earlier, only a small number of talented artists have the gift of natural ability; your progress up this ladder depends almost entirely on your having an open mind, the desire to improve and, finally, time spent on the painting process.

Once you accept these facts and work hard, your work will develop accordingly. To maintain progress it is important for you to be able to step back and, in a measured way, evaluate and be critical of your own work. The following questions and suggestions may help you to evaluate your own paintings.

- Do you find the painting visually exciting, or is it lifeless and dull? Lifeless, dull paintings should be assessed carefully and any necessary changes made.
- Have you captured the mood you experienced when you first saw the subject, or have you merely copied a lifeless version of what was in front of you? Where possible make

Pony and Poppies, 30 × 25cm (12 × 10in).

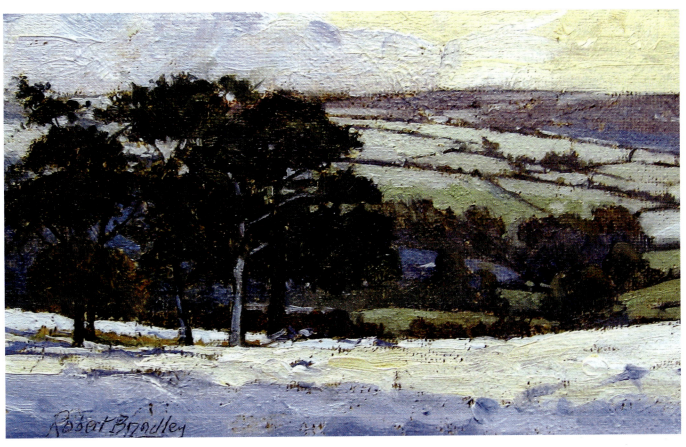

Snow/Eskdaleside, 20 × 13cm (8 × 5in).

any necessary changes. *Pony and Poppies* captured perfectly the mood of the day on which it was painted. Hopefully this small oil painting transports the viewer to a tranquil location on a warm, early summer's day.

- What are the qualities that you feel have been most successful? It may be texture, colour harmony, composition or other elements. The texture and colour harmony work particularly well in the small *plein air* sketch *Snow/Eskdaleside*.
- Does the chosen format work? If not, consider cropping or re-painting. Generally speaking a rectangular format will convey a peaceful scene and a panoramic format will complement a flat, barren landscape. A square format will often suit solid, angular subject matter.
- Does the division of space work successfully? If not, you may need to consider moving your main horizontal or vertical, or any key features that divide spaces into halves or quarters. For example, a lamp column or tree may have been positioned on the centre of a building. In these instances it is best to think in terms of unequal divisions of space, such as thirds or fifths.
- Does your focal point work efficiently?

Your doubt can become a good quality if you train it. It must become knowing, it must become criticism.

Rainer Maria Rilke

COMPLETING A PAINTING

When is a painting completed? This question is asked frequently and, unfortunately, there are no set answers. In general terms the painting is complete when it satisfies the essential criteria with respect to drawing, composition, tone and colour. However, when the above criteria have been met you should ask yourself, 'Does this painting meet my original expectations?' If the answer is 'yes' then the painting is probably complete.

In some instances, you will be unable to answer some of the above questions. One reason for this is that when creating a painting you become too familiar with the work, which makes any assessment difficult. In situations such as this it may help to view the painting through a mirror. By doing this the painting will be laterally inverted and you will see

the work in an unfamiliar way, almost as if you were viewing it for the first time. Another option is to put the work aside for a few days and live with it. You will find that by coming across the painting unexpectedly, any weak areas that require further attention will become apparent.

One of the best ways of analyzing your work and deciding whether it is complete or not is to seek honest advice from a partner, close friend or colleague. In some instances you may not agree with the comments made, but the important thing is that it has focused your attention and made you look again. Try not to be too precious about your work or over-sensitive to any adverse comments. After careful consideration, as mentioned previously, you may disagree completely with the suggestions made and decide to take no action. However, the process of re-evaluating your work in response to these comments is extremely important. It will ensure that you keep an open mind and it could give you a valuable insight regarding the thoughts and reactions of other people when looking at your work.

PRESENTATION AND FRAMING

The way you present your finished work is extremely important. Generally speaking, extremely competent paintings are often ruined by the way they have been framed.

A painting that you are particularly pleased with deserves to be shown to its best advantage; however, framing is extremely expensive these days and, in some cases, spending a lot of money on a quality frame will not always guarantee that your work will look its best. The handmade frame illustrated here shows a beauti-

ful, hand-finished frame that complements the painting perfectly. Frames such as these are fairly expensive and it may be that you decide to reserve one or two for only your better works.

These days there are numerous mouldings available to the oil painter, varying greatly in price and style. You may find some of the following suggestions helpful when framing on a limited budget.

- Consider painting to standard sizes; by doing this you will be able to rotate paintings when showing them in different exhibitions. You may, however, find that this restricts the creativity and variety of your work.
- When considering how to frame your work, be aware of the fact that some paintings may actually look better in simple and in some cases, cheaper, frames. Expensive frames will not necessarily suit all of your work.
- Getting to know a good framer will be an assistance to you when choosing economical frames to suit your work. Most framers will be only too pleased to supply ready-made frames, which you can use with different paintings.
- Should you have reasonable DIY skills, consider buying yourself some basic framing equipment.

Finally, be aware that a frame should never overpower the painting, so it is best to avoid too wide or strong, colourful mouldings, especially on your more subtle works.

A handmade frame.

SUMMARY

As a landscape painter your first consideration should be to paint for yourself and then only what excites you. This will enable you to capture your vision of nature in all its forms and hopefully at the same time transmit your excitement to others.

Your primary motivation must always come from a deep desire to paint a particular subject. Successful communication with subsequent admirers of your work, hopefully rewarded by sales, will also excite and motivate you. This secondary motivation should be harnessed and enjoyed, but never allowed to take over the drive and enthusiasm generated by the primary motivation. Let these successes act as a catalyst to renewed efforts and optimism.

It is my hope that you will be able to draw from some of the positive points discussed in this book and at the same time resist any negative thoughts that may begin to take hold. Bear these factors in mind and you will progress as a painter. Remember: the more you paint, the better you will get. Be patient and accept that progress is often slow and comes in fits and starts. Try to create a working environment that reflects confidence and a positive attitude towards your work and, most importantly of all, enjoy everything you do.

IN THE SPOTLIGHT

Summer/Wheeldale Gill, 30 × 23cm (12 × 9in).

Summer/Wheeldale Gill: detail showing texture.

Summer/Wheeldale Gill was painted on site and completed in the studio. A heavily textured board, under-painted with a 'turpsy' wash of Burnt Sienna was used.

On some occasions when a painting does not quite seem to work it is extremely difficult to determine exactly where it is failing. This particular piece of work stood in the studio for a week or two undergoing several changes before the problems were resolved. In the final analysis, most of the changes made concerned the colour temperature of the greens. Initially, they were too strident and time was taken therefore to repaint certain areas by using a combination of warmer, greyer greens. The sheep were also repositioned several times.

Evaluation

The inspiration for this painting came from the sunlit fields enhanced and enclosed by the back-lit trees and the bank of the stream.

Composition

The composition works extremely well; the tapering, wedge shape of the stream leads the eye straight to the focal point (the sheep in the sunlit field). This focal point is situated ideally on the upper left golden section.

Tone and Colour

The tone and colour now work extremely well; however, as stated earlier, substantial changes were made to this painting by reassessing the greens.

Texture

By using confident brush marks, in conjunction with impasto paint, the light on the background field was enhanced and at the same time the foreground rocks and grasses were brought forward, adding depth to the painting.

There will always be a barrier between what I see and what I am able to portray. This barrier keeps bringing me back to the canvas, carrying on a never-ending desire to express, in paint, what moves me inside.

Scott L. Christensen

FURTHER INFORMATION

Further Reading

Christensen, Scott L., *The Nature of Light*, Christensen Studio Inc.
Curtis, David, *A Light Touch: Painting Landscapes in Oils*,
 David and Charles
Curtis, David, *Capturing the Moment in Oils*, Batsford.
Macpherson, Kevin, *Fill Your Oil Paintings with Light and Colour*,
 North Light Books.
Schmid, Richard, Alla Prima: *Everything I Know About Painting*,
 Stove Prairie Press.
Schmid, Richard, *The Landscapes*, Stove Prairie Press.

DVDs

Here is a selection of recommendations from the many
excellent instructional DVDs available:

APV Films (www.apvfilms.com)
Curtis, David, *A Light Touch: Landscapes in Oils*.
Curtis, David, *Light in the Landscape*.
Curtis, David, *Painting with Impact*.
Howard, Ken, *A Vision of Venice in Oils*.
Pekel, Herman, *A Passion for Paint*.
Wilks, Maxwell, *Colour and Light in Oil*.

Town House Films (www.townhousefilms.co.uk)
Oil Sketching on Location with Robert Brindley.
Painting Atmospheric Landscapes in Oil with Bryan Ryder.
Oil Landscapes: Quick and Easy – with Bryan Ryder.
Inspirational Oil Landscapes – with Peter Wileman.
Painting the Light in Oils – with Peter Wileman.

Stove Prairie Press (www.richardschmid.com)
Richard Schmid Paints the Landscape (a four-part series):
- 'November' (no. 1)
- 'June' (no. 2)
- 'May' (no. 3)
- 'White Pine' (no. 4).

Materials and Suppliers

Paint
Winsor and Newton artists' oils, 37ml tubes.
Winsor and Newton Griffin Alkyd, Titanium White, 120ml tubes.
Vasari Classic Oil Colours, 40ml tubes.

Brushes
Pro Arte Sterling Oil/Acrylic brushes.
Pro Arte series 202 Acrylix brushes.
Escoda 4050 brushes.
Rosemary and Co. Eclipse Filbert brushes.

Boards
Winsor and Newton or *Rowney* canvas-covered boards
in assorted sizes.
Winsor and Newton, Daler-Rowney or *Jackson's* stretched
cotton canvases in various sizes.

Miscellaneous

Rowney texture paste.
Jackson's acrylic white primer.
Easels and other sundry items.
All the above materials can be sourced from most good art
shops or the following on-line suppliers:
- Jackson's Art Supplies (www.jacksonsart.co.uk)
- Ken Bromley Art Supplies (www.artsupplies.co.uk)
- SAA (Society for All Artists) (www.saa.co.uk)

Framing

High quality, handmade frames for all mediums can be
purchased from:
Frinton Frames (www.frintonframes.co.uk; tel: 01255 673707).

INDEX

A

Alkyd paint 12, 15
Acrylic ground 13, 14
Acrylic primer 13, 15, 19
Aerial perspective 33
Alterations and adjustments 21, 39, 47, 48, 54, 57
Animals 52, 54, 108, 130–131

B

Backgrounds 14, 31, 39, 42, 72, 74, 107, 111
Beach scenes 14, 92, 98–99
Blending 15, 84, 126
Block-in 19, 125
Boards 13–15, 16, 17, 18, 19, 60, 61, 72, 98, 107, 108, 111, 133, 136
Boats 11, 27, 31, 36, 51, 60, 88, 95, 98–99, 100–101
Brushes 11, 12–13, 15, 17, 18
Brush marks 15, 66, 107, 112, 115
Buildings 6, 23, 24, 27, 31, 42, 52, 56, 77, 108, 115, 133–141, 143, 144, 145, 149

C

Canvas 9, 13, 15, 16, 19, 56, 60, 61
Chamberlain, Trevor 93
Characteristics 7, 11, 12, 18, 38
Chroma 42
Cities 52, 144
Clouds 72, 75, 76
Coastal landscapes 92–105
Colour
 Complementary colour 44–45
 Cool colour 46–47, 54, 115, 120, 124
 Coloured ground 14, 15, 107
 Hue 36, 37, 38, 42, 44, 47
 Mixing 7, 18, 43, 44, 45, 46, 47, 48, 110, 111
 Primary colour 7, 18, 43, 44, 45, 47, 48
 Secondary colour 44, 46, 47, 111
 Tertiary colour 45, 46
 Warm colour 14, 42, 46, 112
Composition
 Compositional lines 29
 Layouts 30–31
 Theory 25
 Viewpoint 9, 55, 57, 87, 98, 101, 107, 108 143
Computer, use of 55
Contre jour 35–36
Corfu 56, 75, 76, 88, 150
Counterchange 39
Cropping 55, 60, 61–62, 155
Curtis, David 93

D

Demonstrations
 Chapter 2. January Snow/Richardson's Row/Newholm 40–42
 Chapter 3. The Gate/Beck Hole 58–59
 Chapter 4. Sunset Towards Egton 78–79
 Cumulous Clouds/Corfu 80–81
 Dawn Near Pickering 82–83
 Chapter 5. Winter Light/Sandsend 96–97
 Chapter 6. Autumn Frost 113–115
 Sheep In The Snow/Sleights 118–120
 The Moor Near Castleton 127–129
 Chapter 7. Winter Sunset 138–140
 Chapter 8. High Aspect/River Thames 146–147
Design 19, 25–32

Digital photography 42, 54, 55, 131
Drawing 19, 23, 24, 25, 33, 36, 42, 55, 56, 66, 101, 122, 130, 133, 155

E

Easels
 French easel 17, 56
 Pochade 17, 56, 60
 Studio easel 17
Edges 24, 25, 28, 30, 32, 36, 61, 63, 109, 110, 126, 145
Equipment 11–19
Evening light 21, 35, 92, 98, 99, 108, 125

F

Farms/farm buildings 30, 52, 109, 133, 136
Figures 30, 52, 65–67, 107, 144, 145
Focal point 25, 30, 31, 32, 34, 39, 61, 66, 101, 108, 109, 129, 135, 143, 155
Foliage 107, 108, 109, 111, 112, 124, 126, 150
Foregrounds 30, 31, 35, 66, 74, 75, 84, 101, 109, 110, 115, 117, 130, 135, 136
Framing 156

G

Glazes 9, 42
Goa 149
Golden section 25, 27, 29, 51, 61, 143
Greens 107, 109, 110–111, 112, 124
Griffin alkyd 12
Grounds 13–15

H

Hard edges 111
Harbours 52, 92, 98–99
Highlights 39
Hue 42

I

Impasto 12, 95, 115
Inspiration and motivation 21–49

L

Lead in 21, 25, 29, 31, 51, 63, 87, 93, 108, 135, 136
Light 33–36
 Reflected light 76
 Light effects 33, 54, 93, 144, 150
Limited palette 7, 18–19, 36, 43, 47–48, 56, 77, 93, 95, 98, 108, 111, 120
Liquin 15
Lost and found 29, 31, 72
Low odour solvent 15

M

Mahlstick 16
Materials 11–16
 Daler Rowney 12, 13
 Pro Arte 13
 Rosemary and Co. 13
 Vasari 12, 18
 Winsor and Newton 12, 13
MDF board 13
Mood and atmosphere 9, 11, 22, 36, 54, 63, 145, 160
Morning light 33, 84, 92, 133, 134, 143, 144
Morston Quay 84, 93, 94

O

Oilbars 12

P

Painting trips 51, 60, 71, 101, 149
Palette 11, 12, 15, 16, 56, 57, 60
 Glass 15, 16, 48
 Wood 11, 15, 16
Palette of colours 18–19, 36, 43, 47–48, 56, 77, 93, 95, 98, 108, 111, 120
Pencils 18, 55, 56, 95, 98, 122,123, 124, 133
Perspective 23, 24, 29, 33, 56, 65, 75, 130, 133, 136
Photography 24, 54–55

Pigments 7, 12, 42, 111
Plein air painting 7, 9, 11, 13, 16, 17, 18, 19, 33, 35, 38, 51, 52, 54, 56–60, 67, 71, 74, 92, 93, 95, 99, 101, 108, 109, 110, 112, 117, 122, 124, 125, 131, 133, 144, 145, 150, 153, 155
Pochade 17, 56, 60
Preparation 15, 47
Presentation 156
Primer 13–15
Proportion 7, 25, 38, 60, 61–62, 67, 133

R

Reflected light 38, 77–78, 135
Reflections 7, 21, 87–91, 107, 148, 153
Reference material 54–56, 61, 131
Rural landscapes 52, 107–131

S

Sandsend 52, 53, 57, 87, 94, 95, 98, 135
Seago, Edward 71, 93
Seasons 34, 52, 107–112, 124, 149, 150
 Autumn 30, 34, 108, 112, 122, 124, 143, 145, 150
 Spring 109–110, 112, 130, 134, 135, 150
 Summer 37, 57, 87, 93, 98, 106, 107, 110–111, 112, 124, 153, 155
 Winter 35, 39, 52, 77, 84, 107–108, 109, 112, 117, 120, 122, 123
Shadows 30, 31, 35, 45, 51, 54, 55, 57, 74, 77, 91, 111, 120, 133, 135, 144
Simplification 22, 126
Size/proportion 61–62, 67, 133
Sketchbooks 33, 55, 56, 67, 108, 131, 143
Sketching 15, 19, 23, 33, 36, 38, 55–56, 61, 66, 67, 77, 87, 89, 97, 108, 122
Skies 33, 52, 71–85
Sky colour 77
Snow scenes 52, 108, 115–121
Soft edges 25, 28
Staithes 10, 11, 18, 20, 21, 70, 71, 89, 101, 103
Storage of materials 17
Studio/setting up 17–18
Studio lighting 17
Subject selection 51–69

Sunsets 35, 52, 63, 76, 77, 92, 95, 100, 101
Supports 13–15

T

Techniques 19
Texture 11, 13, 15, 19, 21, 22, 25, 51, 54, 55, 56, 93, 101, 124, 144, 149, 150, 155
Texture paste 13, 15, 107
Thinners/Low odour 17
Tone 14, 17, 25, 33, 34, 36–39, 42, 48, 55, 57, 60, 63, 66, 76, 84, 88, 89, 91, 111, 112, 117, 120, 124, 125, 130, 135, 143, 149, 155
Travel 93, 149–150
Trees 21, 29, 30, 31, 33, 51, 52, 65, 72, 84, 108, 109, 115, 117, 122–26, 136, 144, 145, 150
Turner 93
Turpentine 15
Turpentine substitute 11, 15

U

Under painting 44
Urban landscapes 143–151

V

Value 19, 25, 28, 33, 37, 38, 39, 47, 48, 54, 60, 62, 75, 111, 126
Value finder 60
Varnish 16
Venice 14, 63, 64, 65, 66, 67, 68, 69, 77, 89, 90, 93, 143, 144, 148, 149, 150, 153
Viewfinder 36, 60, 109
Viewpoint 55, 57, 87, 98, 101, 107, 108, 143
Villages 133–141

W

Water 31, 52, 77, 87–91, 95, 94, 98, 107, 143, 150
 Moving water 77, 89–91, 150
 Reflections 77, 107
 Still water 77, 87–89, 91
Water mixable oil paints 12
Wesson, Edward 71, 93
Whitby 29, 31, 34, 35, 39, 52, 53, 71, 98, 99, 100, 101, 117, 133, 134